"Some books are to be tasted, others to be swallowed, and some few to be chewed on and digested." Francis Bacon

RotoVision

A RotoVision Book

Published and distributed by RotoVision SA
Route Suisse 9
CH-1295 Mies
Switzerland

RotoVision SA
Sales and Editorial Office
Sheridan House, 114 Western Road
Hove BN3 1DD, UK

Tel: +44 (0)1273 72 72 68
Fax: +44 (0)1273 72 72 69
www.rotovision.com

10 9 8 7 6 5 4 3 2 1

ISBN-10: 2-940361-46-0
ISBN-13: 978-2-940361-46-5

Art Director: Tony Seddon
Design: JCLanaway

Reprographics in Singapore by ProVision Pte. Ltd.
Tel: +65 6334 7720
Fax: +65 6334 7721

Printed in China by Midas Printing International Ltd.

# Issues

# Anatomy

# Portfolios

# Etcetera

# What is publication design?

**pub·li·ca·tion,** *n*
1. the publishing of something, especially printed material for sale
2. an item that has been published, especially in printed form
3. the communication of information to the public

## Print matters

Wherever we go, whatever we happen to be doing, publications surround us. In newsagents (newsdealers), endless racks of magazines and newspapers in multiple languages battle it out for visual supremacy. In bookstores, shelf after shelf of books, covering every conceivable topic, compete for our attention. In our mail, we find everything from catalogs to corporate literature constantly working to pull in that extra sale. Why? Because in today's society, communication is all-important, and the power of print has never been stronger.

This does not mean that the process of designing print is easy. Consumers are bombarded with so much printed matter that it is easy to become jaded with what is on offer—and competition is fierce. Once a new type of magazine hits the shelves, such as the recent arrival of the weekly glossy, within weeks half a dozen competing titles will be jostling for space alongside it. As soon as one of the broadsheet (full-size) newspapers changes to tabloid format, the rest immediately follow suit. Simply coming up with a new concept is no longer enough. Today's publication designers must work harder than ever to captivate and connect with the reader on both an aesthetic and an emotional level.

There are many different categories and types of publication, all aimed at different audiences, from consumer to corporate to trade. Magazines, newspapers, and books are, perhaps, the most obvious candidates, but the world of publications does not end there. It also incorporates annual reports, product catalogs, newsletters, journals, and everything in between. Just as important as the type of publication being created is its target audience. Whereas trade magazines are aimed at specific, niche audiences and designed accordingly, consumer magazines have a much wider appeal, which is reflected in their more user-friendly, inclusive design.

Publications—whether books, magazines, catalogs, or even annual reports—also have an aspirational element. We may not be able to afford the glamorous clothes that adorn the pages of *Vogue*, but we can still buy into that lifestyle via the look and feel of the magazine. In the same way, subscribing to a special-interest publication enables us to connect with like-minded individuals, whether they live in the next street or on the next continent. Books, too, can elicit a powerful response, transporting us to another time and place, simply through the power of words. Even a corporate annual report is tantamount to membership of a private club.

Part of the appeal of a publication is what it feels like to hold. Designers are often limited in choice of format by factors such as size, shape, and, of course, cost, but there is still wide scope for creativity, as the examples in this book prove.

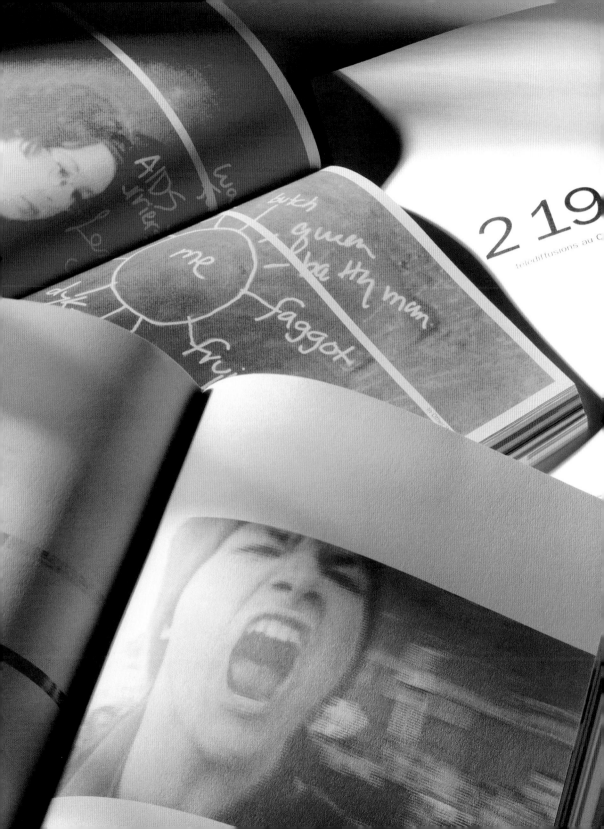

## Six appeal

In terms of publication design, six key areas can affect the finished design:

- format;
- grid;
- typography;
- color;
- cover or masthead; and
- use of imagery.

All of these aspects will be examined in detail over the coming pages. It is the combination of these elements that enables the designer to seamlessly fuse together a publication's content, while at the same time endowing it with a unique identity. The importance of each of these elements will, of course, vary with the type of publication being designed. However, a good design should never override the content, and vice versa; rather the two should work together to support and bring out the best in each other.

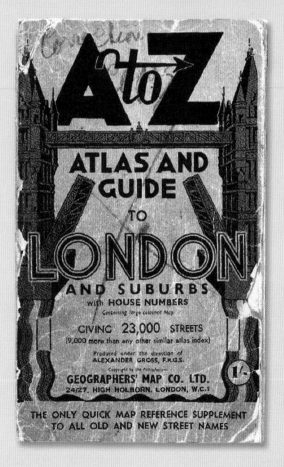

**A to Z London**
Designed in-house for the A–Z Map Company. One of the largest independent map-publishing companies in the UK, the A–Z Map Company currently publishes more than 300 titles. This image shows the cover of the very first *A to Z*, published in 1936.

**Ballpoint
exhibition catalog**
Designed by Pentagram.
Designed to resemble a
school exercise book, this
award-winning, limited-edition
catalog was created to
accompany an exhibition
celebrating the artistic
potential of the ballpoint pen.
(Photo courtesy of D&AD.)

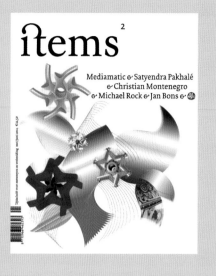

# items ²

Mediamatic & Satyendra Pakhalé
& Christian Montenegro
& Michael Rock & Jan Bons &

# items ³

Matali Crasset    Tjepkema Studio
Russische boekomslagen    Marc Newson
Grensoverschrijdend ontwerpen

Gefixeerd
op
de
gebruiker

# MATALI
# CRASSET

*Chris Reinewald*   Misschien haalden Design
Academy, Droog Design en de
Stichting Premsela met de
Française Matali Crasset (1965)
wel een wolvin in schaapskleren
binnen. Masterstudenten van
het seminar en de workshop

'The French Way' behandelt ze
streng, passend bij haar eigen pre-
cieze ontwerpvisie. Crasset is voor-
al geïnteresseerd in de typologie
van voorwerpen en hoe deze in ver-
houding staan met functionaliteit.
Kort gezegd: in 'des objets justes'.

***Items* magazine**
Designed by Studio Dumbar.
Studio Dumbar was invited
to completely restyle *Items*
magazine. "By allowing only
the smallest variation in the
use of the type font, the
typography has become a
strong binding/connecting
element in the magazine's
design." Specially selected
and constantly varying
typefaces, sourced from
young designers, are used to
create expressive headlines,
making the magazine a great
showcase for new talent.
(Photo courtesy of D&AD.)

**Left: *Board Meeting***
Designed by Browns. This book/catalog was designed to accompany an exhibition as part of a broader rebranding exercise to raise the profile of fashion label Fake London Genius. Twenty-four artists each customized a boogie board to raise money for Greenpeace and its Dead or Alive: Defending Ocean Life campaign. (Photo courtesy of D&AD.)

**Below: Merchant Handbook**
Designed by NB: Studio. Merchant produces a handbook each year to share the company's knowledge about annual reporting. In 2004, Merchant had put the FTSE 500 annual reports "under a microscope." The design team decided to reflect this in the handbook, which they styled in a similarly scientific fashion, reminiscent of old school textbooks. (Photo courtesy of D&AD.)

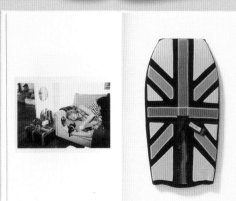

# The power of print

## A brief history

It is hard to believe that heading into the fifteenth century fewer than 50,000 volumes of writing existed in the Western world. At that time, the written word—hand-inscribed on vellum was largely reserved for the wealthy. Although far more durable than paper, vellum was extremely expensive and time-consuming to produce—a 200-page book would take four or five months to create and was of equal value to a farm!

Things didn't change until the art of papermaking was introduced to Europe from China. The first known paper mill in Europe was founded in the Italian town of Fabriano, in 1282. Paper was quick and inexpensive to produce, and soon replaced vellum as the publisher's material of choice. Even as far back as the fourteenth century, Fabriano's paper mills were producing a million sheets of paper a year. It was here that watermarked paper was invented, and Fabriano's paper is still used the world over for banknotes and quality art paper.

By the late 1300s, block books created from single woodcarvings that contained both text and images had begun to appear more widely. But having to create new blocks for every print meant that production was still a lengthy and expensive process. Cutting the wood blocks apart, however, or creating individual letters in steel or iron, meant that the letters could be used over and over again. The advent of movable type in Europe is credited to the German metal-worker Johannes Gutenberg (d. 1468), whose system enabled the production of thousands of durable, reusable letters and allowed for the rapid printing of written materials.

This innovation resulted in an information explosion in Renaissance Europe. Before long, printing presses were springing up across Europe as publishing became an industry in its own right in many major cities. It was now possible to store and share information, languages began to be standardized, and publications were made available to the masses.

One of the most popular early publications was the broadside. A single sheet of paper printed on one side, broadsides were initially used to spread religious information. They were later adopted as a means of sharing regional information and thus became the precursor to the newspaper as we know it today. In addition to being handed out in public, broadsides were fixed to walls and lampposts and, through their detailing of daily occurrences, provided the public with a precise view of everyday life.

Another major development in publishing occurred as a result of the Industrial Revolution in the nineteenth century and the mechanization of the printing process. An economy once based on manual labor now became dominated by industry and the manufacture of machinery. Wages began to improve, as did standards of living, and by the 1820s the first product catalogs and poetry journals had gone into circulation.

The arrival of photography (Joseph Nicéphore Niepce took the first permanent photograph in 1826) was not far behind and brought with it a whole new dimension to add to the printed page. By the early nineteenth century, publications illustrated with photography had become very much a part of daily life.

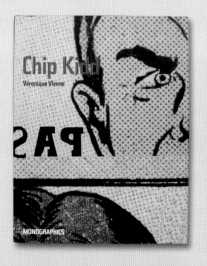

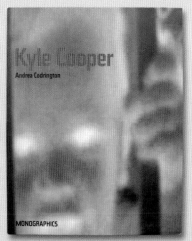

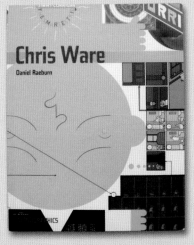

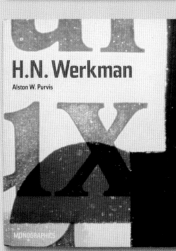

**Book covers for the**
***MonoGraphics* series**
Designed by Design
Typography for Laurence
King. As Design Typography
explains, "the challenge of
designing this series was
considerable. The design had
to complement, rather than
compete with the content,"
allowing the characteristic
style of each subject to
shine through. The final
design achieves this without
becoming anonymous itself.

## Print in a digital age

We may be surrounded by more publications than ever before, but not long ago many thought the days of the printed publication were numbered. It was a common belief that the digital age would see print resigned to the realms of nostalgia, in the same way that vinyl records and cassettes had been. However, if anything, the print medium has become even stronger as a result of the digital revolution. Online publications may be cheaper, faster, and easier to produce, but there is no way that staring at a screen can compare with the touch and feel of a book or magazine. On an experiential level, there is simply no competition. On a more technical level, images are not as sharp on screen as they are on paper. Nor do they have that variation in depth that different paper stocks can produce. In addition, printed publications have an authenticity to them that surpasses their digital counterparts. While anyone,

it seems, can publish information online, printed publications are regarded as being much more reliable sources of information. That is not to say technological advances in the future will not be able to overcome these constraints, but for now the power of print remains as strong as ever.

**Your Creative Future**
Designed by Atelier Works for the UK's Department of Culture, Media, and Sport. *Your Creative Future* is a guide to education and career opportunities in the creative industries. Atelier explains, "We were asked to bring some kind of coherence to the diverse careers literature for the creative industries." This spread answers the question, "What is design?".

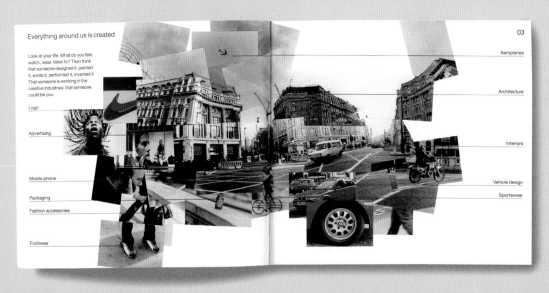

Everything around us is created

Look at your life. What do you feel, watch, wear, listen to? Then think that someone designed it, painted it, wrote it, performed it, invented it. That someone is working in the creative industries; that someone could be you.

Logo

Advertising

Mobile phone

Packaging

Fashion accessories

Footwear

Aeroplanes

Architecture

Interiors

Vehicle design

Sportswear

03

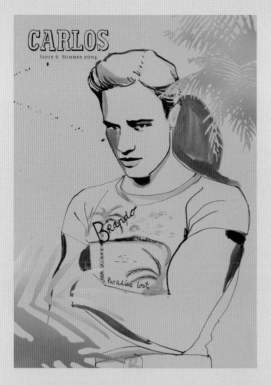

CARLOS

ISSUE 6 SUMMER 2004

44. Two decades ago, the New Romantic heroes of British pop music wowed the USA just as The Beatles had 20 years before. The second British invasion owed its success to style, the emergence of MTV and one killer haircut. Peter York was there to salute...

HOW THE WEDGE WAS WON

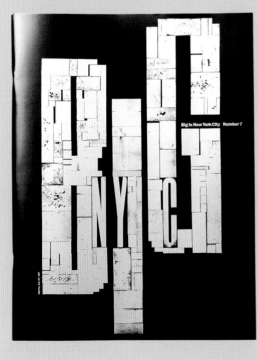

**Left: *Big in NYC***
Designed by Frost Design for *Big* magazine. Frost was drawn to letterpress typography as the perfect way to reflect the gritty realism of New York City. For this cover, he gathered as many of the letters N, Y, and C as he could. He then overturned all the letter Ns except one. He repeated this with the letters Y and C to create the word "BIG" and reveal the letters "NYC" within.

**Above: *Carlos* in-flight magazine**
Designed by John Brown Citrus Publishing. *Carlos* smashes every preconception that ever existed about in-flight magazines. Conceived as a fanzine to promote the "club" feel of Virgin Atlantic Upper Class, its lo-fi approach to design is echoed through the use of only two colors, and of commissioned illustration rather than the usual glossy photography. (Photo courtesy of D&AD.)

**The Process of Printing**
Designed by Design Project. This publication was created to showcase the working methods and philosophy of printing company Team, and to provide a guide to the potential of print. "The 24 plates in this casebound book with half dust jacket are for reference, and show how varied print techniques can be used to enhance the look, feel, and communication of printed materials." (Photo courtesy of D&AD.)

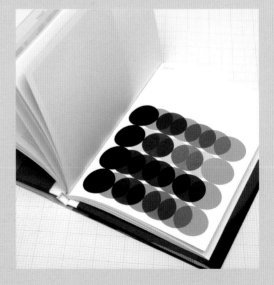

**White Book**
Designed by SEA. Created
to launch the new identity of
paper company GF Smith.
A selection of different-
colored inks swirling in water
were printed on different
papers from the GF Smith
collection to show the varied
results that can be achieved.
(Photo courtesy of D&AD.)

Accent Smooth
Monadnock
PhoeniXmotion
Beckett Expression
Verus
Strathmore Elements
Zen
Parch Marque
Colorplan

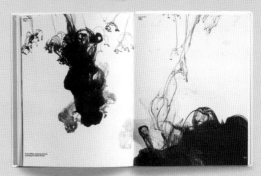

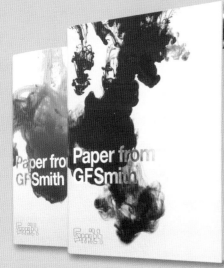

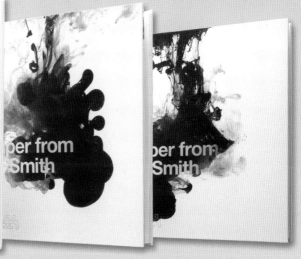

# Design considerations

There are a number of practical design considerations to take into account when designing a publication, such as layout, format, color, and image, as well as the use of hierarchies and grids—all of which will be covered in more detail in the Anatomy section. But what about the content itself?

## Content

A publication's content can take a variety of forms. Text, image, graphics, even color and shape can be considered content in their own right. While a novel or journal may be primarily text-based, a catalog will rely heavily on its visual content. And, of course, there are a multitude of publication types—including many other types of books, magazines, and newspapers—that fall somewhere in between.

Photography, illustration, graphics, charts, and diagrams can all be used as visual content, but what is appropriate for one type of publication may not be so for another, as different types of images are used to convey different meanings. While literal or representative imagery is often used for more objective communication, at the other end of the visual spectrum abstract imagery tends to be used more subjectively. All imagery falls somewhere between these two extremes, and it is up to the individual designer to decide what is most appropriate for the job at hand. For example, product catalogs—particularly those featuring fashion or homewares—are important marketing tools. It is not enough simply to show the products; the imagery must convey a lifestyle, real or aspirational, as well as the company's brand values.

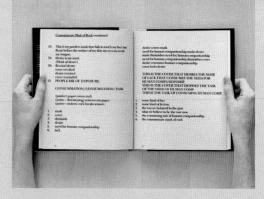

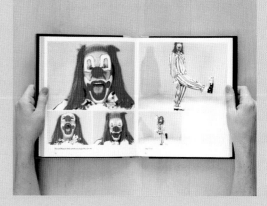

**Bruce Nauman–Raw Materials**

Designed by Cartlidge Levene. Commissioned by Tate Modern to design a catalog documenting artist Bruce Nauman's exhibition Raw Materials, Cartlidge Levene worked closely with the artist and the museum to create this beautiful piece. As the installation consisted entirely of audio works, the designers presented the text as "beautiful typographic pieces evoking the rhythms of the delivery, and capturing the nuances and inflections of the spoken words." (Photo courtesy of D&AD.)

Thank You Thank You
You May Not Want To Be Here
Work Work
Pete and Repeat/Dark and Stormy Night
No No No No — New Museum
No No No No — Walter
100 Live and Die
False Silence
OK OK OK
Think Think Think
The True Artist Is An Amazing Luminous Fountain
Get Out of My Mind, Get Out of This Room
Left or Standing/Standing or Left Standing
Consummate Mask of Rock
Anthro/Socio
Good Boy Bad Boy — Tucker/Joan
Shit In Your Hat — Head On A Chair
World Peace — Bernard/mei mei
Raw Material — MMMM

Bruce Nauman — Raw Materials

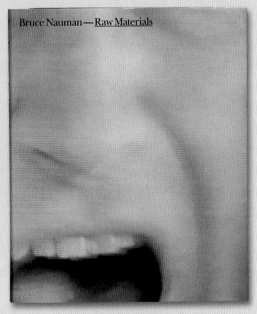

## Text as image

A strong typographic treatment can transform a piece of text into an image in its own right. Images can be expensive; using illustrative typography can provide a very effective, economical alternative.

## Readability versus legibility

The debate between readability and legibility is both longstanding and ongoing—and is especially relevant to the design of publications. *Legibility* refers to the typeform, or individual character, while *readability* is concerned with the speed and ease with which a text can be read. An individual letter may be legible, but when letters are grouped together, the issue of readability comes into play. Hierarchies, navigation, structure, and layout are all vital components in achieving optimum readability. Both legibility and readability can be affected by a number of factors:

typeface, type size, space, color, contrast, and structure; and external factors relating to the medium of presentation, such as format, layout, and size. For some typographers, the fact that a typeface is illegible completely negates its status as a typeface, whereas others are concerned with pushing the boundaries of design and challenging norms.

When it comes to legibility, context is key. Being aware of how a publication will be read, by whom, and under what conditions is crucial to the successful design of any publication. For example, a telephone directory will be read under very different conditions from a novel. It is also imperative that designers know why a typeface was designed and for what purpose it was intended if they are to make an informed choice about its use.

The role of type is central to readability. What is its function? Is it only there to be read? Is there an illustrative element to

**Youth Justice Trust annual report**
Designed by LOVE Manchester. Working to a limited budget, LOVE designed a compact report that conveyed the Trust's message via the changing face of the organization. "Portraying the diversity of the lives it touches, the message grows into a positive and inspirational document celebrating 10 years of the Youth Justice Trust." (Photo courtesy of D&AD.)

be considered? While an annual report is concerned with being authoritative, a high-fashion magazine has more aspirational aims that must be conveyed. A careful assessment of the target audience is essential, and its potential variety should not be underestimated.

Challenging readers to leave their comfort zone when reading a publication is central to the readability/legibility debate, but the appropriateness of stylistic or trend-led design and whether it is acceptable lies in the hands of the reader.

YOUTH
JUSTICE
TRUST

10

'ITS INDEPENDENT VOICE IS A VALUABLE ASSET. IT HAS INFLUENCE WITH DECISION-MAKERS AND IS ABLE TO FOLLOW THE THREAD THROUGH VERY COMPLEX SITUATIONS.'

133

135

137

# The publication life span

A publication's life span can markedly affect the way in which it is designed. A magazine with a shelf-life of a month might be able to follow the very latest design trends, but a book with a life span of years or decades must be able to stand the test of time. Book design in particular demands a high standard of craftsmanship in the designer. To a certain extent, this is true when designing any publication, but while an annual report needs to last only a year and a newspaper just a day or a week, a book is all about permanence and, as such, there is no room for error in its design.

Magazines, on the other hand, exist at the forefront of popular culture. They are not just an integral part of our visual culture; they are a reflection of our times. This has led to the magazine design industry reaching a level of transience akin to the fashion industry—there are more and more magazines with less and less stylistic durability. These days, it is often just a year or two before a magazine's design begins to look jaded and out-of-date, and the transitory nature of magazines and their role within our culture means pushing the boundaries of design is par for the course. That said, in the world of magazine design especially, a well-designed masthead has the power to extend a publication's shelf-life indefinitely.

In the fast-paced world of newspaper design, the publication's content can be redundant within a matter of hours, as most dailies print two editions a day. But despite the fact that its content is ever-changing, the look and feel of the newspaper—or its visual harmony—remains constant.

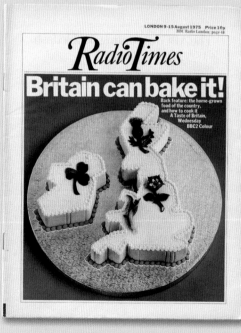

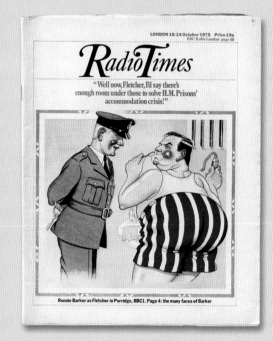

**Time Out**
Designed by Pearce
Marchbank for *Time Out*
magazine. The cover of this
1975 issue of the London
listings magazine *Time Out*
would not look out of place
on the newsstands today.
(Photo courtesy of D&AD.)

Time O

London's
Living Guide
Nov 29-Dec 5 19.. o. 248 20p

'Few men have
exploited their
fellows with
such brutal
insensitivity
as Winston
Churchill'

On his 100th
anniversary we
provide an antedote
to the current stream
of Churchilliana.

Also in this issue:
The changing face of the
Thames. A trip down
London's river side
to look at the
city's biggest
property
bonanza.

**Left: Radio Times**
Art edited by David
Driver and Robert Priest
for the *Radio Times*.
The covers of the *Radio
Times* (a UK TV and
radio listings magazine)
in the 1970s explored
a range of styles, but the
magazine's masthead
has withstood the test
of time. (Photo courtesy
of D&AD.)

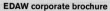

**EDAW corporate brochure**
Designed by Templin Brink
Design. Creating a brochure
with a five-year life span for
EDAW, one of the world's
preeminent landscape
architecture firms, was
no simple task. EDAW's
practices often have some
overlap between landscape
architecture; urban planning
and design; environmental
impact studies; economics;
social, and cultural services,
to shape environments around
the globe. The brochure was
designed to highlight a cross-
section of projects across all
disciplines, bringing to life
stories of breadth and scale
that won't easily be outdated.
The firm's work is showcased
through the use of tritone
photography, giving it an
understated and timeless
feel, in an intimate format.

**Collected Work:
Graduation 2004, Faculty
of Visual Arts
and Design, HKU**
Designed by De Designpolitie.
A showcase of work by
2004's graduate students
from the Utrecht School of
the Arts' (HKU) Faculty of
Visual Arts and Design. "The
design makes good use of all
the classical elements of rich
and refined bookmaking, from
its hard linen cover and gold
print to the colored marker
ribbons used for each section."
(Photo courtesy of D&AD.)

**D&AD Annual
covers 1–43**
Each year a different
designer is invited to
design the cover of
the *D&AD Annual*–a
prestigious honor that
only a few are granted.
This spread shows all
43 covers to date and
demonstrates the diversity
of design talent on offer.
(Photo courtesy of D&AD.)

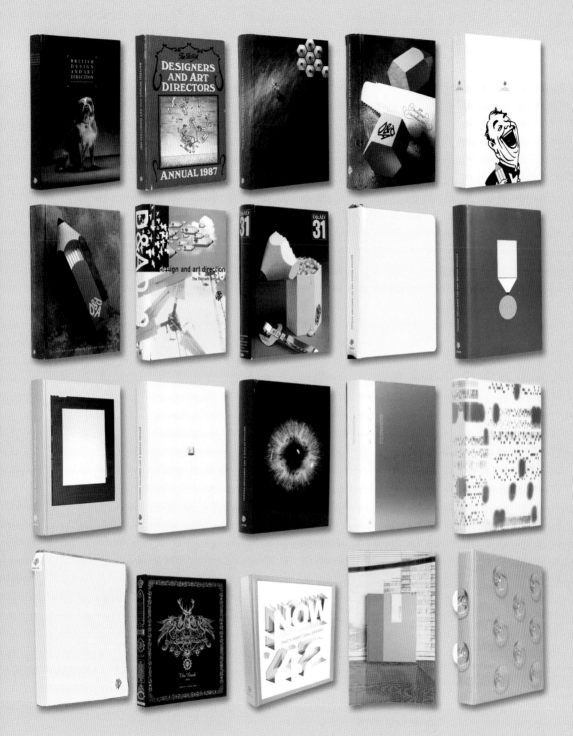

# The digital revolution

The biggest change in publication design over the last 20 years has been technology; this has helped rather than hindered the design and production of publications. The advent of the home computer, and of the Internet, have enabled more people than ever before to create their own publications—everything from community newsletters to novels—without leaving the house. Many designers too are now self-publishing monographs as a means of raising their profiles. Now that the design process has been computerized, it is hard to think of it any other way, but it was not long ago that creating a publication was a time-consuming task that involved laying everything out manually and stripping the content in by hand.

For years, people have prophesied the death of the printed word. Many believed that by the twenty-first century advances in technology and new forms of communication would result in a paperless society, thus rendering the publication, as we know it, obsolete. As far back as 1969, James L. C. Ford in his book *Magazines for Millions* was predicting that it would not be long before we were all waking up, flicking the switch on our "Instant-Fac" and out would print our very own preordered, personalized copy of *Morning Magazine*. Of course, this is not the case, but technology has not failed us—it has simply forged ahead in other directions. Moreover, it has provided us with a diverse range of tools with which to produce evermore flexible and cost-effective creative solutions.

One reason why people have been so quick to predict the death of the print industry is the evolution of the World Wide Web. However, although the Internet may give a company the power to reach a global audience of consumers—something that is both difficult and expensive to achieve with a printed publication—it is not as simple as just transferring pages onto a screen, as many have tried (and failed) to do. The Web is a somewhat unknown, not to mention complex, medium and comes with its own set of constraints. In contrast, the print industry is a known quantity—and it works. Art directors are familiar with it. It does not need instructions or batteries or broadband. Moreover, whether you are designing a book, magazine, brochure, or annual report, working in print enables designers, through the use of different paper stocks, typography, and styles of imagery, to translate a company's brand values in a way that is tactile, expressive, and familiar.

Improved technologies—not least the advent of the Apple Macintosh—mean that graphic designers now have complete control over the content they present. They have the ability to integrate text and image, to create everything from pull-quotes to pie charts, not to mention the myriad of other graphic devices available to them, at the click of a mouse. Today, designers are able to use technology to experiment with mixes of color, image, and text like never before in a bid to engage the reader and make the information they are presenting as accessible and useful as possible.

The Internet means we have a wealth of information at our fingertips, while the ability to transfer files digitally has made the world a much smaller place. A designer can receive digitally the content for a publication from the other side of the world, work on the design, and upload the finished layouts back to the clients without ever meeting them face-to-face.

The arrival of digital photography has made it easier than ever before to capture and store images, saving both time and money. The days of shelling out for expensive film, carefully storing it, and then paying to have it developed are well and truly over. Digital photography means simply buying a fixed amount of memory that can be used and reused over and over again. Photographs are taken, downloaded to computer, where they are instantly retouched, and then stored as digital files that are either emailed, uploaded onto virtual galleries, or printed. Many professional photographers now work with a "live" monitor alongside them, enabling them to see exactly what they are shooting as they go along.

In terms of publication design, Quark XPress has long held firm as the industry-standard page-layout program, but in today's market new programs such as Adobe's InDesign, which offer an integrated approach, are quickly taking over. The fact that InDesign shares an interface with Photoshop and Illustrator means designers can now interchange objects and images between these programs at the click of a mouse.

Our twenty-first-century digital world is a wonderful thing, but technology is not infallible. Things can go wrong, so it is imperative for designers to back up work regularly, as an irrepairable hard drive can wipe out a lifetime's work in a (very expensive) split second.

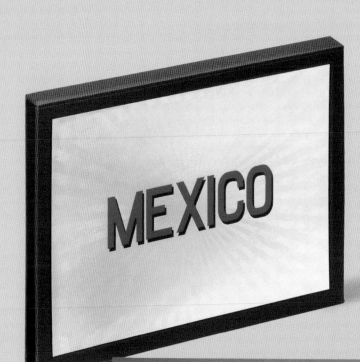

**Mexico**
Designed by Nick Bell and
Matt Willey for Aperture.
Martin Parr's stunning
work is brought vividly to
life in print.

## 1. Metrosexual Cowboys and English-speaking Indians

*The truth is out there – The X-Files*

[body text, two columns]

## 2. The Colours of Globalisation

*Prejudices, superstition, dogmatism, and fanaticism are social phenomena. Some cultures promote and protect them.*
José Antonio Marina, *La inteligencia fracasada* (Failed Intelligence)

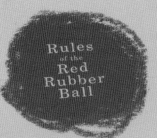

**Rules of the Red Rubber Ball**
Designed by Anne Willoughby at Willoughby Design Group, for dreamBIG! Publishing. This book is an inspiring showcase of different materials and image treatments. Although the book was designed using the most advanced digital technology, the designers intentionally used traditional processes, and added elements like an inlaid piece of rubber ball in the cover, to evoke the reader's memories of childhood.

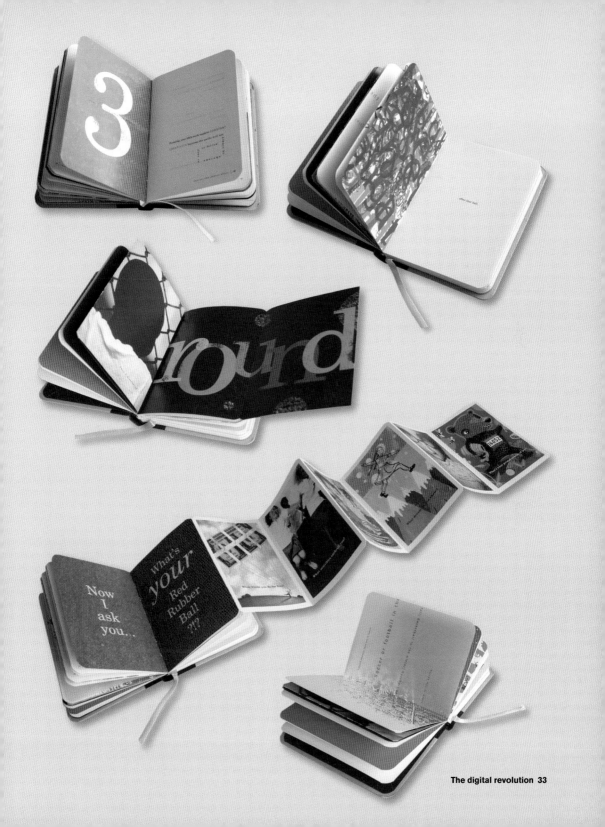

# Buying and selling

The way in which a publication is sold plays a part in its design. It is not just a coincidence that a magazine's masthead nearly always runs horizontally along the top of its cover, or that the publisher's logo appears on the spine of every book. In both instances this has more to do with how the publication will be presented to potential customers than any particular design attributes.

## Magazines

Magazines are positioned in the same way in every store to enable the retailer to pack in as many titles as possible. Magazine racks are specifically designed for this purpose. More often than not, this means that only a magazine's masthead—i.e. its title—is visible to the customer. From a design perspective, this means magazines must initially rely almost solely on their masthead to engage potential readers. Of course, once an initial interest has been registered, the customer is likely to pick up the magazine and view the cover in its entirety. They may flick through the pages to gauge its content. But none of this interaction will occur unless the masthead has done its job first.

Magazines also tend to be produced in a standard size—either 8¼ x 11¾in (A4) or slightly larger. Again, the practicalities of how the title will be stocked come into play. A publication that is of a standard size or smaller will fit comfortably onto a store's shelves, whereas a larger format will not. It is not uncommon for retailers to stock larger formats sideways in order to fit them on the shelf. This means that not only is any type then running vertically, but the masthead is often hidden among the myriad of other titles competing for space.

## Books

Whereas a magazine is reliant on its masthead to attract attention, the limited space available in most bookstores means that only the spine of the book is visible to the customer. As with a magazine's masthead, this means designers have only a limited amount of space within which to make their mark and attract attention.

Most spines will feature the publisher's logo, as well as the book's title, both of which need to be clear and easy to read. A strong logo not only informs customers who the publisher is; in a store with multiple titles by a single publisher it can also work to raise brand-awareness on the shelf. In addition, a book series with a strong spine that uses bold typography and bright colors will create an impressive "patch" on a bookstore shelf.

***Frame* magazine**
Designed by COMA. This
bimonthly, specialist design
periodical uses experimental
layouts, fonts, and colors to
give each issue a new and
different graphic face. (Photo
courtesy of D&AD.)

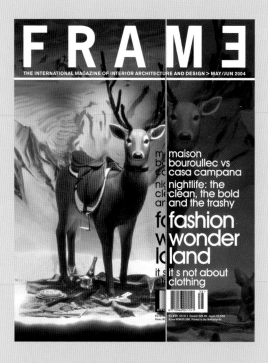

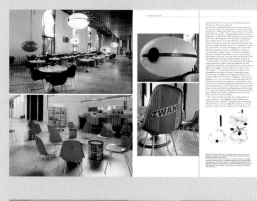

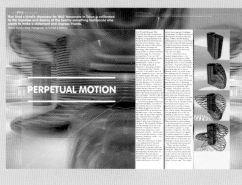

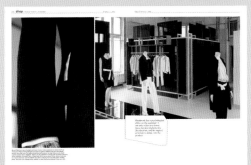

SENECA
ON THE
SHORTNESS
OF LIFE
LIFE IS LONG
IF YOU
KNOW HOW
TO USE IT
PENGUIN
BOOKS
GREAT IDEAS

MARCUS AU
RELIUS · MED
ITATIONS · A
LITTLE FLES
H, A LITTLE
BREATH, AN
D A REASON
TO RULE AL
L—THAT IS M
YSELF · PENG
UIN BOOKS
GREAT IDEAS

ST AUGUSTINE
CONFESSIONS
OF A SINNER
AS A YOUTH
I HAD PRAYED TO YOU
FOR CHASTITY AND SAID GIVE ME
CHASTITY
CONTINENCE
BUT
NOT
YET
PENGUIN BOOKS · GREAT IDEAS

Thomas à Kempis
The Inner Life
A true understanding
and humble estimate of
oneself is the highest
and most valuable of all
lessons. To take no ac-
count of oneself, but al-
ways to think well and
highly of others is the
highest wisdom and
perfection. Should you
see another person open-
ly doing evil, or carry-
ing out a wicked pur-
pose, do not on that ac-
count consider yourself
better than him, for you
cannot tell how long you
will remain in a state of
grace. We are all frail;
consider none more frail
than yourself.
Penguin Books
Great Ideas

JONATHAN SWIFT
A TALE OF A
TUB
'It is a fatal MISCARRIAGE,
SO ILL TO ORDER AFFAIRS,
as to pass for a
FOOL
IN ONE COMPANY,
when in another you might be treated as a
PHILOSOPHER'
Penguin Books .......................... Great Ideas

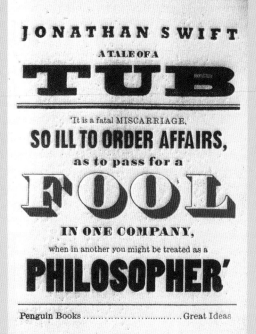

NICCOLÒ
MACHIAVELLI
THE PRINCE

One must be a fox in order to
recognize traps, and a lion
to frighten off wolves

Penguin Books
Great Ideas

## Great Ideas

Designed and published by Penguin. *Great Ideas* is a series of twenty social, political, and philosophical texts. The designs of these award-winning covers use the different typographic styles prevailing at the time of each title's original publication. "Type-led covers were chosen to challenge the reader to project meaning onto them and match the essence of the subject more closely." (Photo courtesy of D&AD.)

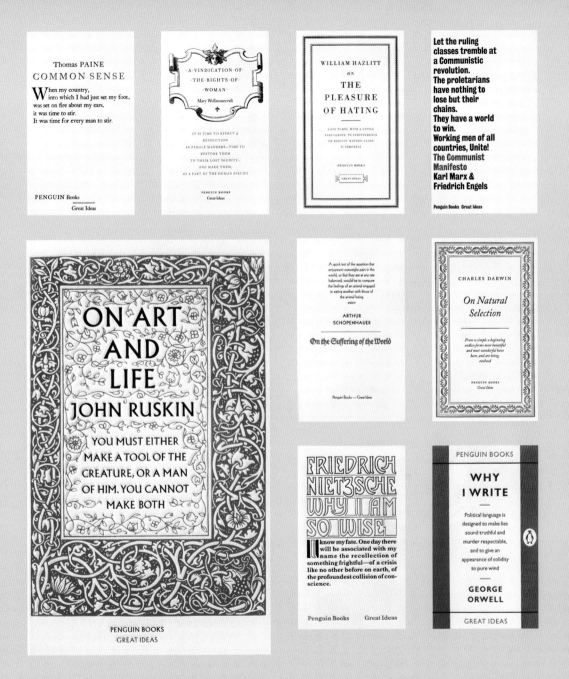

# A word about the environment

Conventional printing is a dirty process, but the latest high-quality recycled papers and environmentally friendly printing techniques mean the time for excuses is over—and the onus is firmly on designers to educate both themselves and their clients and to make a change.

Print is the UK's fifth- and the US's third-largest manufacturing industry, and it is placed in the same environmental risk category as the mining, oil, and nuclear power industries. The environmentally damaging use of solvents and chemicals, high consumption of energy and natural resources, and waste creation are some of the key concerns. Paper is another major factor in sustainable procurement: the use of chlorine-bleached papers is still common, and the continuing prevalence of nonrecycled or nonsustainably forested pulp is staggering.

Beacon Press, the first British print company to establish a green policy, uses only vegetable-based inks (the usual petrochemical-based inks are both nonsustainable and highly polluting), alcohol-free printing processes, and 100 percent green electricity. The company recycles 95 percent of its hazardous, press-cleaning solvent, and has won many environmental accreditations and awards. The company has even initiated a CD recycling scheme to find a use for the numerous artwork disks they are left with. Of course, all the above would mean nothing if the quality of the press's work did not match its high environmental standards. In an industry so reliant on print, it is amazing how few design companies pay attention to the environmental impact of their work.

It is up to designers and print buyers to take greater responsibility, but few do so, because of outdated fears over the quality available with environmental papers and inks. Popular misconceptions include the belief that environmental products are more expensive and that environmental printing is of lower quality, both of which were falsely implied by much of the early printing that sought to convey the environmental message by using rougher-surfaced recycled papers. Paper quality previously deterred many designers from using sustainable products, but the days of recycled stock that resembled thick, gray toilet paper are long gone. Color saturation has also improved beyond measure, and today there is little visible difference between eco and noneco papers.

Mohawk Fine Papers is one of the world's leading environmental paper merchants. It recycles nearly all of its manufacturing waste, actively conserves energy and water, and is now the second-largest industrial consumer of windpower in the US. Mohawk's Options range, for example, is made wholly with windpower, and contains 100 percent postconsumer waste material. The company's technical innovations, such as the patented Inxwell process, which gives fibers a good ink lift, place it firmly at the premium end of the paper market.

By specifying certified papers containing a high level of postconsumer waste, made with renewable energy, designers, printers, and their clients have the power to generate a new market that the rest of the world will have to follow—and then we can really start to make a difference.

**Text contributed by Liz Hancock.**

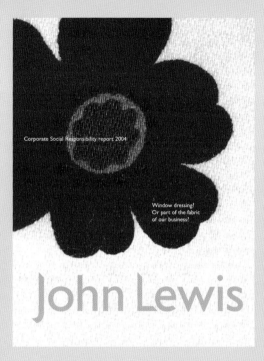

Corporate Social Responsibility report 2004

Window dressing?
Or part of the fabric
of our business?

John Lewis

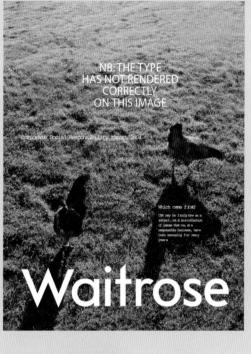

NB: THE TYPE
HAS NOT RENDERED
CORRECTLY
ON THIS IMAGE

Corporate Social Responsibility report 2004

Which come first?
CSR may be fairly new as a
subject, but it is a collection of
issues that we, as a
responsible business, have
been managing for many
years.

Waitrose

Armchairs to zebras

A passion for food

**John Lewis Corporate Social Responsibility Report**
Designed by Flag Designers. Flag is a design company with a conscience. It is committed to being responsible for the social and environmental impacts of its operations. "The people who come to us now tend to be fairly up-to-speed with the whole sustainable printing field,"

says Piers Evelegh, Creative Director at Flag Designers. The company specializes in producing Corporate Social Responsibility Reports for the likes of Ford, Kraft, John Lewis, and Lloyds TSB. "More clients are becoming aware of the environmental impacts of printing and paper use, and by and large they are very interested in guidance."

**Waitrose Corporate Social Responsibility Report**
Designed by Flag Designers. Written with employees and customers in mind, this 28-page printed report was produced in an editorial style, covering the most material issues, and designed to stand alone, yet complement the John Lewis Corporate Social Responsibility Report.

# Copyright

Once you have created a piece of work, it is important to consider your intellectual property rights. Copyright protects your creative property and falls into several basic categories: reproduction rights, derivative rights, the right to create adaptations of an original work, distribution rights, the right to sell a work, display rights, and performance rights. For designers and illustrators, reproduction and derivative rights are the most important.

## What is copyright?
Copyright is a law that gives the creators of copyrighted material rights to control the ways their material can be used, and prevents others from copying the material.

## What does "©" mean?
The use of the copyright symbol does not create copyright protection, but it is important to ensure that a copyright notice appears on every piece of creative work you produce, for the following reasons:

- It shows who the author is, when the work was created, and that the author is asserting their copyright.
- It informs others that they are not entitled to copy the work without the author's permission.
- It is a statement that all legal formalities have been complied with to allow copyright to exist in the work.

## How do I create a copyright notice?
A copyright notice should look like this:
© [name of copyright owner] [date on which the work was created].

## How do you get copyright?
When you create an original piece of work, you automatically own the copyright to it for your lifetime, plus 70 years. The work does not have to be published or registered for you to own the copyright. However, copyright does not protect ideas, names, or titles, rather the *expression* of these ideas.

## How long does it last?
Copyright protection lasts for up to 70 years from the date of the death of the author.

## What happens if someone tries to use my work without permission?
As the owner, you can write "cease and desist" letters telling someone to stop using your copyrighted work, even if the work has not been registered. You can file for a copyright at any time, but you cannot legally file an infringement of copyright action unless you have registered the work in question. Because you cannot use the courts to protect your work unless it is registered, it is a very good idea to register all the work you make public. It is not necessary to register every piece you create, but you should file copyright registration on any piece that will be seen by a large number of people, or any piece that will be used frequently.

## Can the author and the owner of copyright be different?
It can occur that the author of the work may not ultimately be the owner of the copyright. For example, employers will automatically own the copyright of all work that employees create during the course of

their employment. While the law ensures that this occurs automatically, it is normally good practice for employers, in their contracts of employment, to have provisions setting out this legal rule. It is also possible for an author to transfer his or her copyright by agreement for a set fee or in return for a royalty payment.

## What happens if I put my work on the Internet?

The laws of copyright apply equally to works on the Internet as to work in the offline environment. As a result, it is an infringement of copyright to place publications or graphics on the Internet without the owner's consent.

## Will my work be protected internationally?

Copyright is protected abroad under the international system called the Berne Convention. Each country that subscribes to the Berne Convention (currently just under 150 countries of the world) agrees to treat works coming from other member countries of the Berne Convention system as if they were originating in their home country. Therefore, an American book being sold in Germany would be protected in Germany, just as if the work had originated there.

## Creative Commons

www.creativecommons.org, an organization founded in 2001, aims to create a layer of "reasonable copyright" within licences under the principle that "some rights are reserved." It aims to encourage the sharing of different types of material, including music, video, photography, scholarship, literature, coursework, and even speech, but within reasonable licensing restrictions that do not neglect the creator of the work. The organization says, "We work to offer creators a best-of-both-worlds way to protect their works while encouraging certain uses of them; to declare 'some rights reserved.'"

The aim is to facilitate, for example, sourcing photographs that are free to use provided that the original photographer is credited. Creative Commons hopes "that the ease of use fostered by machine-readable licenses will further reduce barriers to creativity."

Among the eleven different types of licence that can be associated with content for online or other forms of digital distribution are:

• Attribution, by which the creator's content is available for use as long as the creator is credited;
• Non-Commercial, by which content is freely available as long as any work based on it is not produced for commercial gain;
• No Derivative Works, by which a creator's work is freely available in its existing form only, and is not permitted to be used in derivative works; and
• Share Alike, by which derivative works based on licensed content have to be distributed under an identical licence.

# Anatomy

The publication designer, unlike the designer of single-format items such as posters or ads, has a number of different areas to consider. The work is not simply about laying the information down over a number of pages. The designer must also look at the style of content, how best to organize it, how to structure each page to make it easy to read and understand, and the weighting of images versus text. Then he or she must consider the audience: who will be reading the publication? Will they have any special needs that must be considered and catered for in the design? How will the publication be read? Does it need to be portable, or will a heavyweight, coffee-table style be more suited to the content? Perhaps the content includes high-quality photography that necessitates a large format or, conversely, if the image quality is of a lower standard, then reproducing the images at a smaller size may be the only option. These are all factors that will determine the success or failure of the design and, therefore, must be fully considered by the designer before they decide how to proceed creatively.

In this section of the book, we will look not only at different types of publications, but also at the different components that make up those publications. Occasionally, a publication type will have a design approach unique to that type—newspaper design is a good example of this—but for the most part, there are a number of common elements that make up these different publications. We will explore these elements further in the first part of this section, from cover design to the use of grids, from hierarchy and typography to the use of images. We also examine the different systems that graphic designers use to ensure that each project runs smoothly. All of these elements are integral to the design of a successful publication, whatever its type, and enable designers to differentiate their work from the work of others.

The second half of this section is dedicated to specific publication types. We will look at seven of the most common types of publication—books, magazines, newspapers, brochures and catalogs, journals, annual reports, and programs—and highlight the specific design needs of each. Of course, each of these publications is made up of the elements covered in the first part of this section but, by their very nature, different *types* of content will give rise to a range of different design solutions.

While a designer may choose to specialize in one particular type of publication design— for example, magazines, books, or corporate literature—most will design for a number of publication types. Not only does this provide them with a varied portfolio when it comes to attracting new work, but it also makes for a much more interesting working life.

# Cover story

The old adage "never judge a book by its cover" may ring true in certain circumstances but, when it comes to publication design, make no mistake: first impressions last. The cover is the first thing your audience will see and, in many cases, will determine whether a reader bothers to open a publication and venture further.

Whatever type of publication you are designing, materials play a crucial role. Many magazines, for example, produce limited-edition cover designs in a bid to attract new readers and boost sales. Using a different or unusual cover material can dramatically alter the look and feel of a publication; this can make it feel more disposable, or give it an added authority.

Think of the thousands of books and magazines available today. When you walk into a newsagents or a bookstore, you scan the shelves in a matter of seconds, and if nothing immediately captures your attention, you move on. For the designer, those seconds are crucial; they provide the one opportunity to sell the work to a potential reader. That's quite a challenge. And with so many books and magazines competing for space on the shelves, there's no room for complacency in the design.

But cover designs are not just about looking good: a well-designed cover must also communicate, clearly and succinctly, what the publication is about. In magazine design, the masthead is a vital tool, not only in reinforcing a magazine's identity, but also in creating a sense of familiarity with its readers—it takes just a second to spot the familiar typeface, color, and style of a successful masthead. In the case of corporate literature and catalogs, and in many cases books and magazines, the cover must also capture the essence of the brand that is being sold.

One of the most important things to consider is how the publication will be distributed. If it is to be sold to consumers, the masthead is vital to the design, whereas if a magazine is to be distributed as part of another publication—for example, a magazine that comes free with a Sunday newspaper—the masthead can play a much less prominent role, and the designer may choose to focus the cover design on the magazine's content instead. If a publication is to be displayed on a magazine rack with only the masthead visible, then this is the designer's key selling tool. If the whole cover is displayed, the designer has much more space to play with and thus more scope for creativity. Equally, if an annual report is being mailed out to a company's shareholders, the cover is not required to sell the content so much as capture the company's brand values.

All these points are vital considerations for the cover design of a publication and can have a dramatic effect on the end result. Good cover design is not about fancy fonts and complex layouts; it is about sending the right message to the right audience in the right way, as clearly as possible.

**Amelia's magazine**
Designed by Amelia Gregory. With its vibrant scratch 'n' sniff cover, Issue 4 came with a set of scented felt-tip pens to complete the "coloring pages," designed by some of the best new illustrators.

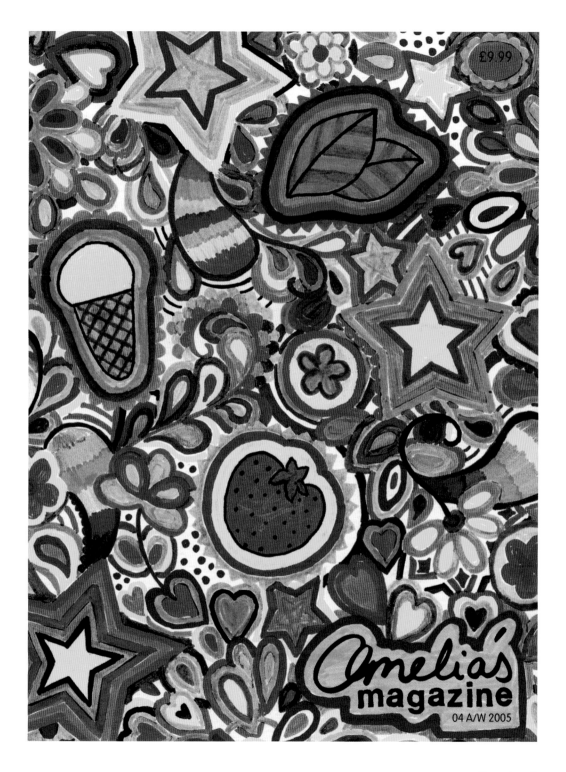

£9.99

*amelias*
**magazine**
04 A/W 2005

## Communicate

Designed by Nick Bell for Laurence King Publishing. This cover was created for a book accompanying the exhibition *Communicate: Independent British Graphic Design since the Sixties.* The title is set large so it stands out when next to all the other books competing for attention in bookstores. It is positioned so that the word "communicate" reads on a single line when the front and back of two copies are placed next to each other on the shelf. The background image is a collage of graphic design works featured in the book: an effective solution to finding one piece of design to represent 40 years of diverse British independent practice.

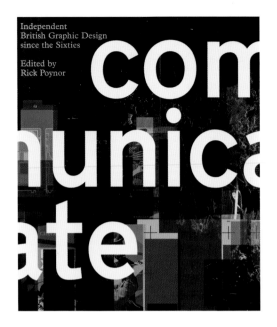

Independent
British Graphic Design
since the Sixties

Edited by
Rick Poynor

com
munica
ate

## Tattoo Icons

Designed by Victionary. *Tattoo Icons* presents a collection of tattoo imagery, as interpreted by graphic designers, illustrators, photographers, and other creatives. Its eye-catching red plastic slipcase also draws attention, and stays in the mind, through its tactile, ridged texture.

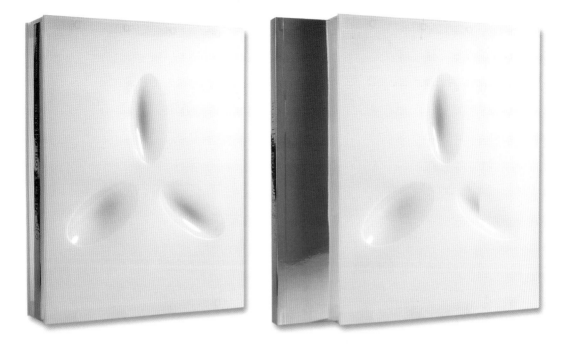

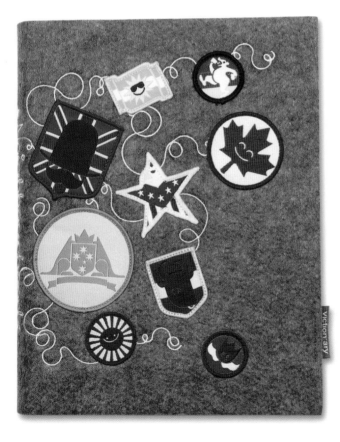

**Above: *Wave UFO***
Designed by Matthias
Ernstberger and art directed
by Stefan Sagmeister for
Kunsthaus Bregenz.
Mariko Mori's book *Wave
UFO* consists of a 200-plus-
page publication hovering in
a semitransparent slipcase.
The entire book talks about
one single piece of art, but
a rather complex one: three
people can enter the Wave
UFO where they have
electrode headsets attached
to their foreheads in order to
experience a 3-D animation
changing in sync with their
individual brain waves.

**Left: *Neighbourhood***
Designed by Victionary
and curated by Rinzen.
Contributors to *Neighbourhood*
reworked 20 handmade toys
using a range of techniques,
including stitching, painting,
and drawing. The special felt
cover, embellished with
embroidered badges and
stitching, displays its contents
both visually and physically.

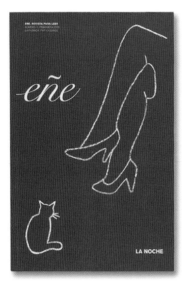

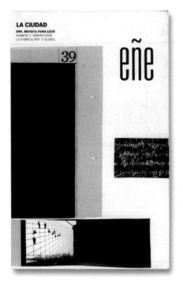

**eñe literary magazine**
Designed by Pablo Rubio at Erretres Design, together with Mikel Garay, and published by La Fábrica Editorial. La Fábrica commissioned Erretres to design *eñe*, a new literary magazine. Each issue has a different theme. Issue 1 explores the night; Issue 2 explores the city.

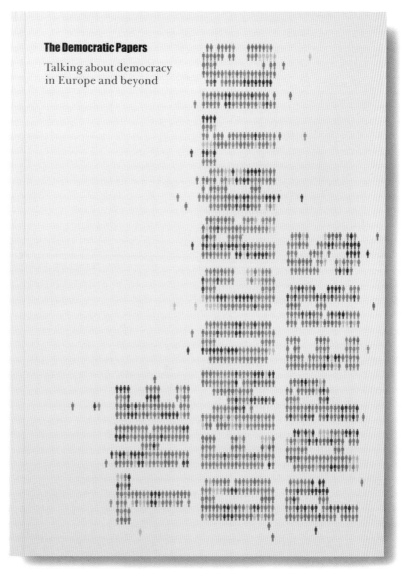

**The Democratic Papers**
Designed by Atelier Works
for the British Council.
*The Democratic Papers* is a
book of essays on democracy
by young thinkers from all
over Europe. The distinctive
title on the book's cover is
made up of images of people
of every political persuasion.

# The right format

*Format* refers to the physical manifestation of a publication. In short, it is the way in which the information is presented to the reader. Books, magazines, brochures, catalogs, and reports are some of the most common formats used in publication design. Within these generic formats, designers can alter specific elements such as size, shape, or weight to give their work an added dimension and customize the design.

Whatever the type of publication, budget will always play an important part and will directly affect the designer's decision-making process. Everything from the size and shape of the publication, to the quality of paper stock, to the print-finishing process is affected by the money available. A hard cover, good-quality paper, and secure binding technique will extend the life of a publication exponentially, but is not always possible if there are budget constraints to consider. That said, many designers find working within such constraints and coming up with ever more innovative design solutions a very satisfying creative process.

## Books

There are many different types of books, with many different functions that need to be addressed by the designer in order to determine the most suitable format. Some books need to fit comfortably in the hand and be easy to carry around; others require larger formats. It is also important to consider the book's life span. A paperback printed on low-quality pulp stock has a much shorter life span than a hardback, leather-bound, gilt-edged bible, and this will be reflected in the design decisions made.

## Magazines

By their nature, magazines are more disposable than books, although many of the decisions regarding format are similar. Most magazines these days are a standard format, and the reason that standard A4-size magazines (8¼ x 11¾in) dominate most newsagents is an economic one. That said, the quality of magazines varies hugely depending on their function. High-end fashion magazines that contain a lot of expensive photography are generally produced in a larger format on very high-quality stock, whereas a weekly gossip magazine with a shelf life of just seven days will be printed on low-quality stock. Once a designer has decided on a format for a magazine, they tend to stick with it. This not only makes the design process easier—redesigning an entire magazine every issue is both unnecessary and impractical—it also gives the reader a sense of familiarity when they walk into a store and spot their favorite magazine.

## Brochures and catalogs

Brochures and catalogs are all about providing information and advertising a service or goods, from holidays to homewares to the latest fashions. While they may look similar to many magazines—and even some books—they serve a very different function. Many brochure and catalog designs, however, provide designers with the opportunity to let their imaginations run wild and come up with something unique. These are often one-off projects, so it is possible to push the boundaries with the design.

## Annual reports

Many annual reports and associated corporate literature are one-off pieces, so designers are free to choose whichever format suits the job best. In the past, annual reports had a reputation for being dull, but today's designers are creating some fantastic designs that go a long way to dispelling that notion. Within such reports, there is also the opportunity to use additional formatting tools to organize the information. For example, financial information may be printed on a different paper stock from the rest of the report, or any imagery printed on very high-end coated stock. These design touches not only serve to organize the information more clearly, they also provide the report with pace and texture.

**Formati sperimentali**
Designed by Struktur for RotoVision. This book was formed from two 80-page, case-bound books bound and hinged on the back covers. This binding method allows both books to be viewed either independently or together. A series of arrows is used to aid navigation through the two books.

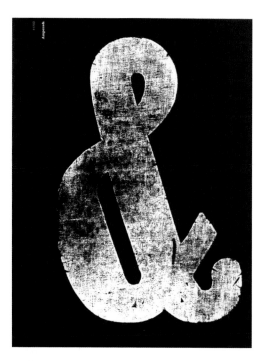

**_Ampersand_ magazine**
Designed by Frost Design
for D&AD. _Ampersand_ is
D&AD's quarterly members'
magazine. In trying to move
the design forward, four
completely different, and
experimental formats were
created over four issues,
two of which are shown here.
Members were then invited
to vote for their favorite issue.

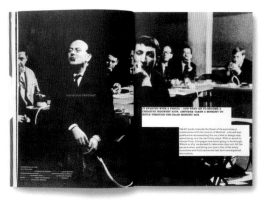

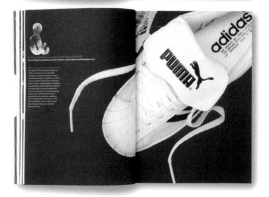

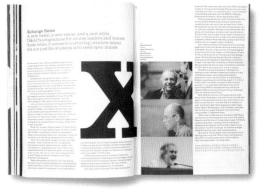

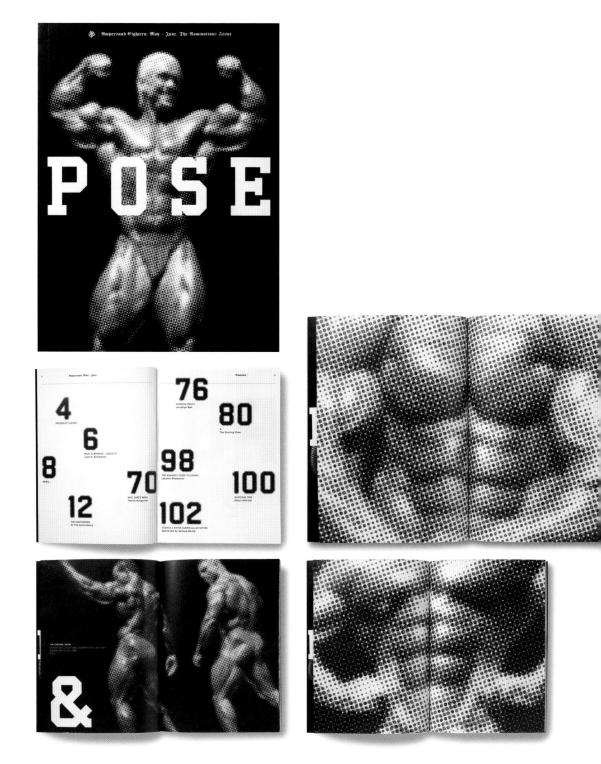

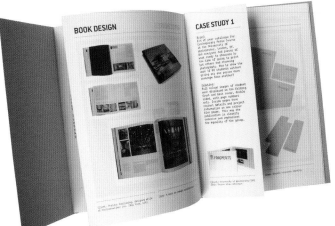

**BOOK DESIGN**

**CASE STUDY 1**

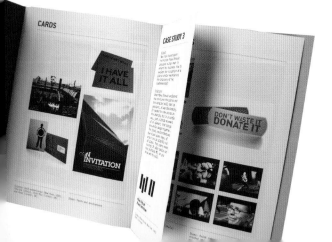

**CARDS**

**CASE STUDY 3**

**Above and left: Self-promotional brochure**
Designed by Emmi Salonen for EMMI. Wherever possible, EMMI uses recycled material, making designing, printing, and paper choices with the environment in mind. The format for this brochure also had to allow for one section to be updated, and a second section to be reordered easily. Keeping the brochure essentially looseleaf—it is "bound" with rubber bands containing 90% pure rubber from sustainable resources—is a simple, pleasing, and effective solution.

**Right: *Cut***
Designed by Atelier Works for GF Smith. The success of this publication centers on its innovative format: a multiple flick-book, which is also a visual pun on its subject matter—a filmmaker.

**Staverton promotional brochure**
Designed by SEA for Staverton. This brochure has a yellow PVC, heat-embossed cover. The high-gloss UV pages are thread-sewn, with the middle spread a four-page throwout.

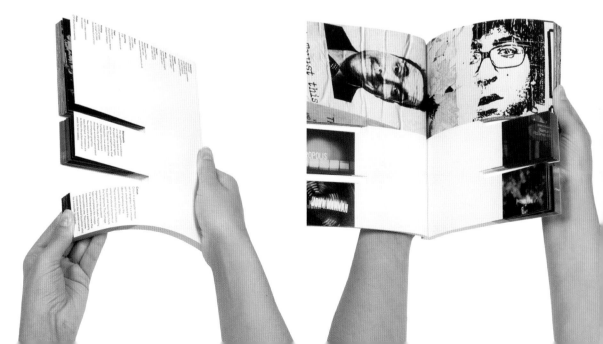

**Kaspar Bonnén:
Photos/Drawings**
Designed by ATWT paris.
This art book is printed on
high-gloss cardboard in the
format of a large children's
book. The weight of the book
(c. 2lb/1kg), together with its
thick pages, make the act of
turning the pages akin to that
of handling a precious object.

**Dockers K-1 sell-in presentation**
Designed by Templin Brink Design. The Dockers K-1 Khakis brand was derived from standard issue army packaging of the 1930s, when khaki pants were first invented for the US Army. For the brand's sell-in presentation book, a format reminiscent of an army briefing of the time conveys the inspiration and authenticity of the brand. Printing techniques stayed true to 1930s' methods, with silk-screening and crude letterpress printing on a raw chipboard cover and uncoated pages.

# Hierarchy and layout

Graphic design is all about the process of visual information management, and layout is just one of a number of tools the designer has at his or her disposal to lead the reader through the content.

The *layout* of a publication refers to the placement of content—text and/or images—and how these elements relate both to each other and to the publication as a whole. The layout can completely alter the way a publication is viewed and read. A well-considered layout can make a publication easy to navigate through and a joy to read, whereas a badly designed layout can leave the reader feeling frustrated and confused.

It is important for the publication designer to organize the space within which they are working—the page. This is largely achieved by devising a grid or grids for the publication that enable you to organize the various elements on the page. The grid will be invisible to the reader, who will only become aware of the structure the designer has created over the course of the publication. We will look more closely at grids and how they are used in the following section.

When it comes to thinking about layout, the designer should only ever have one thing in mind: content. It is the content and the way the publication is to be used that will, for the most part, determine the layout. A novel requires a very different layout from a dictionary. It is also important to think about format and finish at this stage. How will your publication be printed? What binding technique do you plan to use? Does the publication need to open flat? Will it be read up close? Are you designing reference material or is the content fictional? All of these points will lead the designer toward different layout solutions.

## Hierarchy

*Hierarchy* refers to the different typographic styles employed by the designer to guide the reader through the layout. Generally, the larger and more dominant the element, the higher its position in the hierarchy.

One of the designer's primary tasks when designing any publication is to create a strong and consistent visual hierarchy in which the most important elements are

emphasized and the content organized in a logical and user-friendly manner. The text hierarchy enables the designer to organize the text visually on the page and denote different levels of importance through the use of varying point size and/or style.

Readers need to be able to pick out specific information quickly and easily, and an efficient visual hierarchy enables them to do this. The overall organization and graphic balance of the page is what attracts or distracts the reader. An unstructured page of solid, gray text that offers no visual guide as to how the information is to be consumed is extremely difficult to read and dull to look at. Equally, a page dominated by bold typographic elements will distract from the content rather than draw the reader to it. Good design is about striking the correct balance between the two: designing a strong layout and clear hierarchical structure that is both easy to navigate and read—and a pleasure to look at.

**UCCA prospectus**
Designed by Rose Design for the University College for the Creative Arts. Rose Design were brought on board in 2005 to create the inaugural undergraduate prospectus for the UK's University College for the Creative Arts (UCCA) at five separate campuses. The document employs the University College's new identity, combined with details of student work, and is introduced by a section with a distinctly editorial feel, showcasing the success of past alumni. A strong navigation system guides prospective students through the five campuses and their range of courses. The prospectus is the University College's most important promotional tool, and has an essential role in introducing and establishing the new University College within the marketplace, and in the minds of students, parents, and career advisors.

**Pollination**

Designed by Jeff Knowles and Ben Reece in collaboration with TILT for Woods Bagot Architects. The underlying theme of bees was used to hold this project together. The team's decision to include contributors from all areas of design is made stronger by the notion of pollination and the idea that society is driven by the cross-pollination of creative ideas. This metaphor is depicted by organic 3-D forms (created by Supernatural Studios), which provide subtle backgrounds for the spreads. The shapes are based on abstract forms reminiscent of nature and are juxtaposed against the hard edges of architecture. The organic forms provide the base layer for the publication and are enhanced by graphic shapes depicting honey-combs that lie on top of the background. These establish a synchronicity between each of the different disciplines that the contributors specialize in, and ensure that the content of the book is tied together.

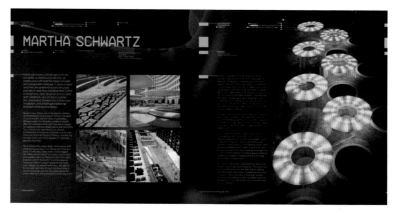

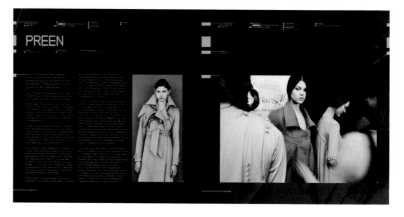

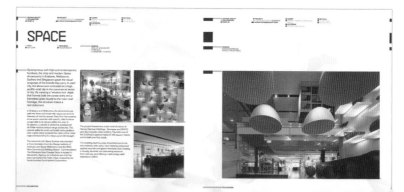

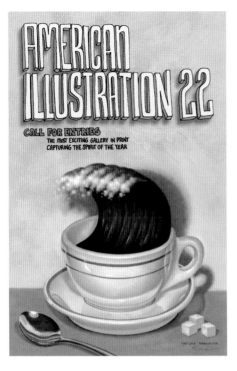

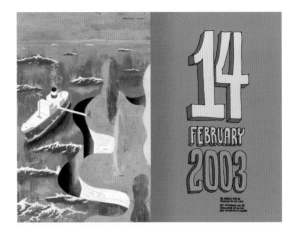

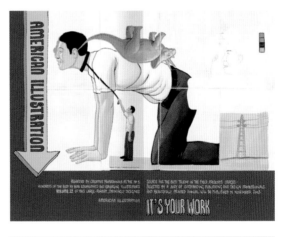

**American Illustration 22**
Designed by Stefan Bucher
at 344 Design, LLC for Amilus
Inc. All of the typography on
this piece was done by hand
to harmonize the great (but
vastly different) images by
past American Illustration
winners. The layouts change
from spread to spread to fit
the illustrations, however, a
clear hierarchy exists between
3-D headline type and simple
lettering for body copy.

# Grid lock

The grid is one of most important tools in publication design. It is worth putting in time and effort to get it right from the outset, as a well-planned grid can eliminate a lot of work later on.

A grid is used to position and contain the different elements within a single design, ensuring a much more accurate and considered result. Different grids can produce vastly different results. In terms of basic structure, a grid, or a selection of grids, can help define the parameters while still providing flexibility within the design. Using a grid is one of the most effective ways of organizing a large amount of information on a page and ensuring visual consistency within a publication. While some designers prefer to adhere to a tight grid, others regard such design rules as there to be broken—this decision, of course, remains at the discretion of the designer.

To a large extent, the format and type of publication will dictate the style of grid used. Using a single-column grid may create a minimal, clean design, but will be unsuitable for a text-heavy publication as the line lengths will be too long and the text difficult to read. Conversely, using multiple columns for a publication with lots of visuals will create a very broken, choppy design that lacks visual coherence. A secondary grid can also be incorporated to allow for special or unusual content items. It is important to remember that such deviations should be visible only to the designer; the reader should not be aware that you have switched grids.

One type of publication that relies on a very strict grid system is the newspaper, which requires the designer to deal regularly with large amounts of content and to work quickly. Using a tight grid system not only speeds up the production process by enabling the designer to flow in content very rapidly, it also provides the reader with a much-needed sense of familiarity.

Using a grid system is an excellent way of organizing the large amounts of information synonymous with publication design. Moreover, having a strong system in place frees up the designer to concentrate on creative design solutions rather than focusing on organizational ones.

However, rules can and often should be broken. Always adhering to a very strict grid can dampen the creative process and produce an uninspiring and unimaginative result—some of the most creative solutions arise when the grid is abandoned altogether.

### Les50ons

Designed by Rose Design for Fifty Lessons. In partnership with the British Broadcasting Corporation (BBC), Fifty Lessons films some of the world's most influential business leaders, capturing their personal and formative experiences. These unique "lessons" provide insight and advice for others and a learning tool for senior management. The content is delivered as short, highly memorable films, each around three to five minutes long. These are conceived in groups of 50, and marketed as separate editions. A DVD of the lessons is housed within a linen-backed, case-bound volume, and inserted into a bespoke slipcase, to reside on the desks and bookcases of corporate executives.

**Mapping**
Designed by Struktur for
RotoVision. In this book, grid
lines and baselines were
printed on divider pages and
across the top of each page,
revealing the normally hidden
structure of the book.

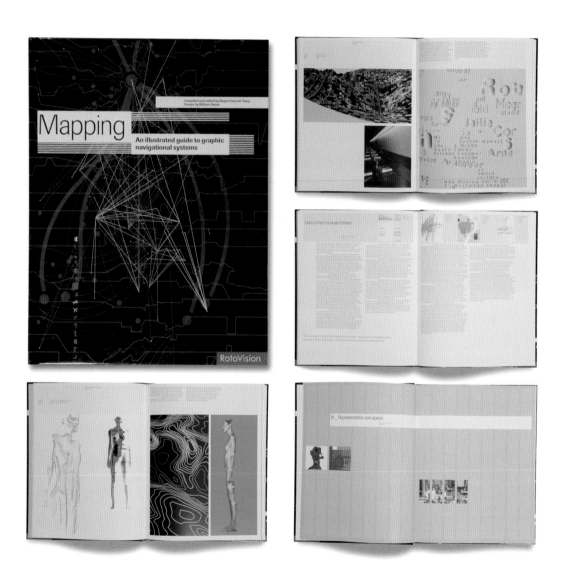

### Open Systems

Designed by Rose Design for Tate Publishing. This catalog was created for *Open Systems: Rethinking Art c.1970*, an exhibition that brought together the work of international artists who radically rethought the object of art in the late 1960s and 1970s. The featured artists sought to connect with the political developments of the decade and make their work more responsive to the world around them, reacting against art's traditional focus on the object by adopting experimental aesthetic "systems" across a variety of media. The catalog explores grid systems that reflect the emerging structures within art at the time, and echoes the diversity of media evident in the show through the use of a range of stocks within the book. The use of Univers typeface throughout is in keeping with the period that

the exhibition represented, while retaining appeal to a modern audience. The 80 pages of introductory text are printed in PMS cool gray 9 on 150gsm Matt Hello. The following 80 pages (work/plate section) is printed in

four-color plus varnish on 150gsm Silk Hello. The final 32 pages form an archive section of essays and research. This was printed in PMS cool gray 5 and 9 on a 100gsm, uncoated Tauro stock.

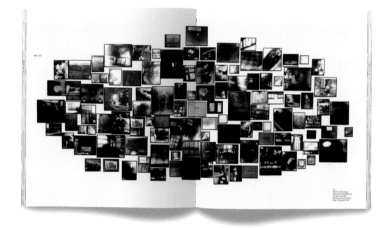

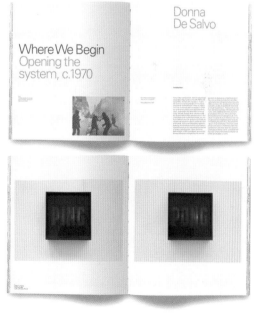

# A tale of typography

*Typography* refers to the way in which written ideas are given a visual form, and can radically affect how a design is perceived. Typefaces have personality and are an excellent means of communicating emotion. A typeface can be authoritative, relaxed, formal, informal, austere, or unassuming, while a graphic typeface is almost an image in its own right.

The debate about legibility versus readability (see page 20) is an important consideration for the publication designer. For example, a telephone directory requires a high level of visual order and coherence; an annual report must be authoritative and capture the company's brand values. Typography can be used to excellent effect in both these publication types in order to achieve these aims.

Usually, designers use more than one typeface when designing a publication. This immediately creates a hierarchy and provides the page with a focal point. Type hierarchy is the visual guide used to distinguish between different headings and body text. It is created through the use

of different typefaces and variations in point size. In a book, the designer might choose to use different point sizes and weighting to distinguish between the book's title, chapter headings, and the main body text.

When a typeface is designed, it is usually with a particular function in mind. Take, for example, the typeface for the UK's *Yellow Pages* directory, art directed by Johnson Banks and designed by London-based company The Foundry. Their brief was to design a new typeface for the directory that allowed more characters per line, and was cleaner and more readable at very small sizes. Optimum legibility was achieved by drawing the typeface for use specifically at very small sizes—and it is estimated that the resulting design saves 500 tonnes (550 ton US) of paper per 75 books.

Publications use a number of typographic effects, depending on their function. A novel that will simply be read from cover to cover requires a typeface with clear, distinguishable forms that are easy on the eye; quirkier, eye-catching typefaces tend to be reserved for headings or cover designs. Most typefaces

**Photolibrary advertising campaign**
Designed by Frost Design for Photolibrary. Vince Frost came up with the idea of this advertising campaign, which involved talking to creatives around the world and asking them to submit their personal photo libraries. Frost's concept involved presenting each contributor's selection in the same format, which then opened out in different ways. This was then wrapped in newsprint and printed with the words "My Photolibrary" in bright red ink. Frost did not feel any single image could fully represent the company's entire collection, which totaled hundreds of thousands, preferring to harness the power of typography instead.

come in families. A type family contains all the different variations of a particular typeface, including the different weights, widths, and italics. This enables the designer to vary the type while retaining the characteristics of that particular family—and thus continuity within the publication.

Typography is a very powerful tool in publication design, and its ability to transform a publication should never be underestimated. Beautiful publications have been created time and time again purely through the power of typography, as the many inspiring examples in this section demonstrate.

**Yellow Pages**
Designed by johnson banks for *Yellow Pages*. For the *Yellow Pages* redesign, johnson banks created a new typeface that would allow more characters per line, that was cleaner and more readable at very small sizes, and that could be used with negative leading. (Photo courtesy of D&AD.)

**_i-jusi_ magazine**
Designed by various
designers (see captions to
individual images) for Orange
Juice Design. Roughly
translated, "i-jusi" is Zulu for
"juice." _i-jusi_ is a biannual
experimental graphic design
magazine, published by
Orange Juice Design in South
Africa. Each issue is themed,
with topics ranging from
religion to pornography.

**Right, top: Spread
from _i-jusi_, issue 17**
Designed by Max Kinsma and
art directed by Garth Walker.
Issue 17 featured typefaces
inspired by Africa.

**Right: Cover for
_i-jusi_, issue 17**
Designed by Wilhelm
Kruger and art directed
by Garth Walker.

Below: Cover for
*i-jusi*, issue 22
Designed by Wilhelm Kruger
and art directed by Garth
Walker. This issue was
centered on the subject of
South African culture after
a decade of democracy.

**Above: Spread from**
***i-jusi*, issue 17**
Designed by Wilhelm
Kruger and art directed
by Garth Walker.

**Above: Editorial spread**
**from *i-jusi*, issue 20**
Designed and art directed by
Garth Walker. This issue was
devoted to the subject of
language in South Africa. The
editorial is by Sean O'Toole.

**Right: Spread from**
***i-jusi*, issue 22**
Designed by Wilhelm Kruger
and Rikus Ferreira and art
directed by Garth Walker.

**Martin Parr**

Designed by Nick Bell for Phaidon Press. Val Williams' book on the British Magnum photographer Martin Parr was the first time that the photographer had been the subject of serious scrutiny by a leading writer. The designer comments, "Up to this point, it was perhaps easy for the photography-viewing public to unfairly dismiss Parr as not serious enough to warrant much discussion and analysis. To counter this view, we decided to start Val Williams' introduction on the front cover. This then upset the conventional book order: endpaper, half-title, title page, contents, etc. Here the introduction (set in oversize text) continues from the cover to the inside cover, and on through the first 11 pages. The cheesy, flower-patterned endpaper, sober half-title, title, and contents follow after that."

Williams declares on the front cover, "Some might say that Martin Parr has exploited our lack of taste and good judgment …" It is this viewpoint that inspired Nick Bell's typographic approach to the design of the book. The text for each chapter is set in a different typeface, which prevents the book from feeling too uniform.

The book is covered and bound to give the appearance of a typical family photo album, which is in keeping with Parr's interest in the fantastical mundanity of the everyday.

**Architecture & Design newsletter**
Designed by Park Studio for the British Council. The concept for this redesign of the Architecture & Design team's seasonal newsletter is based on each subject having its own identity. Folded-paper backdrops sit behind every spread and each has its own typeface, as an expression of the content of that spread. The cover functions as a contents page, which, with the eccentric typefaces, creates an immediate and strong visual impact.

# Picture perfect

Images play an integral role in the visual identity of any publication; they can dramatically alter its aesthetic appeal, whether as a subsidiary element to a main text or as the driving force behind the whole design. How images are used within publications depends on a number of factors, such as who the publication is aimed at and what function the images will serve. Generally, an image has a very short amount of time to convey its message, so it is imperative that the designer opts for the most suitable image type for the job. Sending out the wrong message is not a mistake any designer can afford to make.

Ensuring the correct balance of image and text also provides a publication with pace. Most magazines include at least one visual feature for this reason. There are also times when images are required to perform functions that text simply cannot. For example, it is virtually impossible to describe a new fashion trend using just words.

For the publication designer, there are a number of considerations to take into account when incorporating images into a design, including image quality. If an image is supplied digitally, for example, is it the correct resolution to ensure optimum quality in print? The *resolution* of an image refers

**Brochures and Catalogs: Postprinting Finishes and Production**
Designed by Struktur for RotoVision. Here, clean images and closeup shots are vital to show the detail of the finishes discussed in the text.

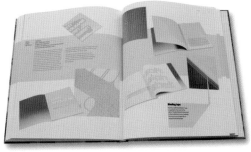

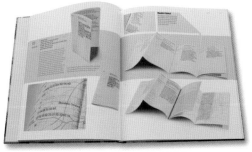

to the level of detail it contains; the higher the resolution, the better the image quality. For printing purposes, a resolution of 300dpi (dots per inch) is standard. When the resolution of an image is too low for printing at the required size, pixelation occurs. An image printed at the wrong resolution can destroy an otherwise perfectly good design. It takes only one "bad" image to compromise the standard of the whole publication.

The most popular type of image used today is photography, and with digital technology advancing at such a rate, the speed with which photographic images can be taken, supplied, and dropped into a design is now faster than ever. Designers have access to a vast number of picture libraries that are able to supply them with their choice of image at the click of a mouse. A full-bleed photographic image can have a powerful effect, although not all designers have the luxury of either space or budget to run full-bleed images throughout a publication. Instead, they must balance the images they do have with the other elements on the page. In such cases, there are a number of techniques a designer can employ to ensure an image has the maximum impact: juxtaposition, reportage, and the use of sequential images being just three.

**Access**
Designed by Sergio del Puerto at Serial Cut for the Istituto Europeo di Design, ModaLab (fashion department at the Institute of Design in Madrid). For this showcase of the best student work, every section needed graphic, still-life pictures with the same feel as the base layout. Shown here (top to bottom) are the *Access* cover, and three double-page spreads which display the consistent styling of the still-life images.

Images can also be manipulated to enhance their appearance. Manipulating even the most basic image can transform it with stunning results. Although photographs have the ability to communicate a message with absolute clarity and without being altered, in today's digital world (reportage aside) this is a rarity. These days, almost every image you see, whether in books, magazines, even annual reports and journals, has been digitally enhanced or manipulated in some way.

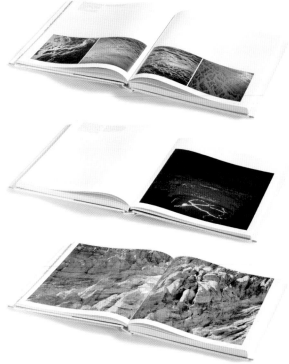

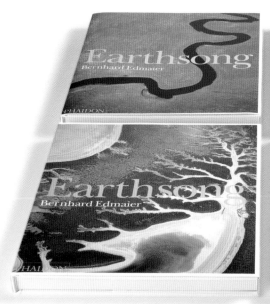

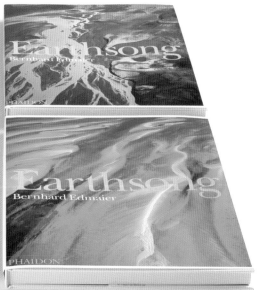

**Earthsong**
Designed by SEA for
Phaidon Press. As this book,
featuring aerial photography
by Bernhard Edmaier, shows,
photography can be a very
powerful medium.

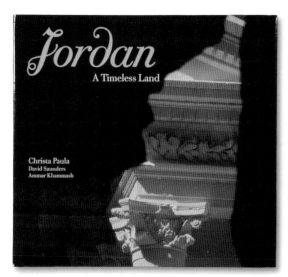

**Jordan: A Timeless Land**
Designed by Struktur for
TG Media. This large-format
book combines lavish, coffee-
table photography with an
authoritative written history
of the region.

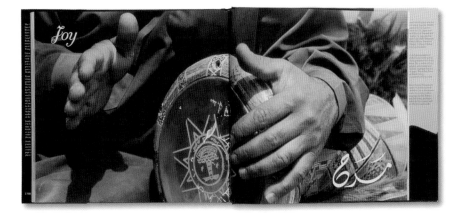

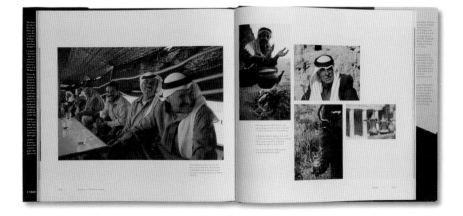

### Derek Newark
### *1933 to 1998*

Designed and published
by Atelier Works. This book
was created to celebrate the
life and work of British actor
Derek Newark. The designers
comment, "Wordless, it charts
his life in pictures. These were
selected from pictures on the
wall or in photobooks so, in
a way, it was a self-edited
history of his life. It starts with
his favorite picture of himself,
and ends with the very last
picture taken of him, and
Harold Pinter's mini-obituary
and tribute to him."

## Letter: **Derek Newark**

*Harold Pinter writes:* It was a great shock to read of the death of Derek Newark *(obituary August 14)*. I worked with him twice. He played Ajax in *The Trojan war will not take place* at the National and Roote in my play *The Hothouse* in the theatre and on television. He was a great comic actor. I have never laughed so much in my life as I did at the first reading of *The Hothouse* at Hampstead when his outraged exasperation with the crassness of those around him assumed monumental proportions. I also fell out of my seat at Ayckbourn's *Bedroom Farce* when the piece of furniture it had taken Derek ages to construct collapsed in front of him. The depth of his paralysed, pained disbelief was excruciatingly funny. It was a masterful demonstration of the essential gravity of farce. Offstage he could certainly be pretty rumbustious, "out of order," as he himself put it, but he was at core a gentle and generous man. I treasure his memory.

## Birthdays

Ginger Baker, rock drummer, 59; Gordon Brand Jr, golfer, 40; Bill Clinton, US president, 52; Lord Cocks of Hartcliffe, former Labour chief whip, 69; John Deacon, guitarist and songwriter, 48; Mary Joe Fernandez, tennis player, 27; Dame Rose Heilbron, former high court judge, 84; Prof Sir David Hopwood, geneticist, 66; Richard Ingrams, editor, the Oldie, 61; Billy J Kramer, pop singer, 55; David Lodge, novelist, 77; the Rt Rev Dr Michael Nazir-Ali, Bishop of Rochester, 50; Dr Elizabeth Shore, former president, Medical Women's Federation, 71; Jill St John, actress, 58; Willie Shoemaker, former jockey, 67; John Mark Taylor, Conservative MP, 57; Henry Wyndham, chairman, Sotheby's, 45.

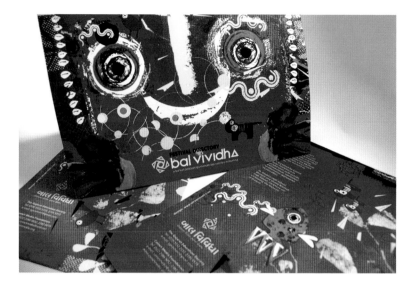

## Bal Vividha festival directory

Designed by Ulhas Moses at UMS Design. Bal Vividha is a children's educational event celebrating alternative approaches to learning. The design for the directory uses original, whimsical illustrations in basic primary colors. Playful fish, bird, and animal motifs have been used throughout to create interest and surprise. The images have been hand-drawn and scanned, with various textures also scanned in to create the final forms.

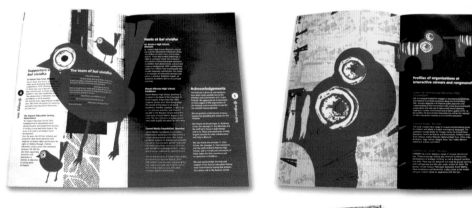

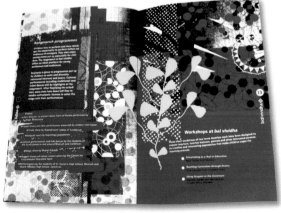

# Color

We recognize and react to color from a very early age. We learn to make associations with certain colors that stay with us our whole lives. As a result, colors can have a variety of meanings and be linked to different emotions. For example, red can be associated with excitement, aggression, or drama, whereas white carries with it a suggestion of purity and innocence. Equally, there are "warm" colors (terracotta, brown, gold) and "cool" colors (shades of blue and gray). These meanings are not universal, however, and will differ from country to country and within different cultures.

Color is one of the most important tools a graphic designer has. It can be used to convey a myriad of emotions and feelings, to instantly capture attention or give out a warning. These days, color printing is not the expensive process it once was and, as such, four-color printing is now used for even the most basic of print jobs.

The most commonly used color system in print publishing is CMYK (cyan, magenta, yellow, and black), while RGB (red, green, and blue) is used predominantly for digital publishing. As a designer, it is your responsibility to remember this and to ensure that any artwork you supply for print is in the correct format and, as a result, will be accurately reproduced in print. Special color processes can also be used to create specific graphic effects by replacing one of the standard process colors or through the use of a separate printing plate.

Color can be used in numerous ways within the realms of publication design. Whether you are looking to attract attention, highlight certain information, or elicit a specific emotional reaction, color can help. A color-coded index system can be used to help the reader navigate through a publication or to organize different types of information. In a particularly complex design, tinting can be used to increase the number of colors available to the designer. More formal publications, such as annual reports, other corporate literature, and catalogs, often use color coding within their design to enable readers to find what they are looking for quickly and easily.

Color can also establish a strong identity. On a well-designed magazine masthead, the color is often all that is needed for a regular reader to instantly recognize a magazine and, therefore, its brand.

It is important to plan how color will be used in your publication. Most publications are printed in sections of either 8 or 16 pages; therefore, if the whole publication is not being printed in four-color, or if a special process color or varnish is required on some pages, it may be necessary to limit color usage to certain sections to keep costs down. Using an imposition plan (a page plan that shows the sequence and position in which the pages will be printed) to work this out is the easiest way to avoid errors. Using colored paper stocks is another way of adding color to a publication.

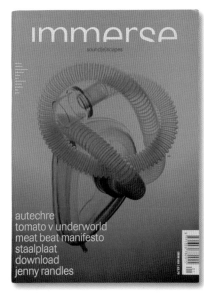

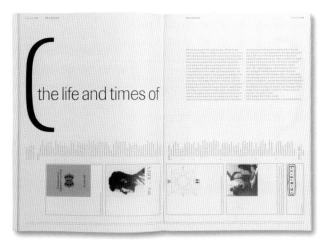

**Immerse**

Designed by Struktur for Immerse. *Immerse* is a magazine about electronic music and related subcultures. Owing to restricted budgets, all the content was printed in black and white; only the cover section was printed in full color. On one spread, the text and linework from the entire issue was overprinted, forming a dense collage of the whole issue.

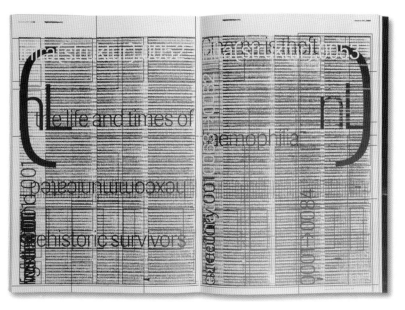

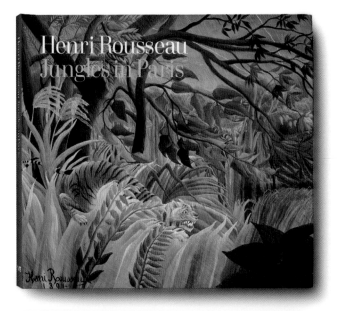

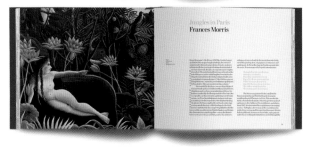

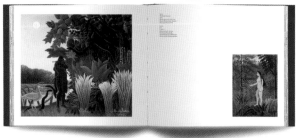

**Henri Rousseau:**
**Jungles in Paris**
Designed by Rose Design
for Tate Publishing.
This case-bound catalog
was designed to accompany
a major retrospective of
Rousseau's work at London's
Tate Modern gallery. The
publication features large,
full-color reproductions and
many previously unpublished
illustrations of Rousseau's
sources and influences. It
also includes five specially
commissioned essays that
provide a definitive overview
on the life and work of this
remarkable artist.

**Surface Seduction**
Designed by SEA for GF
Smith. This publication was
created using a number of
different print techniques.
Images were printed on a
range of four-color, spot color,
spot UV, and high-gloss UV
to showcase the "diverse
printability" of the stock,
Phoenix Motion.

# Bound to last

The process of binding involves physically assembling a publication from a number of separate sheets of paper. The way a publication is bound can have a dramatic effect on both its appearance and function. There are a number of binding options for the designer to consider when planning a publication. Listed below are some of the most common.

## Perfect binding
Perfect binding is a form of adhesive binding most commonly used for paperback books, magazines, corporate reports, manuals, brochures, and annual reports. Perfect binding involves the use of a flexible adhesive to hold the sections together and attach them to the book's spine. Its advantages are versatility, the ability to create a printable spine, and the publication's overall visual appeal.

## Saddle-stitching
Saddle-stitching is one of the simplest and most widely used binding techniques. It involves placing the folded signatures, or sheets, over a "saddle" and then stitching or stapling them along the spine. This style of binding is ideal for smaller publications such as booklets, brochures, newsletters, small catalogs, and pamphlets. Page numbers must be in multiples of four in order to create the folded booklet.

## Mechanical or spiral binding
A mechanical-bound publication consists of single sheets of paper joined together with a coil or comb. Often referred to as comb (plastic) or wiro (metal) binding, spiral binding can be done by a professional binder, a copy center, or by yourself using a DIY kit. With this style of binding, the pages are held together while still allowing the publication to open flat. Most commonly used for manuals and office reports, this method is both simple and inexpensive.

## French folding
French folding uses individual sheets of paper that are folded in half and then bound together at the open (rather than the creased) edge. Sheets folded this way can then be either glued together or bound with a coil, posts, or stitches. This method is useful if the designer wants to avoid double-sided printing, although many choose to print the inner with a contrast color purely for its aesthetic appeal.

## Canadian binding
Canadian binding is essentially wire binding with a wraparound cover. It can lie flat and the pages can be folded around, while offering the professional appearance of a perfect-bound volume with a printed spine.

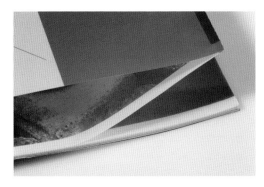

*Photos courtesy of Roger Fawcett-Tang at Struktur Design.*

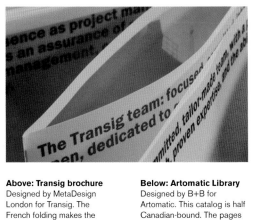

**Above: Transig brochure**
Designed by MetaDesign London for Transig. The French folding makes the whole brochure multilayered. The insides of the pages are printed in two colors: gray and white.

**Below: Artomatic Library**
Designed by B+B for Artomatic. This catalog is half Canadian-bound. The pages are wire-bound into the back of the cover, which leaves the spine and front cover clear of any visible wiring.

**Above: *William Morris* exhibition catalog**
Designed by Kapitza for the Whitworth Gallery, Manchester, UK. This perfect-bound catalog includes full-length flaps on the front and back covers.

**Below: The Photographers' Gallery quarterly catalog**
Designed by Spin for the Photographers' Gallery. To bind this brochure, Spin used saddle-stitching, in keeping with its minimal format and design.

# All systems go

Good design is not just about creating inspiring layouts. The production process is an additional aspect of the creative process that requires equal consideration. Designing any publication involves a complex process, but there are things the designer can do to make it easier to manage. The benefits of adopting a systematic approach should never be underestimated. Being organized with cataloging, managing, scheduling, and budgeting frees up the designer to focus on the creative process. Putting these systems into place at the start of each job means that these organizational skills quickly become second nature and a logical part of the design process.

Being able to design and implement a successful production strategy is a skill in itself—a very useful one. Publications involve designing large amounts of information, all of which has to be logged and stored so designers know exactly what they are working with and can locate any piece of content at a moment's notice. When it comes to preparing materials for scanning or for print, it is imperative to know exactly what needs to be sent, and who has what at any given time. As the designer, you are responsible for every piece of content that comes into and leaves your studio. For this reason, every item and every image MUST be logged in and out every time it enters or leaves the studio. This could save you a lot of trouble if something goes astray.

Systems can also be integrated into the design process itself. Thanks to advances in digital technology, designers are able to adopt a systematic approach to their work that both saves time and ensures continuity. Creating and working from a well-planned style sheet also gives the designer more headspace to focus on creative solutions without having to worry about remembering to resize text or change a typeface.

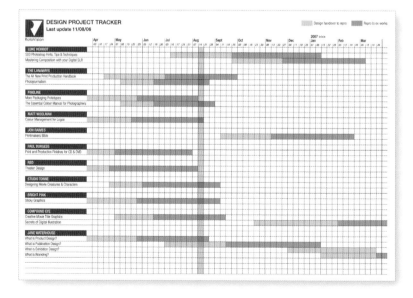

**Gantt chart**
Gantt charts allow projects to be tracked both over time, and by task.

**Progress chart**
Progress chart devised by Tony Seddon for his book *Image Management*. A visual system for tracking the progress of writing and/or illustrating any publication can save much wasted time, and frustration.

**Worklog**
Worklog plan by Lakshmi Bhaskaran for her book *Size Matters*. This plan details the process of collating and organizing the various projects included in the book.

## Imposition and page plans

The design of any publication, irrespective of its size, requires a page plan or flatplan. A page plan is a representation of how the designer imagines the publication will look, including, in the case of magazines and brochures, where ads will be placed. It also details the content to be included on each page and, often, what stage each page is at. Traditionally, page plans were created on paper, but advances in technology, and the fact that, today, publications often have the designer in one location and the editor or author in another—mean this process is increasingly carried out digitally.

An imposition plan shows the arrangement of pages in the sequence and position in which they will be printed before being cut, folded, and trimmed. This is an extremely useful tool for any publication designer, as it allows decisions to be made about color fall, paper stocks, and so on. As most publications are printed in sections of either 8 or 16 pages, if, for example, the whole publication is not being printed in color, its usage may be confined to a specific section in order to minimize costs. In such cases, an imposition plan will be used to tell the designer and/or printer which pages will be printed in color or on a different paper stock from the rest of the publication.

# Books

Books can be produced in a variety of forms, from the eye-catching, large-format coffee-table books that rely heavily on both beautiful photography and strong typography, to regular fiction and nonfiction paperbacks, which are designed simply with a straightforward grid, and with readability a priority. There are limited-edition books with multiple covers; educational textbooks and reference books that use complex hierarchies to aid navigation; and artists' and designers' monographs that are primarily image-based.

There are several ways to construct a book and endless variations can be made, but whatever the type, multiple sheets of paper bound together comprise the blank book, and its basic structure remains the same: cover; title pages; preliminary pages (contents, introduction, etc.); main body, whether text- or image-based; and end-matter (index, glossary, credits, etc). It is imperative for any book designer to familiarize him- or herself with the book's content from the outset, as the format, structure, and eventual design concept should all relate to this. In general, text-only books present fewer fundamental problems than their illustrated counterparts.

The book's binding will be influenced by a number of factors, such as page count, paper weight, desired durability, quantity to be produced, and whether it is important that the book lie flat when opened. Function is another key consideration. If you are designing a coffee-table book that will be left out on display, then a hardback, heavy-weight publication is fine, but if the book needs to be portable or easily referenced, the design will follow a different style.

Ordinary paperback books need to be both cheap and portable and are designed as such, using low-quality paper stock in a standard size that enables the maximum number of pages to be cut from a single sheet of paper with minimum wastage. When it comes to paperbacks, the book's cover is its primary marketing tool, and it is on this that the publisher will spend most money in a bid to entice potential readers and pull in that extra sale.

The concept for a book-jacket design is dependent on a number of factors. Whether the book is fiction or nonfiction, whether it is by a known author or a newcomer, and the book's genre, subject matter, and target audience all contribute to the designer's approach to its cover.

***Petersburg Perspectives***
Designed by John Morgan Studio for Fontanka. This was a hybrid travel book—part literary description of the city of St. Petersburg, part travel photography. Format was crucial here; the tall, thin format is easy to carry around. The essays are printed on uncoated stock and the images are printed in between, on coated stock.

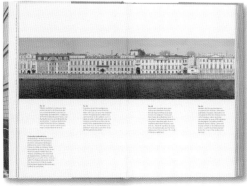

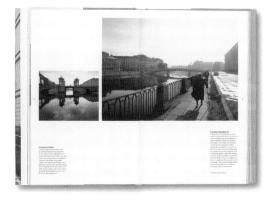

Whatever the type of book, its cover is, in effect, the product's packaging and must advertise both the product and the publisher at the same time. For this reason, its design should be approached in the same way as an advertising campaign. With more books being published than ever before, there is a lot at stake: each jacket is in direct competition with the hundreds of similar titles that surround it. A good design must catch the eye of a potential customer and inform them quickly and clearly about the book and why they should buy it.

Creating a book is often a collaborative process involving everyone from designers, writers, and editors, to photographers, illustrators, binders, and printers, all working together to create the final product. The ability of this group to work together can mean the difference between a good and a great book design.

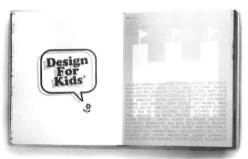

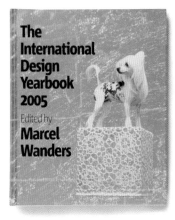

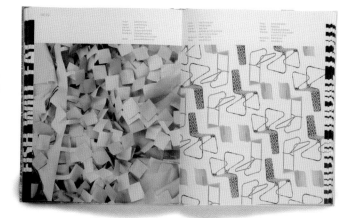

**Left: *Design for Kids*®**
Designed for Victionary Two.
A source for creative ideas,
*Design for Kids*® aims to
help readers connect with
the child inside them, and
to share the enthusiasm of
child-inspired works. The
concept of kids is taken
through the book's complete
package. Victor Cheung, the
key artist in Victionary,
developed the idea to use
soft foam for the cover, and
readers have been given the
choice of neon orange, yellow,
or blue, like a toy. Inside a toy
gun is buried in a die-cut
section of the book.

**Above and left:**
***The International Design
Yearbook 2005***
Designed by Struktur for
Laurence King Publishing.
Edited by the product
designer Marcel Wanders,
this yearbook mixes up
different sectors of product
design on every page. Images
are contrasted with each
other in size and function,
breaking away from the
conventional genres of
"tables," "chairs," "electronics,"
and so on. A quote from
Wanders is used on the fore-
edge of the book. If the pages
are splayed in one direction
the text reads "Grow more
fish;" when splayed the other
way, it reads "Fish will eat."

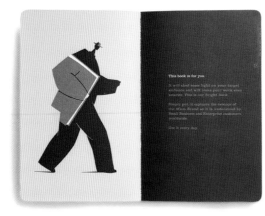

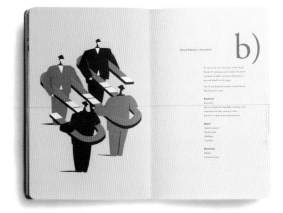

**3Com brand book**
Designed by Templin Brink
Design. The 3Com brand
book was created as a
strategy manifesto with
the goal of uniting 3Com's
diverse global marketing
directors around a central
marketing vision. It was
designed to appear clean
and understated to appeal
to a broad audience, and to
inspire its readers through
expressive illustrations, an
intimate format, and effective
use of tactile materials and
printing techniques.

### french

Designed by Frost Design for Lantern. Vince Frost wanted to create a design that was unique to this project. It was important that the cover convey not only that this was a French cookbook, but also that it was Damien Pignolet's French cookbook. Contemplating this, Frost recalled the hand-drawn logo—a black heart with a knife and fork either side—from Pignolet's restaurant. The simple title completes the design.

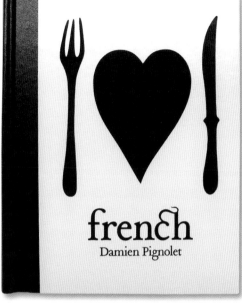

### SHV book

Designed by Irma Boom for SHV Holdings. This weighty, 2,136-page book was created to commemorate the centenary of Dutch multinational Steenkolen Handels Vereniging (SHV Holdings). The book, which took five years to complete, has a "nonlinear structure" and no page numbers. It was created using a 24-page template, which was sent to the repro house to input images and then returned to the designer to input text and finalize the design.

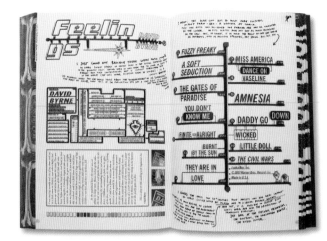

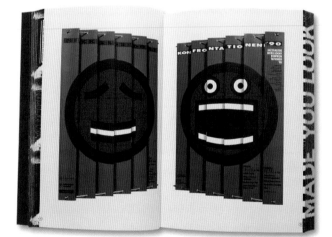

**Made You Look**

Designed by Stefan Sagmeister for Booth-Clibborn Editions.

This monograph of Stefan Sagmeister's work is a paperback housed in a red, transparent slipcase. When you bend the book in one direction, the title "Made You Look" becomes visible on the fore-edge; if you bend it in the other direction, the dog gets something to eat.

### Robert Brownjohn: Sex and Typography

Designed by Atelier Works for Laurence King Publishing. The designers comment on this piece, "There are few graphic designers who ever capture the public's interest. (We tend to be quite a dry lot.) But Robert Brownjohn was far larger than life. He consorted with Miles Davis, the Rolling Stones, Terence Stamp, artists, models, and the whole buzzing 1960s milieu. Brownjohn's best-known work is the title sequence for the James Bond movie *Goldfinger*, and it is a still from this shoot that we used as the cover, printed over shimmering gold."

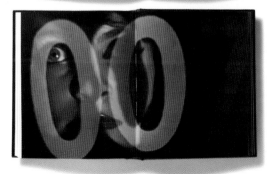

# Magazines

At their most basic, magazines are a combination of text and image created by a core team of designer or art director and editor. In order for this partnership to thrive, it is vital that the designer has a basic understanding of journalism and that the editor understands the fundamentals of design. Elements such as a magazine's editorial policy and philosophy, identity, and brand values are integral to the way in which the content is designed.

A more recent addition to the market is the specific customer magazine. Advertising revenue is integral to the success of any magazine, but buying advertising space in someone else's magazine, it seems, is no longer enough. Everyone from cellphone companies to realtors to motor companies now publishes their own magazines instead.

One of the defining aspects of a magazine is that it is produced at regular intervals, whether that be weekly, fortnightly, monthly, quarterly, or even biannually. This provides the designer with the opportunity to gradually build upon—or indeed change—the design over subsequent issues, in what is very much an organic design process. The complete redesign of a magazine occurs only occasionally. One of the attributes of a successful magazine designer is the ability to make such changes and to develop the design while retaining its core identity. Often working on multiple issues at the same time, the life of a magazine designer is never dull, as each new issue of a magazine presents an opportunity to try something new, to push the boundaries, and to challenge both designer and reader.

A magazine's format is largely dependent upon its function. Although magazines are inherently disposable in comparison to, say, books, the level of disposability varies greatly within the genre itself. For example, a weekly gossip magazine that has a life span of just a few days will be printed on a low-quality, inexpensive paper stock, whereas the nature and subject matter of

**Grazia**
Designed in-house and published by emap. The UK's first weekly glossy magazine uses highlights to capture readers' attention. The disposable nature of this publication (it has a shelf life of just seven days) means that printing on lower-quality stock is perfectly acceptable. (Photo courtesy of D&AD.)

a collectable biannual photography magazine dictates much higher production values. Once a successful format has been established, the focus of the magazine transfers to its content. Aside from the time factor—most magazine designers simply don't have the time or money to continually create new formats—it is important to establish a sense of familiarity through the design. Although readers want their magazine to look fresh and exciting, they also like to know what they are getting and, in many cases, this is what keeps their loyalty. Consistency is also vital to make that all-important leap from being a magazine to being a brand in its own right. Think of *Vogue* or *FHM*—both brands with a global presence that reaches far beyond the confines of the magazines that lie at their heart. The most successful designers are much more than just graphic designers; they are also experts in brand management and are responsible for creating some of the strongest brands in the world.

**Venue magazine**
Designed by ATWT paris. ATWT paris designed and developed the first three issues in close collaboration with journalist Ingrid Sommar. Portraits of designers and their creative environment were a continuing feature. ATWT paris came up with the idea of the "still life and life" series, with portraits taken in the subjects' kitchens, bathrooms, and kid's rooms.

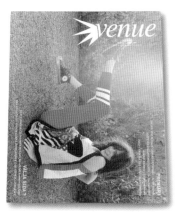

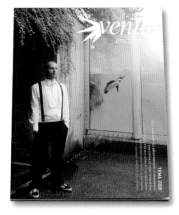

Creation & Enterprise

Includes:
Gerald Scarfe
Cartier's Bernard Fornas
Richard Avedon
Karim Rashid
Peggy Sirota
California Dreaming
Reza Deghati
Jordan Crossing

**theBite**
Designed by Struktur for
TransGlobe Multimedia
Enterprises, based in Dubai,
United Arab Emirates. *the
Bite*, a quarterly cultural
magazine, has a Middle-
Eastern focus. Struktur's
reputation for understated
typography, attention
to detail, and logical
organization of information
and imagery shows through
in the restrained design of
these covers and spreads.
The detail in the masthead
is a pleasing graphic
representation of the title
itself, and the clean layouts
avoid the clichéd use of
ornamentation to reflect
Middle-Eastern design.

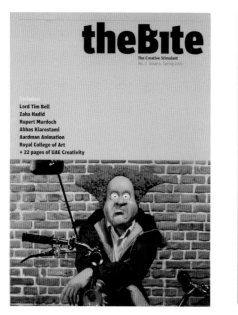

theBite

The Creative Stimulant
Vol. 2 Issue 4, Spring 2005

Features:
Lord Tim Bell
Zaha Hadid
Rupert Murdoch
Abbas Kiarostami
Aardman Animation
Royal College of Art
+ 22 pages of UAE Creativity

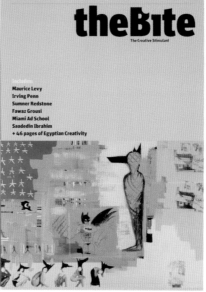

theBite

The Creative Stimulant

Features:
Maurice Levy
Irving Penn
Sumner Redstone
Fawaz Grousi
Miami Ad School
Saadedin Ibrahim
+ 46 pages of Egyptian Creativity

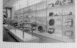
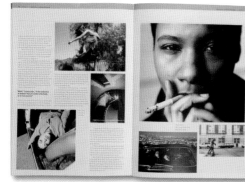
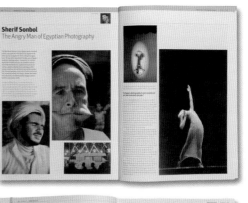
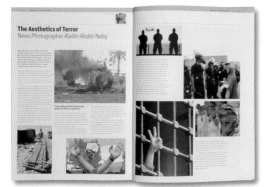

## eye magazine

Designed by Nick Bell for Haymarket Publishing. Nick Bell was creative director of *eye*, the highly influential international review of graphic design, from 1997 to 2005. His experience on *eye* enabled him to develop a more curatorial method of editorial design. *eye* celebrates great graphic design and embraces positive contributions to our visual environment, yet is critical, analytical, and reflective.

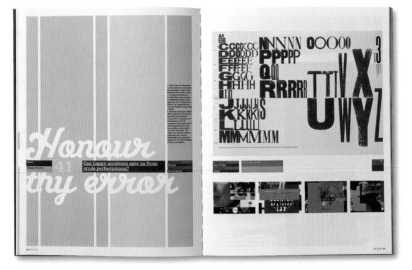

**Left: Spread from *eye*, issue 41**

"Honour thy error," by Anna Gerber. Featuring *Wood Letter* for *Broadside* No. 3 by Alan Kitching and screens from *Random Compositor Player* by Michael Worthington.

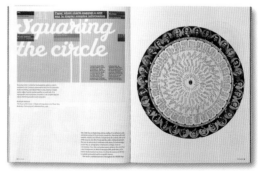

**Left: Cover for *eye*, issue 41**

A wheel chart from the collection of Jessica Helfand.

**Above: Spread from *eye*, issue 41**

"Squaring the circle," by Jessica Helfand. Featuring *Story of Our President's Wheel*, Chart of Knowledge Company, Boston, MA, 1932.

**Cover for *eye*,
issue 42**
Detail from "Dior bikini," by
Jasper Goodall. An illustration
commissioned as part of a
swimwear fashion story.

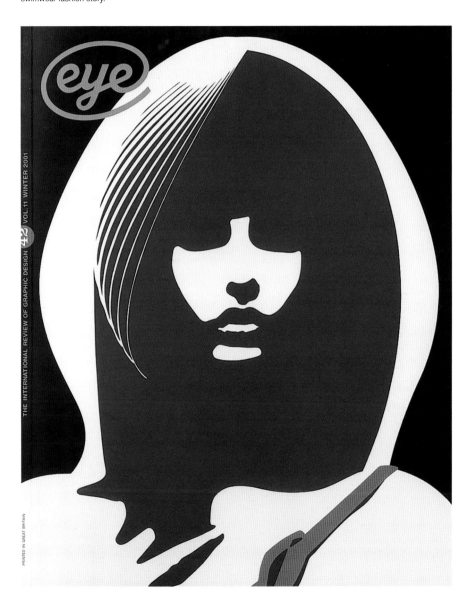

The physical materials that make up a magazine are straightforward and predictable: there is no need to re-invent the wheel with each issue. Each has the same page dimensions as the first, and though we changed the grid and some of the fonts with the redesign unveiled in issue 41, most of the mechanical aspects of *Eye*'s production (with the exception of inserts such as this) remained the same.

Yet within the flat surfaces of this relatively glossy magazine we are charged with representing all manner of physical objects, from T-shirts to TV animations, from thick cardboard artefacts to fragile historical ephemera. The silk-screen posters shown in Julia Bigham's article (see page 32) mark a brief phase in hippie capitalism, when live events were used to support loss-making publications. The posters aimed squarely at one subculture also brightened up the streets and lives around them, and the spiritual, musical and chemical interests of the artists soon spread to mainstream culture.

And from the theme of print and paper, and of materials, emerged a complementary refrain – that of flatness – in David Crowley's essay (p18) about the visual fallout of post-Situationism. The fashion for shiny blankness (using alienation as a hip commercial signifier) contrasts with the use of rough uncoated surfaces to denote authenticity, as Adrian Shaughnessy argues in 'Truth lies in the surface' (p54). Yet sometimes it is all part of the same game that commerce plays with image-makers, courting the need for novelty and sensation, whether that audience be tired and cynical or 'cool' and gullible. Or perhaps the target market is made up of graphic designers themselves – throwing another set of beautifully produced samples into bulging wastebaskets, a phenomenon we explore in 'Pulp artefacts' (p60).

Stephen Byram seems like the complete design auteur, who has built up a personal body of work while working for sympathetic clients. Yet he may be one of the most commercially effective designers in the current market. His CD covers perform a gritty hard sell for uncommercial music, and his illustrations and designs give authority both to fresh talents and to established stars.

Current affairs may only have a tangential effect upon the slow-moving editorial policies of a quarterly, but recent tragedies have inevitably informed some of the contents. Graphic design can be a servant, an observer and a communicator of human triumph and folly. It may be harder to get work, as Steven Heller notes in 'The next small thing' but there is still plenty worth doing. For all the talk of 'design's new role', and however weighty or trivial its context and purpose, the practice of graphic design seems likely to remain as diverse and potentially satisfying as ever.

And it is curious to note how the contents of this issue's Archive, the animated graphics for the *Hitch Hiker's Guide to the Galaxy* TV series, echo many of the concerns about environmentalism, humanism and suffering that author Douglas Adams was to develop further, in books, radio and Internet projects, before his death this year. Not only do the flat colours and hard outlines of Rod Lord's illustrations look like information graphics for alienated post-Situationists: a sci-fi comedy about the universal propensity for non-communication, stupidity, pointless sacrifice, revenge and mindless destruction seems all too painfully relevant to our present times. JW

**Top: Spread from *eye*, issue 42**
Editorial insert with visual contents page.

**Above: Spread from *eye*, issue 42**
"Information imagined," by Andrew Robertson. This story featured images from the animated sequences of *The Hitchhiker's Guide to the Galaxy*, BBC TV, designed by Pearce Studios.

**Above: Spread from *eye*, issue 42**
"Detach, détourne & consume," by David Crowley. Featuring images from *NatWest Escape*, a television commercial for NatWest Bank designed by Vehicle for TBWA GGT communications.

**Below: Spread from *eye*, issue 42**

"Day-Glo mind blow," by Julia Bigham. Featuring Martin Sharp's screenprinted poster *Roundhouse UFO*.

**Bottom: Spread from *eye*, issue 42**

"Stephen Byram: art & design," by John L. Walters, with cover detail from *Accordance*, designed by Stephen Byram.

**Right: Spread from *eye*, issue 43**

"Reputations: interview with Zuzana Licko," by Rhonda Rubinstein. Featuring a portrait of Licko by Hope Harris.

**Below right: Spread from *eye*, issue 43**

"Bigger than life itself," by Steven Heller. Featuring Klimaschin's poster for the USSR Agricultural Exhibition.

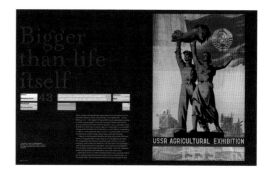

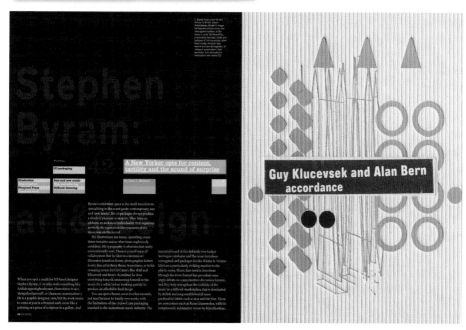

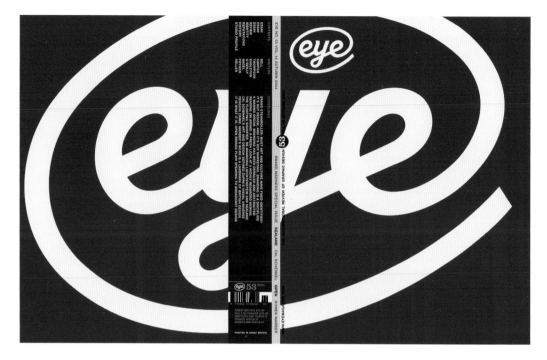

**Above: Cover for *eye*, issue 53**
The "Brand Madness" issue featured the *eye* logo. Concept by Nick Bell, drawing by Magnus Rakeng.

**Right, top: Spread from *eye*, issue 53**
"The steamroller of branding," by Nick Bell. "Art and culture are open to interpretation. Why must we give them fixed identities?"

**Right, bottom: Spread from *eye*, issue 53**
"A waking dream: the language of branding," by David Thompson. "The notion of the brand and its plausible functions have been derailed and abstracted."

**Below: Spread from
*eye*, issue 54**
"Forensic types," by Alice
Twemlow. Featuring
"nontypographic" lettering
in Manhattan, New York,
photographed by Tobias
Frere-Jones.

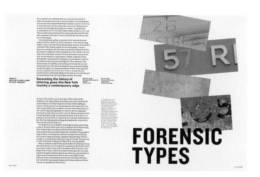

**FORENSIC
TYPES**

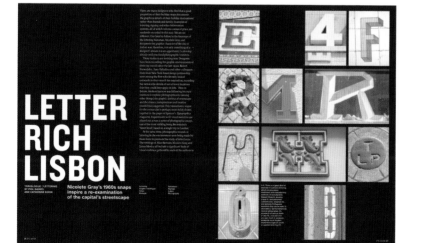

**LETTER
RICH
LISBON**

**Above: Cover for *eye*,
issue 54**
Collage by Nick Bell using
manipulated photographs
from the collection of typeface
designer Tobias Frere-Jones.

**Left: Spread from *eye*,
issue 54**
"Letter rich Lisbon," by Phil
Baines and Catherine Dixon.
Featuring details of street
lettering and signage in
Lisbon, Portugal.

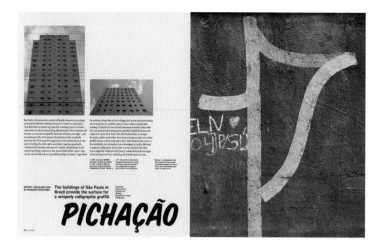

**Below: Spread from *eye*, issue 57**
"Thinking in solid air," by Steve Rigley. Featuring letterpress work by Edwin Pickstone of the Glasgow School of Art, in Scotland.

**Bottom: Spread from *eye*, issue 57** "Nameless thing," by John Warwicker. Featuring Tokyo Type Directors' Club awards entries from Taku Satoh and Hajime Tachibana.

**Above, top: Spread from *eye*, issue 56**
"Pichação," by François Chastanet. Featuring graffiti in São Paulo, Brazil.

**Above: Spread from *eye*, issue 56**
"Working lunch," by Steve Rigley and Kurnal Rawat. Featuring Mumbai's dabbawalla tiffin-box lids and the Mumbai city signage proposals by Typocity that were inspired by them.

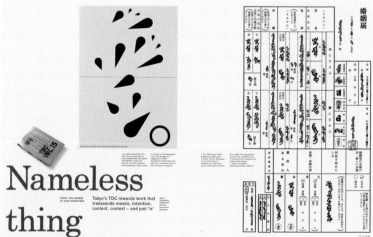

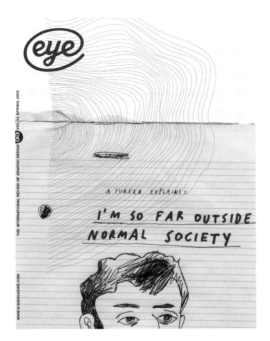

THE INTERNATIONAL REVIEW OF GRAPHIC DESIGN VOL.14 SPRING 2005

WWW.EYEMAGAZINE.COM

A SURFER EXPLAINS:

I'M SO FAR OUTSIDE NORMAL SOCIETY

**Left: Cover for *eye*, issue 55**
Detail from surfer portrait by
Paul Davis, commissioned by
designer David Carson for
*Big* magazine, but not used.
Doodle by Nick Bell.

Making
visible the
invisible

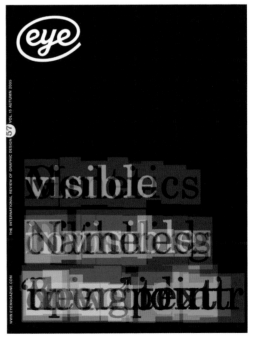

THE INTERNATIONAL REVIEW OF GRAPHIC DESIGN VOL. 15 AUTUMN 2005

WWW.EYEMAGAZINE.COM

**Above and right: Cover
and spread from *eye*,
issue 57**
"Making visible the invisible,"
by Stuart McKee. Featuring
computer-generated images
of viruses and bacteria by
Laurie Fink, Chris Burda, and
Adam Weins.

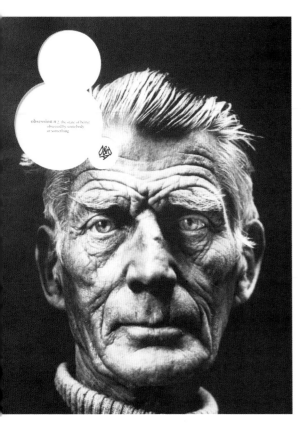

obsession n 2. the state of being
obsessed by somebody
or something

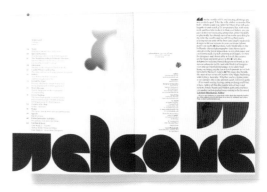

Q&A Terry Jones
i-D magazine

The World According
to Massimo and Lella
Quentin Newark salutes
the Vignellis and their rare
and extraordinary versatility

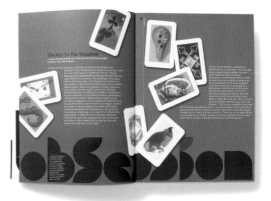

***Ampersand* magazine**
Designed by Frost Design for
D&AD. In 2006, *Ampersand*
was relaunched under the
creative direction of Vince
Frost. The concept for the
redesign was centered on
ideas and creativity. The
*Ampersand* logo, die-cut into
the front cover, is made up
of thought bubbles, and a
specially designed title font is
featured within. Frost's strong
typography and unique design
approach has transformed
what was once simply a
newsletter into a beautifully
designed, tactile publication.

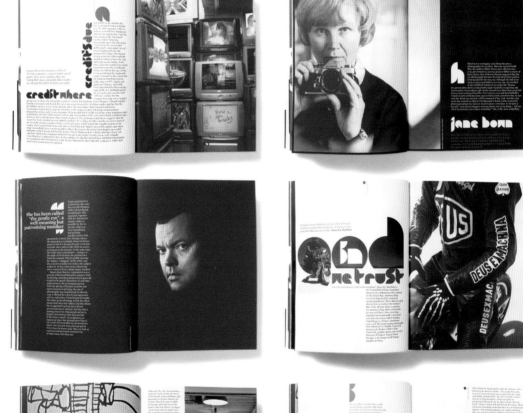

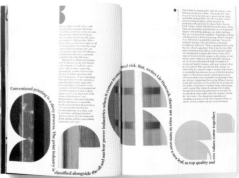

# Newspapers

The world of newspaper design is unlike any other. A newspaper's content changes every day as the latest headlines, stories, and images flow into the newsroom, yet the overall look and feel of the paper remain the same. Day in, day out, there is an overall coherence to a newspaper's design that preserves its identity to such an extent that just a quick scan along the shelf of the newsagents enables us to instantly identify any particular title.

Successfully designing a newspaper does not provide the designer with the opportunity for experimentation in the way that magazine design does. But newspaper designers are still faced with a myriad of daily design decisions that must be addressed if they are to present the information in as accurate, fair, and clear a way as possible. One story may need an additional graphic element for clarification; another may require two or even three subheads because of its complexity.

It is up to the designer to organize and optimize the content so that the reader can be easily guided through it. Having a basic design stylebook can be a huge help to the newspaper designer, both as a means of ensuring consistency within the design and also as a point of reference for any newcomers to the newspaper.

A strong page structure, integrated navigation system, and optimum readability are integral to a good newspaper design, and are achieved through a combination of contrast, rhythm, and harmony. The designer uses a combination of elements such as type, headlines, pictures, white space, and color to achieve contrast on the page. Typographic contrast may be achieved by using a combination of type styles, while contrast with pictures can be the result of introducing color imagery or varying the column widths. The rhythm, meanwhile, refers to the ways in which the designer guides the reader between the different elements on the page; this can be achieved by simply staggering headlines, stories, and pictures.

An effective design strategy is the key to success, and will allow for changes in a newspaper's content without affecting its identity. Newspapers achieve consistency and flexibility by adhering to a complex set of design principles throughout the publication. For example, one typeface will be used for headlines, another for secondary headlines, and a third for body text, with a fixed point size and leading for each; all body text may be justified left, image captions emboldened, etc. Whatever rules the designer imposes, once set they

must never be broken. One would think that working to such a strict set of rules would serve only to limit the design, but in reality this approach is comprehensive enough to allow for every eventuality that the paper's ever-changing content may bring about, while ensuring the newspaper looks the same each day and retains its visual harmony.

The vast amount of skill and time required to work in newspaper design means that only a few designers ever take up the challenge. However, the basic skills required for this type of coordinated design are not confined only to newspapers, but are a useful asset to any publication designer.

**The Guardian**
Designed by *The Guardian* for Guardian Media Group. After the UK's other broadsheets had all downsized to tabloid format, *The Guardian* scaled down to a Berliner, or midi, format (18½ x 12½in/ 470 x 315mm). The redesign, seen here, went on to win a highly coveted Black Pencil at the 2006 D&AD Awards. In contrast to its predecessor, the redesigned *Guardian* is printed in color on every page, while bold, black, sans-serif headlines have made way for a new font. The typography is built around a single family, Guardian Egyptian, designed especially for the newspaper. (Photo courtesy of D&AD.)

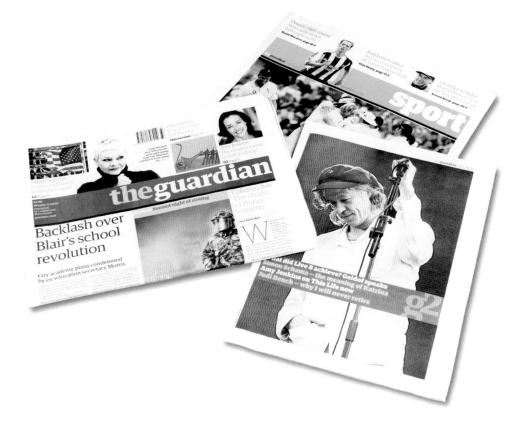

**Anni Kuan brochure**
Designed by Stefan Sagmeister for Anni Kuan. This fashion brochure for New York designer Anni Kuan celebrates New York laundromats. The designer explains, "We really only had the budget to print a postcard. But a friendly designer told us about a really cheap newspaper printer who could do the entire run for under $500. We then bought wire hangers (2 cents apiece) and corrugated boards (12 cents apiece). We got a shrink-wrap machine ($500) and the client hired a student to put it all together."

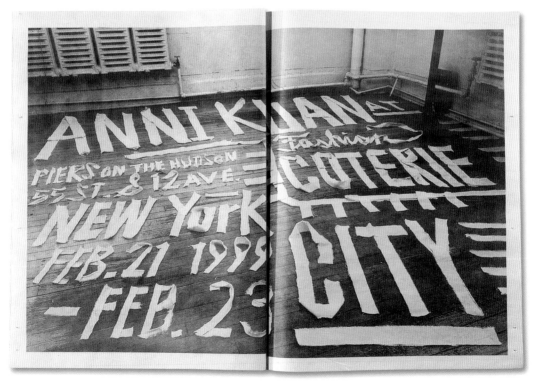

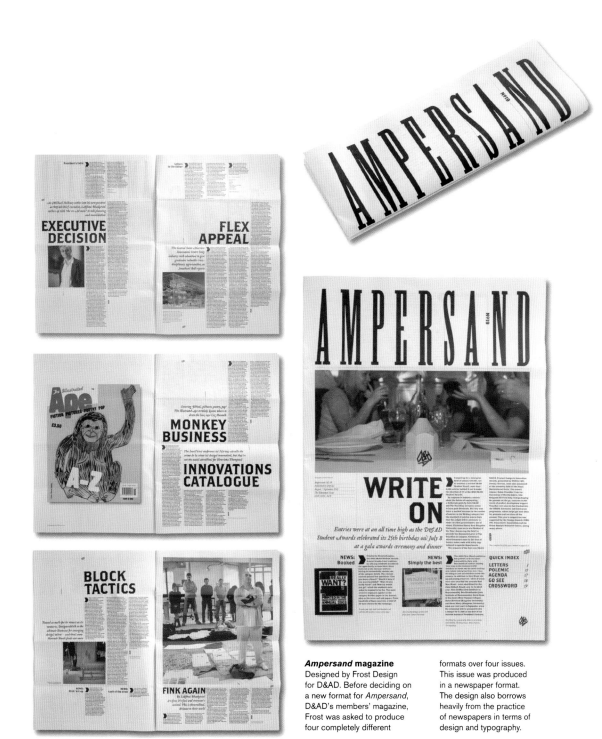

**Ampersand magazine**
Designed by Frost Design
for D&AD. Before deciding on
a new format for *Ampersand*,
D&AD's members' magazine,
Frost was asked to produce
four completely different
formats over four issues.
This issue was produced
in a newspaper format.
The design also borrows
heavily from the practice
of newspapers in terms of
design and typography.

# Brochures and catalogs

Brochures and catalogs are important documents for any company. While most adhere to many of the rules of book design, their function is very different. These types of publications are primarily marketing tools created with the aim of selling a product or service, and must be designed as such. Every brochure and catalog has a different purpose and is aimed at a specific target audience. It is up to the designer to determine these two factors from the outset. A good designer is never afraid of talking to the client and asking as many questions as are necessary in order to clarify the brief in his or her mind before embarking on a solution.

## Brochures

A brochure is a booklet or pamphlet that contains descriptive information or advertising. Brochures have one of the most flexible formats of all publications and come in all manner of shapes and sizes. For the designer, the opportunity to experiment and push the boundaries is huge in this field. As brochures are often commissioned as one-off publications, so far as the budget allows, the designer has the freedom to pull out all the stops without having to worry about repeating the design on subsequent occasions. And as a marketing tool, both client and designer alike often favor innovative and unique designs.

## Catalogs

Any catalog design should be backed up with good-quality, clear imagery of the products being presented. It should also be well organized into different sections and product categories to ensure readers are able to find the information they need quickly and with ease.

By their very nature, product catalogs have the potential to become boring. There are many different types of catalog, and, as with most other forms of publication design, it is the combination of content and target audience that largely determines the direction the design will take. For example, a trade product catalog for a tool company

is required to be purely functional. A basic image, along with the product details, technical specifications, and prices are all that is required. As a result, catalogs tend to be printed on low-quality paper stock and distributed free.

In contrast, a retail catalog for a high-end furniture company will have much higher production values in order to attract customers not only to the products, but also to the lifestyle the company portrays. Rather than straight product shots, the photographer may be commissioned to shoot the products on location. Products may be grouped together to encourage customers to buy an entire setup rather than a single product.

In addition, the catalog is likely to be printed on more expensive paper. Some companies even charge for their catalogs. This not only helps them to recoup some of the cost, but also gives the catalog a must-have cachet. These types of catalogs are all about inspiring the reader. Many have an aspirational element akin to that of a fashion magazine, and it is the task of the designer to reflect that in the design. However, in many ways, this style of catalog—with its beautiful photography and big budget—presents less of a challenge to the designer. For many designers, coming up with an innovative design that is solely responsible for bringing an otherwise mundane product to life can be far more satisfying.

**OJ brochure**
Designed by Garth Walker for Orange Juice Design; self-promotional. This brochure was produced in three parts: one section holds the copy and one the work, while the third holds a personal message from each designer.

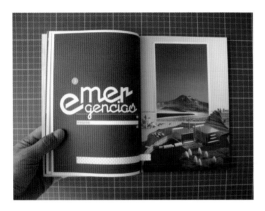

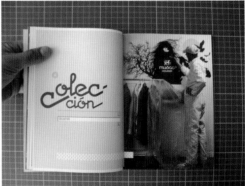

**Promotional brochure for
MUSAC (Contemporary
Art Museum of Léon, Spain)**
Designed by Serial Cut for
MUSAC. The museum gave
an open brief, the only aim
being "to create a publication
that people would keep as a
collector's item". Most of the
photographs include designed
elements, which were cut out
and placed in the background.

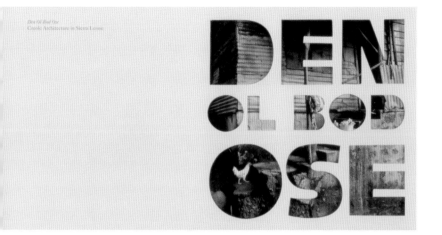

Den Ol Bod Ose
Creole Architecture in Sierra Leone

**Den Ol Bod Ose**
**exhibition catalog**
Designed by Park Studio
for the British Council. This
exhibition catalog is about
architecture in Sierra Leone.
The inside pages are split
in two with a perforation, so
the image pages can be torn
out and used as postcards
while the text pages remain in
a contained book format. As
the image pages are torn out,
the cover image changes: the
cover has a die-cut through
which shows whatever image
page lies beneath. The
catalog is bound together
with two utilitarian rivets.

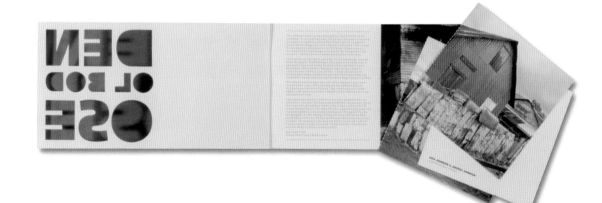

## Camberwell Arts Festival brochure

Designed by Park Studio for Camberwell Arts Festival. The design of this brochure is based on the idea of using a "Camberwell" font, specially created by Park Studio. The designers felt the design "needed to reflect the creative and 'rough around the edges' area of Camberwell [in southeast London], so we went out and took photos of any type we could find in Camberwell, from shop signage to church signs to graffiti. Then, using separate letters from our collection of images, we created a Camberwell font. As there were no images to be included, we decided to add little snippets about Camberwell throughout the brochure, adding another narrative to the content."

The brochure has a foldout map, which helps readers navigate (listings are located on the map), and serves as a bookmark.

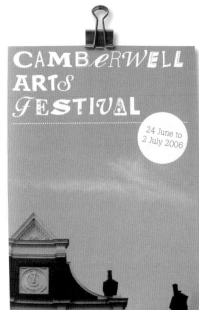

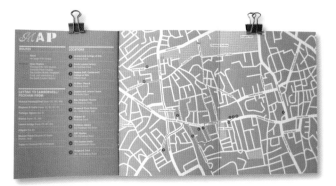

**The Flower Cabinet brochure**
Designed by Rose Design. This catalog, for Barbara and Zafer Baran's exhibition at London's Blue Gallery, was designed to allude to the idea of Victorian flower cabinets and specimen trays. The concertina format folds out to reveal the flower samples. The triple-coated satin board is contrasted with a thin, tactile, uncoated stock housing the 16-page text section, which is wire-stitched into the cover.

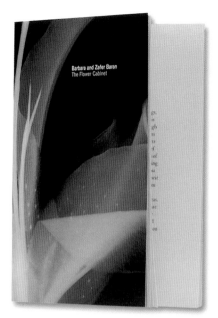

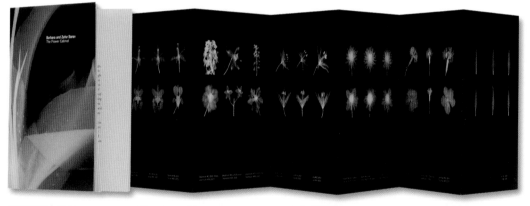

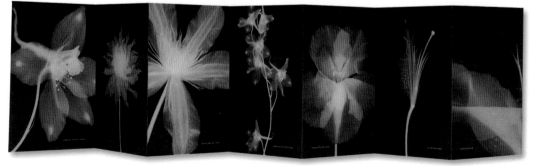

# Annual reports

For many companies today, the annual report is much more than a financial statement—it is the single most important piece of print they will produce all year. For smaller businesses especially, who do not have huge marketing budgets, the annual report is also an opportunity for recruitment, public relations, and advertising all rolled into one. Although some companies now publish their financial and shareholder information digitally, many still produce a printed report for these very reasons. In addition to clearly addressing shareholder concerns, the most effective annual reports also deliver compelling messages for customers, employees, partners, the media, and analysts. This makes them both more memorable and more cost-effective than a straight financial report—and, in turn, places the onus on the designer to get the job absolutely right from the start.

At its most basic, an annual report must communicate a company's values. This includes presenting tangible information, such as its financial statements—revenue and expenditure, assets and holdings, and so on—as well as the more intangible aspects, such as the company's intrinsic values, its vision, and personality. Of course, the financial information is vital, but being able to connect with a company's core values could well be the deciding factor for a potential shareholder looking to invest.

When it comes to designing annual reports, there is no room for error. Ongoing communication with the client is vital to ensure that both sides are happy with the way the project is progressing. The level of communication needed will vary from client to client and will decrease as the designer becomes more familiar with the company and a level of mutual trust develops.

In recent years, disclosure issues have affected the design of annual reports, resulting in many clients abandoning the exuberance of the annual reports that characterized the late 1990s in favor of a more subdued, purer approach that leaves no room for misinterpretation. But this has not dampened the enthusiasm of today's designers, who continue to come up with innovative design solutions year on year. This ingenuity is not an easy task, however. Creating a report for a complex company involves an immense amount of research in order to understand the nature of the company and its business on the most basic level. It is the designer's task then to devise a system to explain this information in a way that will make readers care about the company and its mission.

**Left: MIG annual report**
Designed by Frost Design for Macquarie Infrastructure Group (MIG). MIG owns many of the world's toll roads. For its 2005 annual report, the design team wanted to contextualize the roads by showing the people who use them. Entitled "About Time," it shows how these roads save time for both people and businesses. In this spread, road vernacular was used to represent the report's facts and figures. A chart showing the geographic split is represented by a freeway exit sign; the length of the concessions is detailed as a traffic-light pie chart; and the lifecycle of the roads is shown as a graph made up of traffic cones.

**Right: MFI quarterly report**
Designed by Rose Design for MFI. This report was created for MFI managers to help them encourage their teams to be more proactive with problem-solving. It draws on an example of a match-factory worker who suggested saving money by putting a sand-paper strip on only one side of the matchboxes. The sandpaper strip was applied to the cover by hand.

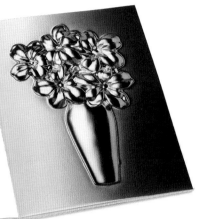

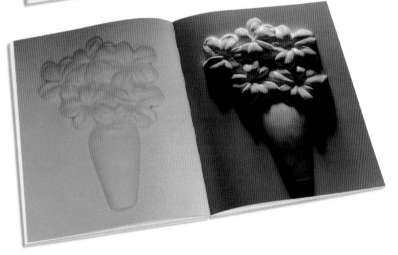

**Zumtobel annual report**
Designed by Stefan
Sagmeister and Matthias
Ernstberger for Zumtobel.
Zumtobel is a leading
European manufacturer of
lighting systems. The cover
of this annual report features
a heat-molded relief sculpture
of five flowers in a vase,
symbolizing the five sub-
brands under the Zumtobel
name. All images on the
inside of the annual report
are photographs of this exact
cover, shot under different
lighting conditions, illustrating
the extraordinary power of
changing light.

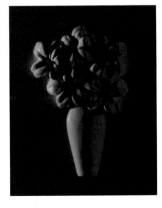

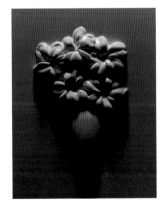

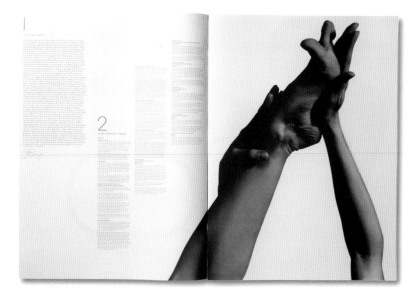

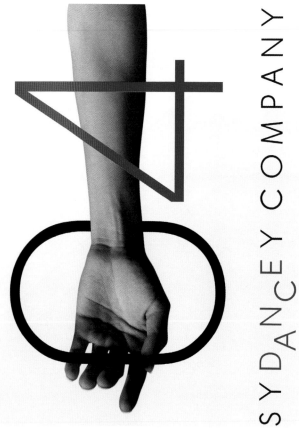

SYDANCEY COMPANY

### Sydney Dance Company annual report

Designed by Frost Design for the Sydney Dance Company. The combination of stunning photography and a beautifully clean layout make this annual report really special. Frost also designed the Sydney Dance Company identity, seen here. Determined not to opt for anything overtly dance-related (that would have been too easy), Vince Frost's epiphany came when he noticed that by adding two letters to the word "Sydney," he could make it "dance."

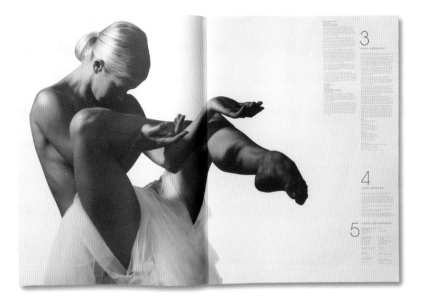

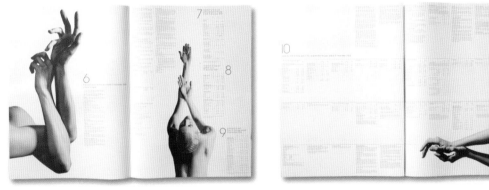

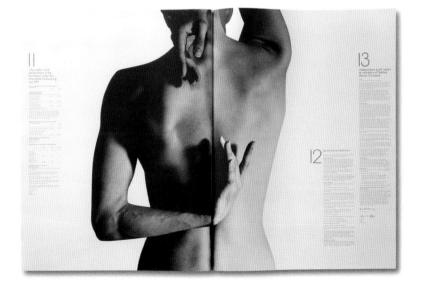

# Programs

Working on small-scale cultural projects, such as the design of a program for a theater performance or an art show, is often a favorite task of graphic designers. Although often produced on a tight budget, this type of project allows designers the headspace to come up with their most creative ideas—and in many cases some of their best work.

In terms of function, a program has a clear role: to provide information not only about a performance itself, but also about the performers. Often designed to a fairly open brief, most programs are a combination of text and image, with the type of performance dictating the quality of imagery used. As programs are generally

C!R

**Season 2005  Surround Profound**

In 2005 Circa presents four strikingly new ways to experience circus.
Four meetings between extraordinary physical skills and bold theatrical poetry.
Four glimpses of how dynamic performance can be.
I look forward to seeing you in 2005.
Yaron Lifschitz Artistic Director

1/ This text has legs: an SMS circus

handed out before the performance, the designer can use whatever format and size is deemed most appropriate and achievable within the allotted budget.

A program may be designed as a souvenir, beautifully produced with specially commissioned photography on high-quality, coated stock, or as a simple, functional guide to an event. Either way, it is important to consider how it will be used. For most programs, the layout will need to facilitate the reader's need to access individual pieces of information, as they are unlikely to read the entire publication in one sitting, preferring instead to dip in and out as and when the need arises. There is little point in designing a program on a large sheet of paper with complex folds and graphics if it is to be given to a theatergoer sitting in a confined area and unable to open it without blocking the view of an entire row! This may seem an obvious point to make, but the need to consider a publication's function cannot be emphasized enough.

**Circa season program**
Designed by Frost Design for Circa. The round design of this program for Brisbane-based performance company Circa reflects its name. Having decided on the format, it was not until Frost constructed a dummy that he realized how much wastage there would be in cutting it from a standard rectangular sheet of paper. This inspired an additional concept. As each season covers four performances, Frost used the offcuts to create four miniprograms that could be handed out to the audience as they arrived for each performance.

**The Old Vic programs**
Designed by Rose Design
for The Old Vic theater, in
London. The designers
explain, "We were asked to
design the programs for The
Old Vic in order to help them
express the personalities of
the productions, while
retaining a consistent means
of communicating the theater
as producer, or in some
instances, host, of the
performances. In borrowing
from the language of
magazines (both editorially
and visually), we created
a format that sits above
conventional theater
programs and delivers
content, which adds to the
theatergoers' experience."

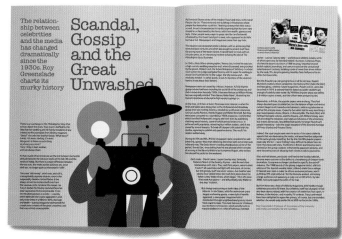

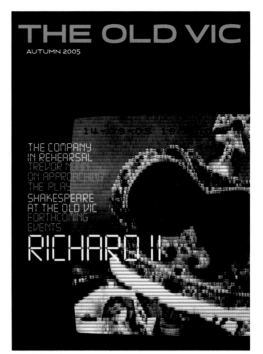

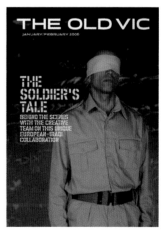

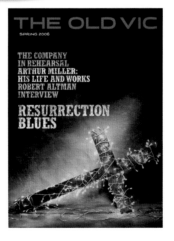

# Portfolios

The purpose of this section is to showcase the breadth and diversity of publications being designed today, as well as providing some background to the designers and design studios behind the work. The studios featured here are producing, in my opinion, some of the very best publication design in the world today. I have chosen a cross-section of designers, from the more established, larger studios to smaller design firms just beginning to consolidate their reputations in this field. I also felt it was important that this section be as global as possible. The designers featured are based all over the world, from Sydney-based Frost Design, to Paprika in Canada, to Big Active and Bibliothèque in the UK.

Publications come in many shapes and forms, as you will see in the following pages. From commercial magazine design to smaller cultural projects such as theater programs, to books and annual reports, the spectrum of work is vast. With each project I have tried to provide, where possible, a short introduction to the project itself, as it is this background information that so often drives the design solution. The aim of these texts is to provide you with a better understanding of why the specific design decisions pertinent to each project were taken. Being able to look at a piece of work and fully understand why it looks the way it does is a skill in itself—and an invaluable tool for anyone seeking to pursue a career in publication design.

Founded in 2004 by Tim Beard, Jonathon Jeffrey, and Mason Wells, Bibliothèque is a graphic design consultancy based in Shoreditch, London. In their own words, their "design methodology is based on analysis and research. Regardless of scale or budget, we deliver clear, relevant, and thought-provoking communications."

Although the studio has been running for a relatively short time, it already has a strong clientele from a wide range of sectors, from some of the biggest brands in the world (Adidas and Motorola, to name but two), to smaller cultural projects, such as the book they recently designed for photographer Richard Learoyd. "Design is about solving a problem, and we have been lucky enough to work for a broad section of clients," comments Jeffrey. "The fact is that design is a commercial activity and there is no difference between the way we would approach a brief for a multinational client and a smaller, less corporate, client."

The strong, equal partnership that exists between the studio's three founders, as well as their integrity and dedication to their work, are integral to their success. Every project begins with a collective discussion around the big studio table in order to "inform the creative direction." "Projects always start collectively," says Beard, " and I think that makes for genuinely better solutions. Although we've got a common path, we each have different angles on that, which molds every single project."

Citing the likes of legendary design collective 8vo as an inspiration, Bibliothèque prefers not to follow in the footsteps of fashion. "The work we like has a longevity, it's survived the test of time—you can't always put your finger on when it was done," Beard continues. "Ideally, we'd like to feel the same about our own work in 10 years' time."

**Adidas Predator brochure**
For the 2004 European Soccer Championship held in Portugal, Adidas wanted to document the development of its Predator boot and ball. Each spread featured a ball and its associated boot, photographed at actual size. A short return page featuring a plan photo of the boot contains text explaining its technical development and construction materials.

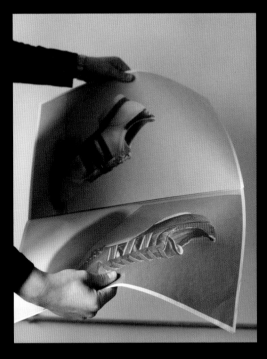

**Adidas Predator brochure**
The content for this brochure was selected from Adidas' archive of original sport shoes. Bibliothèque commissioned Dan Tobin Smith to photograph the shoes in a variety of gravity-defying positions. The typography was then composed in similar 3-D environments to reflect the dynamism of the concept.

**Adidas Predator brochure**
Here, thumbnails of the shoes contrast with the brochure's super-size format.

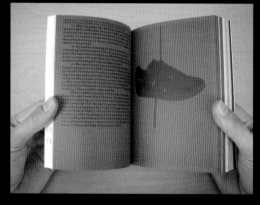

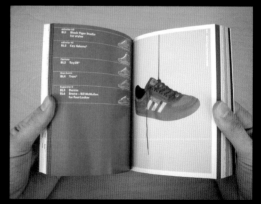

In 1983, Adidas launched a set of all-white shoes complete with felt-tip pens for customization. In 2006, the concept was relaunched, this time in collaboration with some of the world's most highly regarded creatives, resulting in a series of limited-edition shoes based on the six colors of the Adicolor range.

For the launch, Bibliothèque produced installations in two London stores: Comme des Garçons on Dover Street Market, and the Adidas Newburgh Street Lab Store. The company also designed a book containing a profile on each collaborator and featuring photography of the shoes they had designed. This was printed using a range of colored paper stocks to represent the six colors used in the Adicolor range.

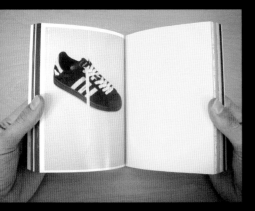
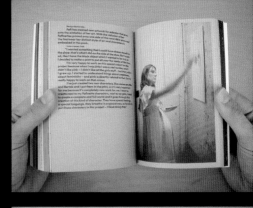

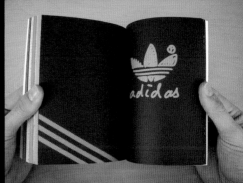

**Design Council logotype**
As part of the identity for this
project, the logotype was
brought to life as a 3-D form.
This was photographed and
used on the cover of this
Design Council publication.
The cover also doubled as
the contents page.

# dott 07

## Designs of the time

**Design Council brochure**
Commissioned by the
London-based Design
Council, this publication was
created to launch a 10-year
initiative to engage designers
and businesses with the
public by focusing attention
on the role design plays in
improving every aspect of our
lives. Powerful typography
coupled with a strong format
make for a clear, concise
publication that is easy both
to navigate and to read.

### Designing the nation

Dott 07 in detail

#1. Public design commissions

'I'd like to redesign…'

Text-heavy books can sometimes seem rather dry and academic. Bibliothèque countered this by devising a flexible grid that allows a controlled level of expression.

# How/to/be/ a/graphic/designer,/ without/ <span>Adrian Shaughnessy</span> losing/your/soul/

Interviews with: Neville Brody, Natalie Hunter, Rudy VanderLans, John Warwicker, Angela Lorenz, Alexander Gelman, Andy Cruz, Kim Hiorthøy, Peter Stemmler, Corey Holms. / Designed by Bibliothèque.

**How to Be a Graphic Designer Without Losing Your Soul cover**
Bibliothèque explain that their brief for this book was "to design an engaging, content-driven, typographically led book, within a limited budget." As this is a reference book, its contents quickly became the basis for the cover design.

**Richard Learoyd cover**
This cover design was driven
by the book's content. Acting
as a visual synopsis, the
book's flatplan was used
for both front and back.

**Richard Learoyd**
This book of photographer
Richard Learoyd's work
presents a cross-section
of his projects. "We used
Japanese binding in order to
eliminate any show-through,
and also to give the book
added weight," comment
the designers.

# Big Active

Big Active is a London-based studio renowned for producing "creative design and commercial art based upon ideas with an accessible, common touch." What makes Big Active unique is its representation of other commercial artists. Big Active includes a number of associate imagemakers—illustrators and photographers—who are represented under the Big Active umbrella. This visual synergy makes for a dynamic and proactive creative environment.

Headed by creative director and founder member Gerard Saint, Big Active is driven by the work of art directors Mat Maitland and Richard Andrews. The studio's graphic approach is particularly focused toward the specialized areas of music, editorial, and book design.

This studio has produced numerous high-profile music campaigns, branding, and packaging for leading UK acts including Goldfrapp, Athlete, Garbage, The Futureheads, Basement Jaxx, Sugababes, and most recently Snow Patrol, Keane, and Boy Kill Boy. Their music work has won much critical acclaim and been featured in many design awards and exhibition events worldwide. The studio's book-design credits include David Bailey's *Chasing Rainbows*; Jocelyn Bain Hogg's photo-documentary on London's gangster underworld, *The Firm*; Deidre O'Callaghan's much-acclaimed *Hide That Can*; and the studio's own *Head, Heart & Hips: The Seductive World of Big Active*, published by Die Gestalten Verlag.

Over the years, Big Active has also gained a solid reputation for distinctive magazine design. Editorial art direction highlights have included tours of duty for fashion magazines including the influential *Scene* and the rebirth of *Nova*, as well as the award-winning redesign of *Viewpoint*, the international journal of design and marketing trends.

These highly collaborative areas of art direction have led Big Active to form close working relationships with many like-minded visual conspirators. This association of interest inspired the formation of Big Active's creative management operation. The current lineup of Big Active commercial artists includes: Jody Barton, David Foldvari, Pete Fowler, Genevieve Gauckler, Kate Gibb, Jasper Goodall, Simon Henwood, Mat Maitland, Parra, Kristian Russell, Shiv, Will Sweeney, Kam Tang, and Vania Zouravliov. The studio also recently launched Product of God, a webspace selling special-edition prints and artwork by its artists.

Big Active declares a straight-up attitude toward visual communication. "If an idea can't be articulated simply and successfully over the phone—it ain't worth a fuck! Our philosophy has always been to produce work that is bold, spirited, and direct—design that makes you look. Life's too short to get side-tracked...."

**Another cover**
This cover for the first issue of *Another* cleverly states the magazine's title by incorporating it into the cover image itself.

# ANOTHER

ISSN 1355-5901

9 771355 590010

Issue 1 £2.80  Supported by Stella Artois Dry

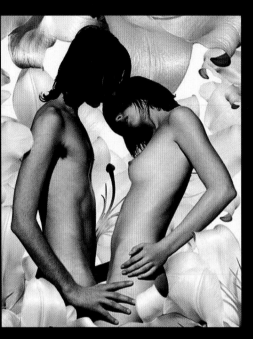

### Head, Heart & Hips

Playing with the theme of seduction and pleasure, *Head, Heart & Hips: The Seductive World of Big Active* explores the sexier fantasies of commercial art and its application. As firm believers in the seductive spirit of collaboration, the creative synergy between Big Active's collaborators and core design team is an essential part of the studio's aesthetic and way of working. The book contains specially commissioned new work and "remixes" by Big Active and its associated collaborators. It is "an alluring and colorful landscape of ideas, styles, and applications."

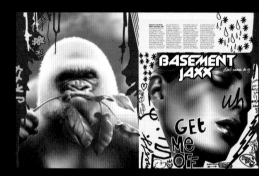

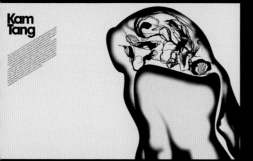

**Kam
Tang**

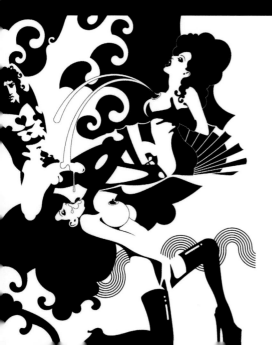

Aphrodite
*Goddess of Love and Passion*

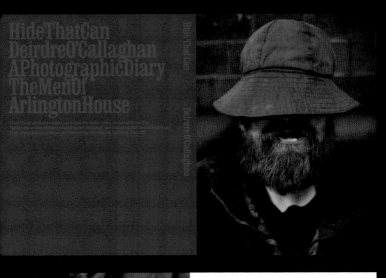

HideThatCan
DeirdreO'Callaghan
APhotographicDiary
TheMenOf
ArlingtonHouse

**Hide That Can**
In this book, photographer
Deirdre O'Callaghan brought
together four years' work at
Arlington House, a refuge in
Camden, London. *Hide That
Can* is her record of the
despair, humor, and hope
on the faces of the refuge's
residents, a gallery of a largely
expatriate community at odds
with the world outside. The
studio explains, "The primary
objective was to afford the
men the humanity and dignity
they deserve, while reflecting
their strong characters. We
set out to give them a voice,
and to bring a positive
viewpoint to a poignant,
hidden existence that is
so often ignored."

"I
came
to
London
looking
for
the
Rolling
Stones"

48-Plate

# HideThatCan
## DeirdreO'Callaghan
### APhotographicDiary
#### TheMenOf
#### ArlingtonHouse

trolle

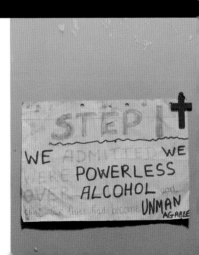

**JOCELYN BAIN HOGG**

## Picturing Gangsters Paul Ryan

DM 120 / FF 450 / Lit 130.000 / £45

# VIEWPOINT:

## #9
## FEAR
## UNCERTAINTY
## &DOUBT

# VIEWPOINT:

DM 120 / FF 450 / Lit 130.000 / £45

### #10

## TheStateOfMan

# VIEWPOINT:

D € 61 / I € 61 / E € 68 / £45

### #11

## Blur
*TheImpactOf*
*SpeedOnConnected*
*Culture*

**Viewpoint relaunch**
A biannual forecast publication with a wide international audience of key creatives, *Viewpoint* takes an inspirational approach to trend reporting. Big Active's creative director Gerard Saint was asked to completely redesign the identity and structure of the magazine, and then to art-direct the subsequent three issues. "A new, original masthead was created as a way of branding the relaunch. To restrain the design theme further we chose to use only one font throughout— Monotype Baskerville."

PACIFIC OCEAN I BY NADAV KANDER

# ZoningOut

Forcefielding was once the preserve of blue chip social ____ wanted to sidestep media and public attention. Now, a____ demanding the same opportunities; to shield ourselves ____ everyday, to benefit from the attentions of personal she____ in private dining clubs, live in gated communities; to re____ and while away precious gilt edged hours in spas, perse____ and self-selected social groups whose membership is o____ one person only; ourselves.

TEXT: Justine Harvey and Andrew Wilson; IMAGES: Jasper Goodall & Big Photography, www.bigpictures.com

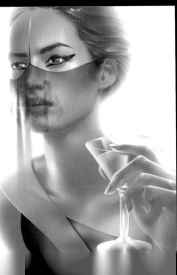

**TRANSLATOR**
Language barriers no longer exist - it's as simple as using necklaces which translates as you speak. The inspired punch of fabric developed by artist Franco Gavin and sound awareness expert Ron Govan, will sense vibrations from the voicebox, and, using Voice Response Translation technology developed by BVT Integrated Voice Technologies, translate to the desired language at the wearer speaks. The potential for vibration technology is enormous, says Ron Govan. "Not just with sound, but feelings and emotions also translated into clothing: the deeper levels you can get hold of in people along with verbal syntax, the better communication can be." source.co.uk / www.vtigroup.com

CONCEPT: Christopher Sanderson
TRANSLATOR: Ron Halverson/blogs.co.uk / Ron Govan/source.co.uk www.gavinchristopherstudio.co.uk

Jester by Erica, shirt by Gustav Burns

One third of Lone Wolves have partners but

A quarter of Lone Wolves hol____

He has average earn____

On-line purcha____

The text on img_4 area and the "KOS OSMOND" block is too small to read fully.

KOS OSMOND
London, United Kingdom. Aged 36.
Girlfriend, actor, variable salary.
*'I seriously get pissed off with the whole 'aspirational' lifestyle advertising that just wants us have to buy cheese polished furniture hotlegs and have a neat looking supermodel bird to replace the spirit stripes, all encapsulated within a 1970's rock movie soundtrack. Clothes are an anoyance because I'm neurotic about them, and I wish it was the other way around. I like things to be just right and they never are so I'm fighting a losing battle.'*

Cars, sports and electronics – the Italian Lone Wolf's Obsession

*Grey wool suit, tank top and shoes by Prada*

Wears labels that are about quality rather than glamour

German Lone Wolf has doubled his income

French Lone Wolf loves to dine out

# TheInformation

The 'lovemark' as hallmark, the death of the 'Values' Generation, smart cars, net publishing, the lightness principle, the male bimbos' wardrobe, solutions for a small country, the beauty register, designer drugs, personality pets, decompression culture, 'experience wells'... It's all here. *Text: Martin Raymond, Justine Harvey & Dene October*

I CLEVER

I ♥ BT

mpressive international clientele, including the Jewish Museum Berlin, a fascinating organization with a vigorous range of cultural, social, and educational activities that go far beyond that of most museums; the Institute of German Resistance, "which has opened our eyes to the bravery of an extraordinary number of German citizens during the Third Reich"; the European Space Agency, "whose achievements are nothing which fuses a postgraduate fine-art degree course, a museum, and a cutting-edge film-producing facility, all within a spectacular piece of architecture; and the UK's Cambridge University Press, which produces some of the most specialist technical texts in the history of publishing.

"We apologize for discussing our clients in preference to our own design approach, but this is how we work," says Mark Diaper. "Introspection doesn't come easily to us. We do not place ourselves at the center of the process; equally, publication design sometimes doesn't seem central to our role in the process. We often move into other territories, editing and publishing several titles, and have set up Laconic Press with a view to making this a permanent feature of our activities. We have managed to stay fascinated; the rest seems to follow."

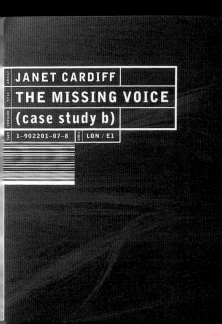

ARTIST
**JANET CARDIFF**
TITLE
**THE MISSING VOICE**
VERSION
**(case study b)**
ISBN
**1-902201-07-8**   AREA **LON / E1**

**The Missing Voice**
Janet Cardiff is an artist specializing in audio walks. Cardiff uses an advanced recording technique called binaural sound, which reproduces 3-D sound in a startlingly convincing way when listened to through

imagined world, blur and merge as you experience the walk. This publication contains the complete compact disc and transcript of *The Missing Voice* and presents the multilayered experience of this audio walk in a montage of images. The

**Artangel publications**

Artangel commissions provide artists with the space and time to realize new work that extends beyond conventional frameworks. Established in 1998, Artangel Publishing provides these projects with a parallel manifestation in the form of books, videos, and CDs. Presented as a series of imaginative monographs, the form of each publication is conceived and realized in close collaboration with the individual artists.

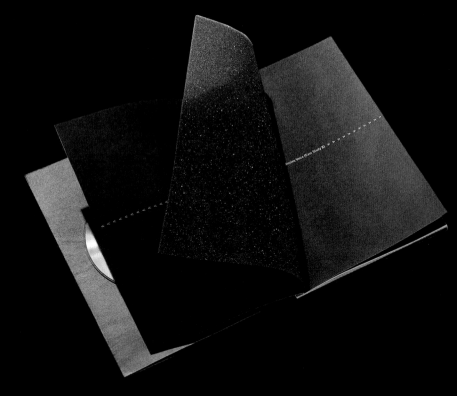

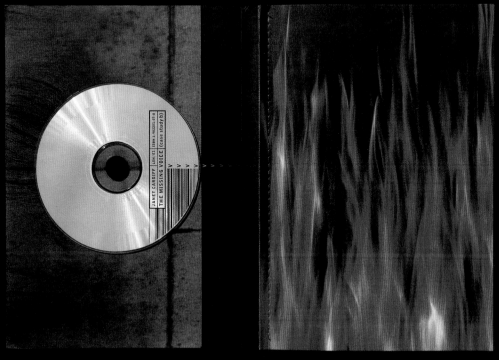

**European Space
Agency typeface manual**
Eggers + Diaper were
commissioned to design
a new typeface for the
European Space Agency.
As circular forms are found
to be stronger than their
rectangular counterparts
when in space, this was
reflected in the letterforms
of the typeface.

**European Space A**
**typeface manual**
Presented in a ring b
this manual contains
the technical informa
the typeface. Shown
the inspiration for the
"a"–a technical draw

**European Space**
**Agency handbook**
For this handbook,
the letter "a" was
silkscreened onto
the reverse of the
front cover.

**Jüdisches Museum Berlin**
The Jewish Museum Berlin is dedicated to the telling of narrative history. The museum contains a vast amount of material concerning all areas of German Jewish history. As a result, the museum's publications, including the newsletter and additional material shown opposite, must succeed in conveying and translating this history to visitors and readers alike, from the exhibition book that accompanies two millennia of German Jewish history to the souvenir book, and the book series about individual themes and objects.

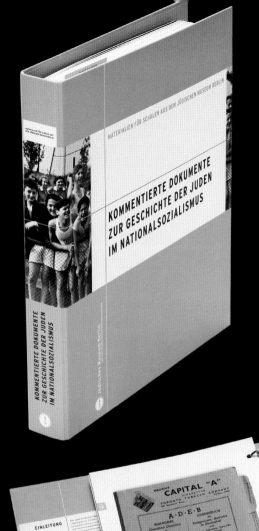

**Jüdisches Museum Berlin, archive material**

Presented in a ring binder, this publication contains a collection of archive material directly related to the Holocaust, including official paperwork from concentration camps, and personal letters that were smuggled out. These binders were sent out to schools across Germany. By reproducing most of these documents at actual size, the designers wanted to emphasize the reality of these events to the students who received them.

### Break Down

Artist Michael Landy collected everything he owned: every piece of furniture, every record, every article of clothing, every book, every gadget, every work of art, even his passport and car. Over 10 days he then destroyed everything—more than 5,000 items—using an industrial disposal (grinding) unit that he installed in a former department store on London's Oxford Street. Eggers + Diaper were commissioned to design the accompanying publication, *Break Down*. Part manual, part inventory, part research file, *Break Down* includes the complete list of his sketches, technical drawings, research documents, possessions, and interviews, as well as a selection of photographs from the actual installations, including a two-foot foldout showing the grinding unit and conveyor belts.

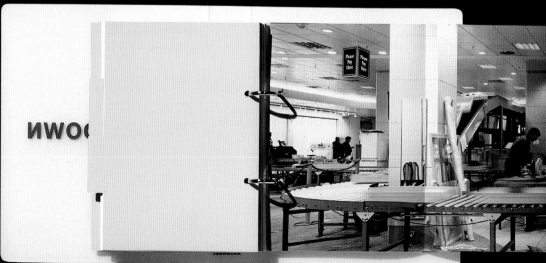

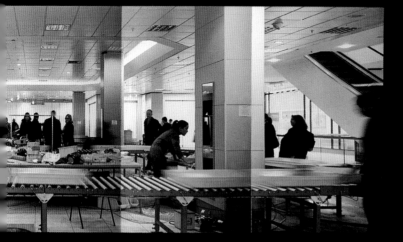

### Witness

Susan Hiller's project, *Witness*, involved the collation of hundreds of firsthand eyewitness accounts of UFO sightings from around the world. Presented as her research file, the publication contains a large selection of original statements, as well as a selection of Hiller's personal notes, sketches, and drawings on the work as it developed. The book also comes with a selection of nearly 50 spoken statements on a CD. The two consistent elements to these sightings were the pulsating light and the shiny metallic object, both of which are reflected in the publication's design. The cover was the most expensive element of this publication, eating up some 80 percent of the entire budget. It was created by sandwiching two sheets of aluminum together with a sheet of plastic. Two lengths of aluminum were then stripped out and the exposed plastic melted to create the malleable spine. The UFO-inspired circular cutout on the front cover exposes the iridescent reverse of the CD stored on the inside cover.

**Rodinsky's Whitechapel**

In 1969, a Jewish language scholar named David Rodinsky mysteriously disappeared from his attic room above a synagogue in London's Whitechapel. The synagogue was closed shortly after. More than a decade later, workers refurbishing the building came across the forgotten attic and discovered a room that had been left in a state of chaos—an unfinished meal on the table, even the imprint of a head on the pillow. Rachel Lichtenstein's *Rodinsky's Whitechapel* connects the story of her quest for Rodinsky with that of her own history (her grandparents immigrated to the Whitechapel area in the 1930s) in a small guidebook, highlighting the vanishing remainders of a once vibrant Jewish community. The book starts with the discovery of Rodinsky's room. The author used clues left in the room to trace his fate. The great mystery was: what happened to him? Did he die, and if so, where and when? Eventually the author established that he died in 1969 and was buried in a pauper's grave in a north London cemetery.

A special binding technique called Otabind™ was used to create a "hidden moment" within the book's design. This style of binding mimics case binding, but the end result is still a paperback. When the book is opened, the bound pages pull away from the spine to reveal the dates of Rodinsky's life (1925–1969), suitably difficult to access.

### Add. 17469: A Little Dust Whispered

This small, intimate book combines blown-up, grainy photographs with notes and text by Rachel Lichtenstein, along with musings from British Library staff, readers, and members of the public. Throughout there are textual disruptions printed in large red type on thin white stock, which function like visual voice-overs, and photographs that reveal the creation process, research notes, and ideas for the book's design. Add. 17469 is a British Library shelf mark.

Add.70931

This is a select manuscript that arrived on my desk boxed in green leather with a gold trim. I carefully opened it up and extracted the travelogue. A librarian wandered past at regular intervals, throwing me a backward glance every now and then. Inside the front cover '£1500' is written in pencil and I wondered if the diary has been bought by the Library in an auction or donated. Every page of the book is covered in shaky handwriting from a thick-nibbed blue ink pen. The writing is orderly but almost impossible to decipher as if it has been deliberately written in code like Leonardo da Vinci's notebooks. I struggled to read it for over an hour, managing only to pick out single words like 'heat', 'drinking', 'Havana', 'prostitutes' and 'beef', the words creating an aura of violence and danger in a distant, exotic location. I wondered if his writing is a reflection of inner turmoil or whether he learnt how to write like this during his time as an MI6 spy. Maybe it's a coded form of personal shorthand to protect his writing from someone like me, trying to read his private, unpublished thoughts. It's something I often think about whilst researching in the manuscripts room. Is it morally right for any reader to be able to leaf through the private journals and diaries of those long dead, who almost certainly never intended for these documents to be made public property? Out of a desire to protect his privacy I have decided to photograph a tiny section of his nearly illegible handwriting which transforms into a series of painterly marks. R.L.

Add.70931

Detail from Graham Greene's diary entitled A Few Final Journeys, recording travels to Panama, Nicaragua, Russia and Spain, and including notes relating to his novel The Captain and the Enemy, 1984–1985. (vol. 13, f. 23, p. 37)

[See opposite]

19

Poem XLIX.
Collected Works,
1937, p 232.

Delightful
All pleasure die?.
O Changing lights
and wavering glory
Adieu vain joy,
Half told your story
To you we die

Add.48210

Through the magnifying glass, the marks on the paper take on their own landscape.

etc., que l'on peut découvrir là, avant de les retrouver dans les lieux consacrés et consacrants qui viennent d'être cités. C'est donc un premier regard qui est proposé au public curieux des tendances nouvelles et du travail des jeunes artistes au seuil de leur carrière, avant toute classification esthétique, critique ou marchande. Le mot "Panorama" indique que le paysage est vaste et varié – le pittoresque pourrait même y apporter sa touche –, et que toute cette richesse est contemplée sereinement à partir d'un point de vue particulier. Effectivement, le panorama des productions annuelles du Fresnoy correspond à un paysage d'où la monotonie est absente. Aux espaces et aux présentations traditionnelles de l'exposition, il a fallu articuler ceux du spectacle vivant, de la performance, du concert, eux-mêmes mitoyens de ceux de la projection cinématographique ou vidéographique. Sur cette effervescence protéiforme, dont le Fresnoy se doit de rendre compte équitablement – avec pour seul critère l'engagement réel de ses créateurs dans un projet et dans une œuvre, quel qu'en soit le langage ou le support –, le point de vue particulier est celui du commissaire qui, chaque année, sera invité à porter un regard "panoramique" sur le paysage, en choisissant son site d'observation. C'est une stratégie du regardeur qui devra permettre au commissaire de transformer un paysage complexe et mouvementé en tableau, sans possibilité d'éliminer ou d'effacer, mais avec cependant la liberté de quelques retouches ou, plus exactement, de quelques touches supplémentaires : deux ou trois artistes extérieurs au Fresnoy pourront être invités à compléter ou à contraster le "panorama". Tout cela dessine un événement à la fois resserré dans le temps (trois semaines), et plein de surprises, de rebondissements, de vifs passages d'un mode de regard à un autre, d'un plaisir à un plaisir différent. Du jour au lendemain, autour d'un noyau stable, "Panorama" aura changé, le "panoramique" continuant de balayer le paysage d'un site à un autre, d'un éclairage à un autre, d'un horaire de jour à un nocturne. Certains se plaindront qu'on ne venant qu'une seule fois ils ne pourront tout voir : bonne raison pour revenir. Mais Le Fresnoy ne peut que revendiquer cette irréductibilité de ce qui s'y produit à un seul espace, à un seul temps, à un seul dispositif comme, aussi, bien des œuvres présentées à "Panorama" résistent à la reproduction satisfaisante dans les pages d'un catalogue. Si le "panorama" désigne le point de vue d'un observateur qui s'est donné du recul, il renvoie le voyageur curieux d'aller y voir de plus près à un véritable déplacement, à la fois physique et intellectuel, où le sentiment du confort cède la place, avantageusement, à celui de l'aventure. **Alain Fleischer, Directeur du Fresnoy, Studio national des arts contemporains**

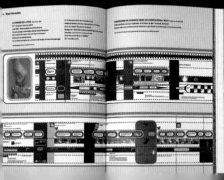

TONY OURSLER THE INFLUENCE MACHINE

TONY OURSLER THE INFLUENCE MACHINE

### Spoon

This book showcases the work of 100 innovative 3-D and industrial designers. The publishers, Phaidon, had come up with the title "Spoon" and wanted an "innovative, 3-D design" to accompany it.

Eggers + Diaper's proposal struck midway between the form of a catalog and that of a spoon. Although the idea was striking, bringing the design to fruition was not easy. In the end, wooden tooling (which is much cheaper than metal) was used to produce the polymer-coated, stainless-steel cover, challenging the assumption that such jobs have to be done using metal. The steel cover was then coated with a very thin layer of plastic to protect it from surface scratching and fingerprints. The designers also had to ensure the use of a suitable paper stock; one that would fall into the shape of the book's cover successfully.

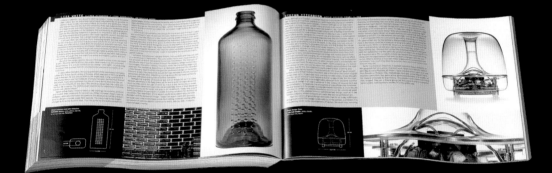

### Le Cadeau

For this project, Jochen Gerz invited everyone who lived around the Le Fresnoy art center in France to be photographed. As a means of integrating the community, each participant was then given a portrait of someone else. These portraits make up *Le Cadeau* (The Gift), a visual directory of the local community, featuring face after face of close-up portrait shots. The images speak for themselves and required very little "designing."

# Frost Design

When it comes to publication design, a lot of studios tend to specialize in one area, whether that is corporate work, such as annual reports, or consumer editorial and book design, or magazines. Not so Frost Design. In a career spanning more than 10 years, Vince Frost has amassed a vast portfolio that incorporates every type of publication design imaginable, including annual reports, cultural programs, books, consumer and trade magazines, interactive design, and environmental graphics. "Whenever I sit down with a brief, ideas begin to formulate immediately—it can be a typeface, a color, even just an image in my mind. The trick is translating those ideas into a physical reality," says Frost.

Frost's innovative use of photography and striking typography have been applied to a variety of work, including the award-winning literary magazine *Zembla*, stamps for the Royal Mail, and setting up the look of the *Financial Times*' *The Business* magazine. His award-winning work on both *Big* magazine and *The Independent Magazine* consolidated his credentials as an editorial designer, earning him considerable praise from the international design press and early international awards. In 1996, he was awarded Designer of the Year at the Chartered Society of Designers and shortlisted for the BBC design awards.

Previously based in London, Frost relocated to Sydney, Australia in 2003, from where Frost Design's 26-strong studio now operates. Frost continues to work for a range of international clients, including New York-based Rizzoli Books, D&AD in London, and Swiss Re: in Zurich. The studio has added a number of Australian clients to its portfolio, such as the Sydney Dance Company, Macquarie Bank, and *Australian Creative* magazine, for which Frost is now creative director.

Frost's longstanding passion for magazine design has never faltered, but with so many projects on the go at any one time, he simply doesn't have the luxury of time that many in-house magazine designers do. It's a very quick turnaround, and designing an issue of *Zembla* or *Australian Creative* in five days is perfectly normal at Frost Design.

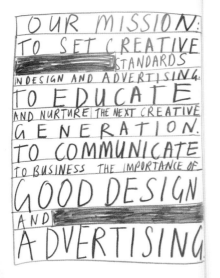

OUR MISSION:
TO SET CREATIVE STANDARDS
IN DESIGN AND ADVERTISING.
TO EDUCATE
AND NURTURE THE NEXT CREATIVE
GENERATION.
TO COMMUNICATE
TO BUSINESS THE IMPORTANCE OF
GOOD DESIGN
AND
ADVERTISING.

D&AD PENCIL
Only the best work gets into D&AD. The best of the best is awarded a Yellow pencil, voted the pride of gold simply to indicate work that breaks new ground and is deemed to make work itself the best of the best.

6

7

## COMING&GOING
COMPETITION by Simon Finch, Publisher

strapline, "Fun With
epitomized through

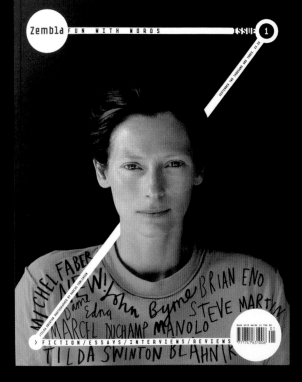

*Zembla* **cover**

For the cover of issue #1, which featured the British actress Tilda Swinton, Frost replaced the writing on her T-shirt with the magazine's contents. Rather than run the masthead along the top of the magazine, as is the norm in magazine design, the letter "Z" forms Zembla's masthead and identity, and spans the entire front cover.

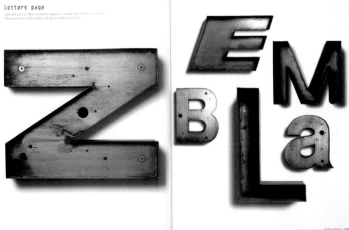

*Zembla* **letters page**

Using "found" typography for the magazine's inaugural letters page gave the magazine a distinctive, bespoke feel from the start (and filled what would otherwise have been an empty page, as this was the first issue!).

**Super Cheap Auto
annual report**
Rather than producing a
"designed" annual report for
Super Cheap Auto, Frost
decided to replicate the
company's confident, brash
identity and create a report
that looked as though it
could have been made by
the staff themselves. This
was achieved by adopting
the company's own visual
vernacular throughout. The
imagery used was the result
of a "Super Cheap shoot,"
shot with a digital camera
at the local store. Frost has
been inundated with requests
for copies of this report from
designers around the world.

**Right: Packaged annual
report**
The finished 2004 report was
presented in typical Super
Cheap Auto packaging.

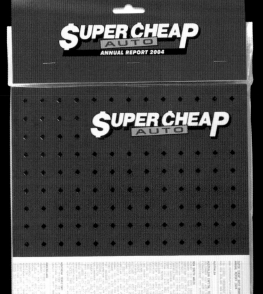

**Bottom, left: Andy spread**
A closeup of one of the
company's products, the
Handy Can, crops the label
to read "Andy Can," and this
is placed next to his portrait.

**Below: Financial
statements**
Frost juxtaposed closeups of
Super Cheap Auto's product
packaging with the report's
content throughout. Here, the
company logo—a dollar sign—
becomes the opener to the
financial section, which was
printed on receipt paper.

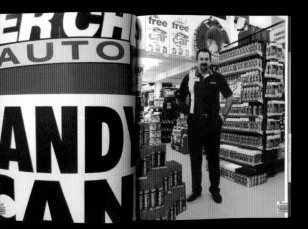

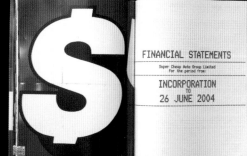

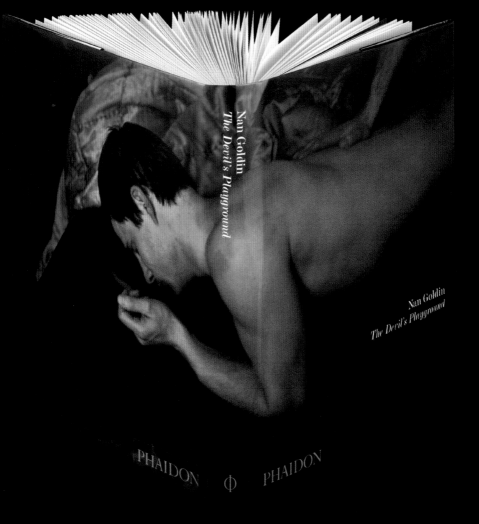

**The Devil's Playground**
As *The Devil's Playground*
was the first major collection
of photographs by renowned
photographer Nan Goldin
to be published since 1996,
Frost was asked to find a
definitive image for the cover.
Many changes were made to

## Australian Creative magazine

Frost was invited to become creative director of *Australian Creative* magazine in 2005. He began with a complete redesign, including the name. As the magazine's name appears in its entirety on the first page of the magazine, Frost came up with the bold idea of shortening it to "Creative" for the cover. The use of stencil for the masthead captures the rawness of the creative process at its most fundamental, while the strikethrough represents its infinity. Frost, along with Anthony Donovan, who became the magazine's art director, also implemented the idea that each issue would feature a lead interview whose subject would appear, in their own environment, on the cover. Working closely with the magazine's editor, the design team are now also actively involved in the editorial process. They are often given the freedom to come up with titles that evolve as a result of the design process.

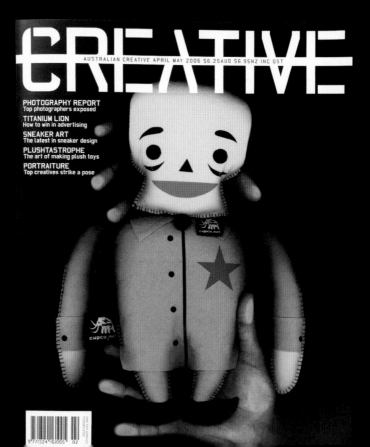

AUSTRALIAN CREATIVE APRIL MAY 2006 $6.25AUD $6.95NZ INC GST

**PHOTOGRAPHY REPORT**
Top photographers exposed

**TITANIUM LION**
How to win in advertising

**SNEAKER ART**
The latest in sneaker design

**PLUSHTASTROPHE**
The art of making plush toys

**PORTRAITURE**
Top creatives strike a pose

Fourth Estate NEW TITLES JULY - DECEMBER 1998

**Above: Fourth Estate
swatch book**
A book catalog designed for
Fourth Estate uses paper, the
material books are made of,
to create a "book swatch."

# John Morgan Studio

Founded in 2000, John Morgan Studio is a London-based graphic design studio "steeped in the tradition of design as a means of enhancing, illuminating, but never overwhelming the message or the content." For Morgan, and his collaborator Michael Evidon, the earlier the designer can be included in a project, the better. "Being involved right from the beginning—the conception stage, determining the format and structure of a book is always beneficial," he says. "It is increasingly common these days not to meet the author at all, to just be handed the text and the images. In fact, in some publishers' minds, the designer should be kept as far away from the author as possible, but you get a much better book, I think, the more involved you are with it."

Morgan also refuses to follow any form of house style in his work, preferring instead to start each project from scratch.

The studio's broad client list reflects this approach, with recent works ranging from a new prayer book for the Church of England to the redesign of *AMBIT* (the "foremost organ of the Lucid Orgasm Party") magazine. "It's not a conscious thing—it's not that we produce work that is unfashionable; we just aim for a longer shelf life," Morgan says of his apparent status as a "modern traditionalist."

This approach also enables the studio to work with a variety of collaborators—from designers and photographers to artists, writers, and illustrators. "The key to each of the projects shown here is that they are quite small-format, user-friendly designs that sit comfortably in the hand. You also get a real sense of materials with each one. For me, books are as much about materials and the way they sit in the hand as they are about content," comments Morgan.

# Prospectus for the Invisible University correct at 07.00, 19th June 2006, 35 Clerkenwell Road London EC1

Imagine yourself with a lap-top on a lawn by a shed, the screen is your tutor, the lawn is your classroom and the shed your university.

EXP Research into the architecture of the culture of smaller and faster.

## Invisible University prospectus

This prospectus for the Invisible University was produced in newspaper format for a number of reasons—principally because it could be produced very quickly (it took only two minutes to print 2,000 copies) and economically. The final prospectus was distributed from traditional newspaper racks in Clerkenwell, London, and its throwaway, ephemeral nature was perfectly suited to this format. The copy on the front cover was handwritten by David Green, one of the university's founders.

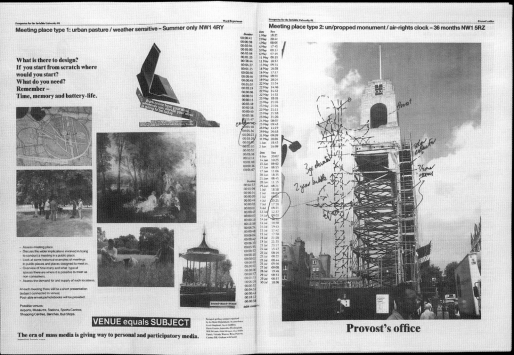

**Invisible University prospectus spreads**

Each department of the university was allocated a spread within the prospectus. Morgan also tried to incorporate some of the language and style associated with the newspaper format, such as using the fonts Times and Helvetica. "It was a good excuse to use Times, which looks great at these sorts of sizes," he comments.

**Meeting place type 4: lost ideas office – 29.12.04: Forest Row, East Sussex**
**06.06.06 Brisbane, Australia**

I.U. Caretaker
照顾者的

The Caretaker should take care of everything - people, things, places and ideas.
管理员 应当去照管一切，包括人、物、地方与观念。

The care of lost, stolen or misused ideas is a particular responsibility of the Caretaker.
照护丢失、被盗用或被滥用的观念是管理员的特殊责任。

The Caretaker must collect up all lost ideas and maintain a lost ideas office.
管理员必须收集所有丢失的观念，同时管理维护一个失物招领办公室。

Making a mess in the I.U. will be positively encouraged and rewarded.
在 IU 里，制造混乱将得到积极的鼓励和奖励。

The Caretaker should dispose of excesses of information before someone thinks it might be useful.
管理员在有人想到可能有用之前，应该将过量的信息处理掉。

The Caretaker is required to maintain a tool shed full of equipment for coping with too much information, subduing excessively loud drawings, de-rendering (not make things become into a state?) computer images, a sump pump to drain off excess information.
管理员需要维护一个工具棚，里面装满了各种工具，用于应对过多的信息、抑制过于喧闹的图纸、对电脑图像进行去渲染、以及抽取多余信息的水泵。

The tools will be more powerful than we can yet imagine, concentrating on assisting with comprehensive thinking rather than specialist tasks. Some will be extensions of our minds and fundamentally change the limits of our thinking and imagination. Most of them will take the form of extended (phenotypes and set us as turbochargers to the brain by compressing future space and time – a form of accelerated evolution.
这些工具的威力比我们想象的还要强大，它们主要聚焦于辅助全面综合的思考，而非专业化的任务。其中的一些将会是我们思维的延伸，并从根本上改变我们思考和想象力的极限。大部分将采取延展表型的形式，像涡轮增压器一样，通过压缩未来的时空，把我们设置为大脑的加速器——这是一种加速演化的方式。

The motto of the Caretaker shall be - TAKE CARE
管理员的口号是：请当心。

JHF 2005 SH/DG Nov05

**The shortage of more**

2004/02/25

Dear Professor Green,

I have read your advertisement for the I.U. with interest and wish to apply for the post of Caretaker. I enclose a project description. (I know of a job description, a project description - I hope I'm an appetiser + 2 diagrams).

Trusting that I can be of service to your esteemed institution.

Yours truly,

John Frazer

# The motto of the Caretaker shall be
## 管理员的口号是

# take
# care
## 请当心

## Position Description: Distance 7 (IU 1366-001)

**Ginogriffiths Architects**

18 lectures
12 exhibitions
22382 miles of road
134 suburban housecalls
2593 photographs
178 days

Adjunct professor will teach Distance 7 (IU 1366-001) for the Invisible University during Fall and Spring semester. This course explores the applied principles of transitional exchange in developing a design process by combining the experience of distance with new development in the making of space. These issues are investigated collaboratively and individually in a project with a specific and predominant use, within clearly defined contexts, and in connection to a mass of prevalent public spaces. Classes will meet on Mondays, Wednesdays and Fridays, L. A. Wu. N campus from 6:00-9:10pm.

# Hope

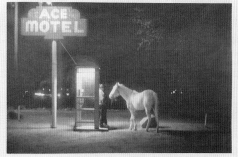

**Duration:** At IU members are enrolled without exception, in perpetuity from the moment of conception. Members are known throughout not as students but as Seers. For their Duration, members are considered to be Amateurs until such time as they think of themselves as professionals.

**Extelligence:** Membership then lapses until the age of retirement when they are reinstated as Amateurs again. At the onset of death their work is entrusted to the Department of Extelligence. It is here that the Reader Emeritus of Thaumatography, Andrew Holmes, acts as Unco-ordinator of Studies.

**Infinite Patience:** The only requirements of a full time Seer are infinite patience, an excitable mind imperfectly disciplined by education, a willingness to be exposed to enthusiasm and a belief that we are all looking to a bright new future.

**Department of Thaumatography** was founded in 1929 by Ernest Dudley Chase who produced the first true thaumatograph, an encyclopedic compendium of superlatives describing a broad range of cultural and natural wonders, depicting these phenomena on the Mercator projection.

**Walter Hope:** On August 9, 1888 Ed Cross and Shorty Harris discovered unusually high levels of thaumantle in the Bullfrog Hills. The men founded the town of Hope close to the gushing spring on land settled by Walter Hope, a Squamos searching for a cache buried by the Jayhawkers in 1849.

**Mr Crump Don't Like It:** AC Crump, aka Ace, a hunter of extraordinary ability arrived in Hope in 1927, having left Memphis under something of a cloud. The occasion being recalled by Frank Sinkes in his hit 'Mr Crump Don't Like It'. Ace was the right man in the right time in the right place.

**Crump's Vision:** Crump's vision was to create a Beacon of Light in Hope for visiting Seers. The Beacon still remains prominent at the entrance to Ace's original dwelling. It is said that a Seer standing in the aura of the Beacon perceives a whole horse, a thaumatrope, travelling through time.

**Limning:** Thus it was that Ace chanced upon the combination of thaumantle and limning that we now call thaumatography. To accommodate the increasing number of visitors to Hope he designed and built the motel that bears his name, the first of many structures that comprise the Department of Thaumatography.

### In The Dark

In this book, British film director Mike Figgis explores his approach to cinema. "Essentially, the book was about how to show film in a book and the different ways of doing that," says Morgan, "so we made the book in the spirit of the Figgis' films—the designer is invisible, his job being to record and register, but not influence the author or subject."

In a stylish apartment we see a WOMAN called SOPHIE with a CLIENT.

This could be in another room in the hotel, or in an apartment near the hotel. (to be decided later).

We join them at the last moment of truly strange sex. Something that not even a t-cell's wildest dreams had dreamt up as a possibility (suggestions welcome). The CLIENT pays her a very large amount of money. Her mobile phone rings and she hates it, as... from...

ON CAMERA 3 (bottom left of screen)

THE MAGIC GANGSTER. He's handsome, it's a little psycho. He's a gangster ... .. selected the investor.

MAGIC phones SOPHIE ... the actors have sex just ... but she tells the ..., film an associate. He wants to meet her once, he comes to have rough sex and he wants her to be wearing a RED DRESS. They agree a price, he doesn't agree a bed ...

SOPHIE quickly changed from her black dress to an identical RED VERSION. She gives him the name of the hotel and says she will meet him in the lobby in, say, 10 minutes. She doesn't want him to come straight to the room because the hotel manager is so or her being an expensive hooker. Meanwhile...

ON CAMERA 4 (bottom right of screen)

A PERIOD FILM is being shot. Very intense Shakespearian dialogue, actors in period costume but with contemporary elements combining with the old beauty of Venice. TRENT is directing! he's good, a bastard but good. The producer, JONATHAN is something. He has a huge crush on the actress, NAOMI. The scene is intense and seems to be about jealousy and betrayal.

TRENT is very arrogant and each time JONATHAN suggests something he dismisses it cruelly. NAOMI always sides with TRENT, we feel a bit sorry for JONATHAN; he is always the underdog, the sucker. Afterwards the dukes make their way back to the hotel.



OK - that's how the characters introduce themselves. What happens next is, roughly speaking, this...

MAGIC enters the hotel by a back door.

then MAGIC appears and almost TRENT several times.

*We never really find out why TRENT is shot!*

MAGIC then heads for the lobby where he spots GRETA waiting for the BUSINESSMAN. A familiar natural mistake causes as he picks her up in RED DRESS awaits and suggests they go directly to her room...

SOPHIE waits in the lobby and is spotted by the REAL BUSINESSMAN as the woman in the RED DRESS. They both make the same mistake and end up in her room where she proposes to pimp him the time of his life, as per MAGIC's request...

As the scene is ending:

MAGIC gives GRETA a lot of money.
SOPHIE demands the same amount from the BUSINESSMAN.
NAOMI finally discovers TRENT on the floor. Unable to speak Italian she goes in search of JONATHAN, he comforts her and in their grief there is a moment of tenderness and perhaps some love.

TRENT speaks to us in voice over and we learn that although he appears to be shot or lies dead, in fact he can hear and see perfectly well - he just can't move any part of his body.


Treatment for the scene (where the Director (TRENT) gets shot.

The book was allowed to
design itself. Figgis' colored
scripts and notebook pages
were reproduced in their
original form, and any

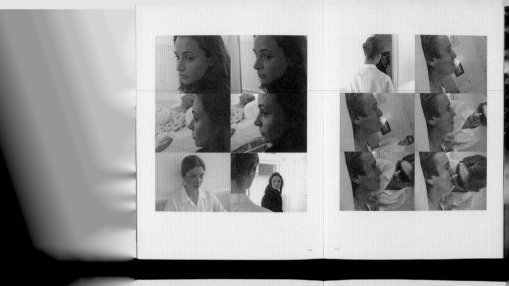

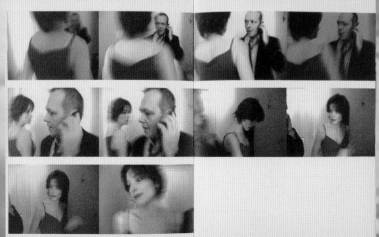

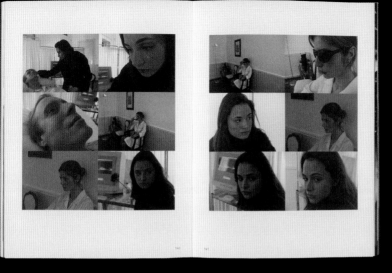

***In The Dark* images**
Figgis produced contact
sheets on his ink-jet printer
and, after numerous trials of
papers and output settings,
these became the originals
ready for high-end scanning.
The postproduction route of
producing higher-resolution
images would have been
expensive. Besides, the ink-
rich Epson prints offered the
own quality.

**Church of England prayer book**

Designing prayer books for the Church of England was a project Morgan began while working with the renowned graphic designer Derek Birdsall, before taking it on by himself. The nature of the production process was one of the most interesting aspects of this project, largely due to the number of people involved. With so many committees and commissions needing to approve the designs, it was exhausting.

## Church of England prayer book text

For this version, Morgan introduced vertical red lines to differentiate between optional and mandatory text. This had previously been distinguished by indents, which were lost over page turns.

## Church of England prayer book

Spanning more than 900 pages, this gilt-edged, leather-bonded prayer book is the perfect weight and size.

**Right: *AMBIT* magazine mastheads**
The magazine is a user-friendly, easy-to-hold size. It is also jacketed and predominantly black-and-white, making it economical to produce. This image shows a series of the magazine's mastheads prior to Morgan's redesign.

**Right: *AMBIT* magazine redesign**
Set up in the late 1950s by Martin Beck, a London pediatrician, *AMBIT* magazine is a combination of poetry, fiction, and art, "sometimes shocking, sometimes erotic, sometimes comic, always compelling." It is a nonprofit magazine, now sponsored by Arts England. Morgan was responsible for the recent redesign of the publication. To distinguish between the different types of content, prose is set in serif and justified to give it a bookish feel, while poetry is ranged left and set in sans serif. Here, the magazine's outside back cover doubles as its contents page.

CI ALIS    from $3.75
XANA X
VI AG RA   from $3.33
V ALIUM    from $1.21

www.morganstudio.co.uk

|  | Am | from |
|---|---|---|
|  | So |  |
|  | VIA |  |
|  | CIA | $2 |
|  | VA | $1 |
|  | Xan | $3 |
|  | bie | $3 |
| VIragra - $3.3 | ma | $1 |
| Lemvitra - $3.3 | GR | $1 |
| Cimalis - $3.7 | LIS | ,89 |
| Imiutrex - $16.4 | LIU | ,12 |
| Flohmax - $2.2 | ax | ,75 |
| Ultlram - $0.78 | n | ,75 |
| Viloxx - $4.75 |  | ,21 |
| Amsbien - $2.2 | A | ,42 |
| Valirum - $0.97 |  |  |
| Xabnax - $1.09 | M |  |
| Somea - $3 |  |  |
| Mereidia - $2.2 |  |  |

**AMBIT spoof ads**
In this issue, the design team
were given four pages "to
play with"; they placed spoof
Viagra ads, inspired by the
junk emails that regularly
appear in our inboxes.

Experiments
in Architecture

Edited by Samantha Hardingham

Experiments in Architecture — Edited by Samantha Hardingham (repeated cover tiles)

Excerpts from the script for
THE WORLD'S LAST HARDWARE EVENT – 1970
A four-screen multimedia presentation

Imagine a landscape and imagine these people
sitting there – they are in a bottery. The bottery
is part of the idea of space park earth.

DEFINITION:

A BOTTERY IS A FULLY
SERVICED NATURAL
LANDSCAPE.

THE
BOT:

MACHINE-
TRANSIENT
IN
THE
LANDSCAPE.

a bush or could be seen as a service point, eliminating the
building and it's just lying about, no fuss, no landscape, like
the group in the landscape, there are no grids and no mega
structures, it's just waiting to be used.

This could be a servicing frame in a field, waiting to be used
or built upon, very concentrated, the nearest thing to a village
or town or building that should be allowed. These marks on the
ground are the building or traces of the invisible university. They
mark out the territory … they could be seen as catalysts for
the symbiosis. We obviously need hardware at the moment but
we confine its uses by pre-electric lifestyles and constraints.

This picture might have something to do with what it
could be, how the development of electronics could displace
the building.

(Running time for complete script – 35 minutes).

**Experiments in
Architecture**
Unlike most architecture
books, which tend to be very
weighty tomes, *Experiments
in Architecture* is a handheld,
pocket-size book. Short
stories, letters, and notes
written by architects, artists,
educationalists, design tutors,
clients, makers, and
developers have been put
together here to illustrate
how, by asking more
questions than is often
deemed necessary or
appropriate, extraordinary,
unpredictable, and arguably
better work can be created.

1

**David Greene**

**Notes
from
the
Institute
of
Electrical
Anthro-
pology**

2

**Cedric Price**

**GOOD
NUTS**

*Growing the Vines*
September–November 2004

### *Chatham Vines* production

For this project, Morgan also controlled the production. "Increasingly, publishers have in-house production departments, so for some books we control production, and others we don't. I think you get a much nicer book when you do control the production," says Morgan.

# Paprika

Paprika, a graphic design and strategic communications studio based in Virginia, US, specializes in business communications services. From designing corporate brochures to annual reports to catalogs, publication design is a core part of Paprika's portfolio and central to its ongoing mission to meet the needs of today's business community. "At Paprika, we set our sights on satisfying clients' needs from the broadest possible perspective, working to standards that continually raise the bar in our industry," the studio explains. Since opening its doors in 1991, Paprika has been making its mark by helping businesses to "maximize their image while perfecting their images," winning more than 300 national and international design awards along the way.

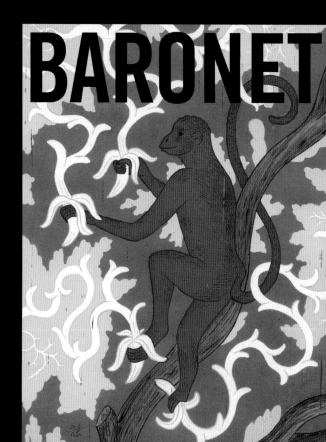

CE NOUVEAU

**THIS EDITION**

**Baronet catalog**
In 2005, Paprika was asked to produce a catalog for Baronet, a high-end furniture manufacturer known for its superb craftsmanship and distinctive design. Intended for both consumers and retailers, the catalog had to include all Baronet furniture collections and technical specifications for every piece of furniture, along with as much additional information as possible. The resulting design is based around the idea of 2005 being the Year of the Monkey. Working to this theme, Brian Cronin created the cover illustration. Inside, a combination of location-based imagery and product shots shows every aspect of every collection. A separate booklet focusing on wood, craftsmanship, and various "how-tos" was designed as an insert to further promote Baronet's reputation as the leader in its field.

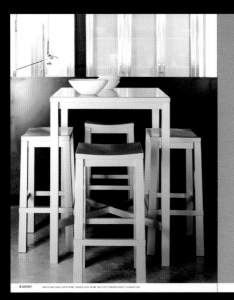

**DENVER**12
COLLECTION AUX LIGNES ÉPURÉES DIGNE DES GRANDS CLASSIQUES NORD-AMÉRICAINS. THESE OCCASIONAL AND DINING TABLES ARE AMERICAN CLASSICS, WITH CROSSBARS, LATTICEWORK TOPS AND SLATTED SEATS.

BOULEVARD45

SOHO40
ADAPTÉS À MERVEILLE À LA VIE URBAINE, CES MEUBLES EN ÉRABLE MASSIF AVEC PLATEAU EN FRÊNE ET PARÉS DE POIGNÉES EN ACIER SATINÉ SONT À LA FOIS ÉLÉGANTS ET SOBRES. AN ELEGANTLY UNDERSTATED FURNITURE DESIGN IDEALLY SCALED FOR URBAN LIVING. ASH TOP AND MAPLE CABINET BODY WITH SATIN FINISHED HANDLES.

## National Film Board annual report

Like most government agencies, the UK National Film Board (NFB) works within tight budgetary constraints. Even so, Paprika was confident in its ability to produce an annual report equal to the NFB's world-renowned reputation for creativity in the film and animation industry. The look and format were completely revised, transforming a black-and-white, 120-page tumble-file book into a perfect-bound, 248-page visual treat in a format half its previous size. The publication featured a hot-stamped, two-color cover and seven different types of paper stock that delivered the impact of full color, even though no section was printed in more than one color. "Our breakthrough approach was to make a common visual section in the middle half of the book, which meant we didn't have to repeat the visuals," comment the designers. This highly refined design ensures the information is carefully organized, enabling the reader to simply turn the book around to continue reading in an uninterrupted flow.

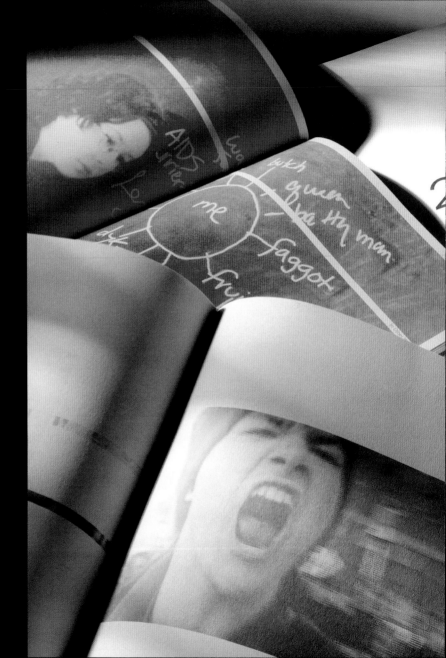

193

diffusions au Canada

SOLITUDE  LONELINESS

The Tree that Remembers

DOUTE  DOUBT

## National Film Board of Canada annual report

This annual report was divided into three distinctive documents: a 288-page report of activities, a 288-page display of National Film Board (NFB)/Office National du Film du Canada (ONF) productions and coproductions, and a DVD presentation of the organization. These three pieces were then united in a single sleeve. Paprika's design solution to the requirement of publishing in both French and English involved creating bilingual sections with a common visual element. This enabled more productions to be featured.

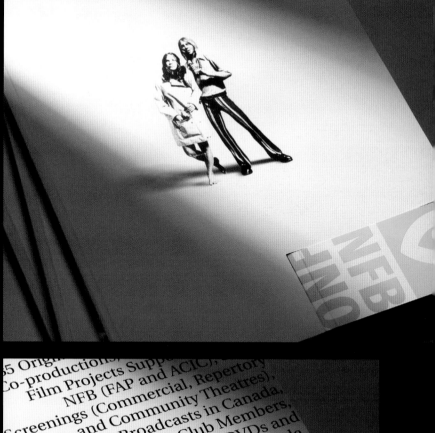

## NFB Canada annual report

The following year, Paprika was asked to find a cost-effective design solution that would enable NFB's annual report to double up as a promotional brochure for NFB productions. The answer lay in an annual report in which all the corporate information is presented in a standard 8½ x 11in (21.5 x 28cm) black-and-white document. This report was then die-cut to receive another brochure where all the NFB productions and coproductions are presented in color. "The concept was developed around the promotional signature, so we carefully selected the images, looking for 'looks and glances,'" explain the designers. The design of the report meant that the mini promotional brochure could be either glued to the report or distributed separately, purely as a promotional tool.

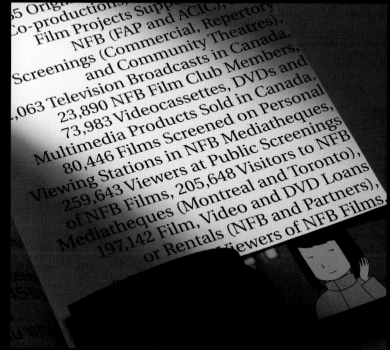

## Transcontinental Litho Acme calendar

There was a lot of history in the making when printing company Transcontinental Litho Acme gave Paprika the go-ahead to design a calendar. Creative director Louis Gagnon and art director René Clément immediately went to work churning out ideas like there was no tomorrow, and given that the project called for 12 different themes, each with 29 to 31 visual executions, tomorrows were in short supply. The result was a 366-page publication that really pushed the design and photographic envelope. Gagnon and Clément searched extensively for examples of the roles numbers play in everyday life: in the subway, on television, on the shelf, and in Mother Nature, as she displays her bounty in August and her relentless harvesting on tombstones in November…

SAINT-VALENTIN VALENTINE'S DAY

DIMANCHE LUNDI MARDI MERCREDI JEUDI **VENDREDI** SAMEDI
01 02 03 04 05 06 07 | 08 09 10 11 12 **13** 14 | 15 16 17 18 19 20 21 | 22 23 24 25 26 27 28 | 29
JANVIER **FÉVRIER** MARS AVRIL MAI JUIN JUILLET AOÛT SEPTEMBRE OCTOBRE NOVEMBRE DÉCEMBRE

SUNDAY MONDAY TUESDAY WEDNESDAY THURSDAY FRIDAY **SATURDAY**
01 02 03 04 05 06 07 | 08 09 10 11 12 13 **14** | 15 16 17 18 19 20 21 | 22 23 24 25 26 27 28 | 29
JANUARY **FEBRUARY** MARCH APRIL MAY JUNE JULY AUGUST SEPTEMBER OCTOBER NOVEMBER DECEMBER

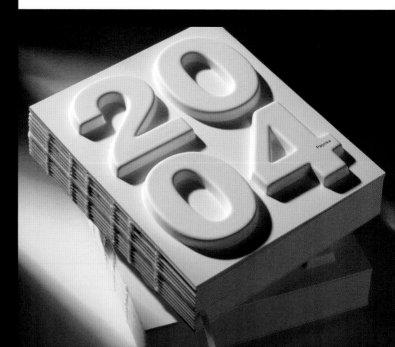

## Christmas placemats

Paprika was approached by Transcontinental Litho Acme to create a unique piece to be distributed as Christmas gifts to clients, suppliers, artists, and friends of both firms. The main challenge was to impress and please as well as promote the expertise of both companies in their fields of excellence: design and printing. Paprika created a book containing an exclusive series of eight paper mats.

***Bori,* Edgar Bori CD**
Designing a successful CD booklet presents a special challenge to the publication designer. Working to a predefined size and shape, and often incorporating a large amount of text, the designer must work within these boundaries to come up with a challenging and innovative creation, as seen here on this Edgar Bori CD. The front of the booklet doubles as the CD cover, necessitating a strong, distinctive, and attention-grabbing design.

**Périphère catalog**
Paprika was asked to design the new catalog for high-end furniture maker Périphère. The idea was to use graphic communications tools to convey a fundamental idea— make it beautiful. The designers comment, "Our goals were numerous: to establish Périphère as the hallmark of design and beauty, to create emotional and visual impact, to convey a sense of the group's ideas and style, to offer a tantalizing hint of the collection, and, finally, to highlight the group's innovative capabilities."

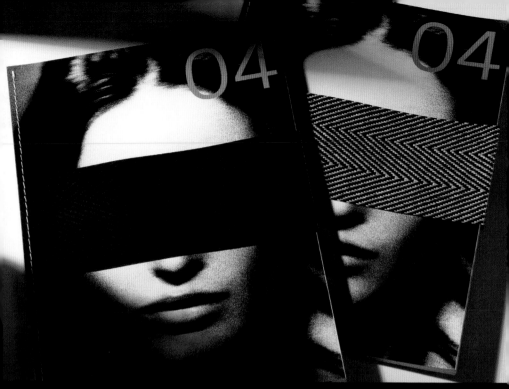

**Périphère brochure**

This second brochure for
Périphère was created to
reach mostly American and
European clients. The big
issue here was truth and
harmony. The main idea was
to produce a special effect
by juxtaposing the beauty of
very modern furniture made
from steel and fabric with the
almost untouched nature
of one of North America's
most beautiful spots. (The
cover was shot in the Eastern
Townships in Quebec,
Canada.) "To reach our goal,
we mixed location shots of
the furniture, model pictures,
and infographic effects," the
designers explain. To
emphasize the high quality
and originality of the products,
the catalog was printed
on folded pages and used
artisanal stitch binding with
linen. Readers have to break
the seal (a paper ribbon)
to open the brochure and

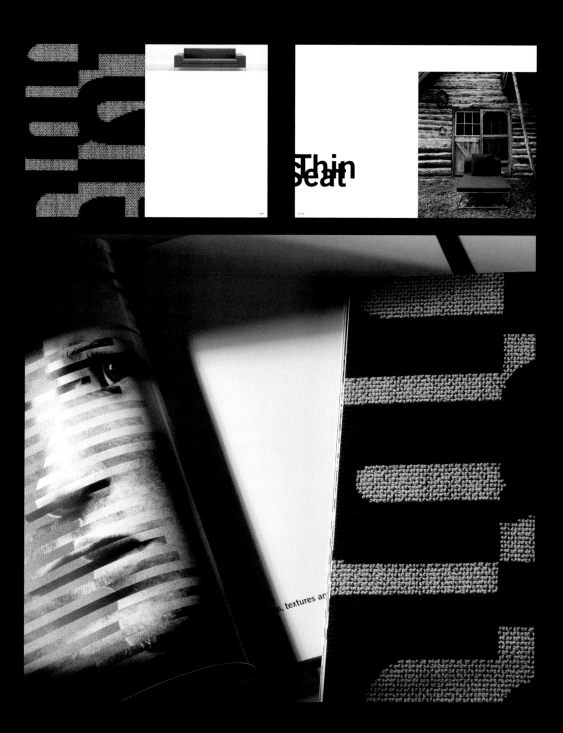

Thin
Seat

s, textures an

**Tella brochure**

Paprika was asked to produce a series of communication tools to establish the brand Tella in the high-end furniture industry. Tella has a very strong reputation among designers and architects, and the first print job was a corporate brochure to promote the company as one of the most exclusive tailor-made furniture-makers in North America. Instead of a regular corporate brochure, Paprika opted for a booklet. "We wanted to inspire rather than just present actual realizations of the company. We wanted people to trust Tella and consider this unique company as a collaborator in the development of their own projects."

TRADITION

"OUR FURNITURE IS DESIGNED BY THE MOST TALENTED AND DEMANDING PEOPLE IN THE WORLD OUR CUSTOMERS."

Eric Perlinger
President

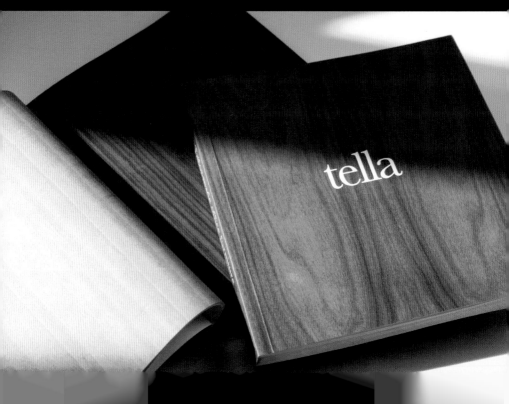

tella

*Tailor-made*
*office*
*furniture*

**WE BEGIN** with a perspective that is completely different. First of all, we're not furniture
manufacturers or even custom furniture manufacturers per se. We're architectural
woodworkers who just happen to make office furniture. Like a fine bespoke tailor,
we lovingly translate your corporate image into precious wood, down to the finest
detail. And we control every step of the process to make sure that what you get in wood
exactly matches what you had in mind.

NATURAL BEECH EXECUTIVE DESK

CORAL ANIGRE CONFERENCE TABLE WITH SOLID CHERRY EDGE

# Research Studios

Neville Brody opened the first Research Studios in London in 1994 together with his business partner, Fwa Richards. Since then, many designers have worked at the London studio, both on a temporary and a full-time basis, while some have gone on to establish other studios in the Research Network. In 2001, Lionel Massias opened Research Studios Paris. In 2002, Jason Bailey and Daniel Borck, formerly senior designers at the London studio, moved to Germany and opened Research Studios Berlin.

What differentiates Research Studios from other design studios is its approach. The small core team that makes up the Network's infrastructure brings with it some of the best creative visual communications experience in the business. "Exploratory development is at the heart of our being, and the award-winning communication languages that we create are vital, challenging, and evolutionary," the studio comments. Research Studios has been highly influential in the visual communications industry, and has generated many groundbreaking ideas. "Every client we work with deals directly with the designer responsible for their job. Through this process we are able to gain an in-depth working knowledge of the client and their needs, and in turn translate this into specific, tailored results."

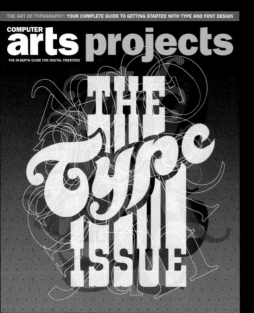

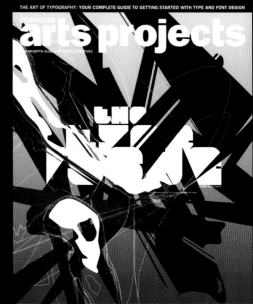

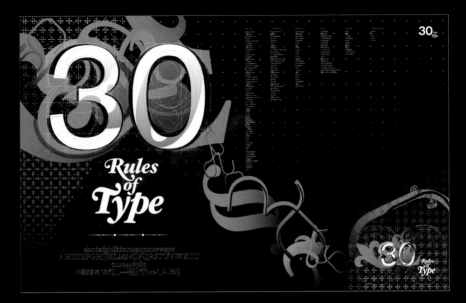

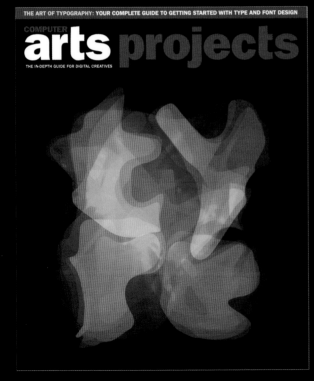

***Computer arts projects***
Research Studios regularly
contributes to the magazine
*Computer Arts Projects*, with
front cover designs or section
spreads in the magazine.

**Royal Court Theater program**

Research Studios created this spring program for London's Royal Court Theater. The typographic treatment, particularly the color and placement, creates a strong visual hierarchy.

**Panel 1 — Stoning Mary**

"So what happened to the bitches that gotta conscience?
The underclass bitches, the overclass bitches
the womanist bitches... What about alla them then?
Not a one of them would march for me."

JERWOOD THEATRE DOWNSTAIRS

One prescription isn't enough for two.
A child soldier comes home.
And Mary faces her last request.

# STONING MARY

**1–23 APRIL**
by debbie tucker green
directed by Marianne Elliott

'a thrilling new voice.' ALEKS SIERZ THE STAGE

**Panel 2 — My Name is Rachel Corrie**

Why did a 23-year-old woman
leave her comfortable American
life to stand between a bulldozer
and a Palestinian home?
The short life and sudden death
of Rachel Corrie, and the words
she left behind.

# MY NAME IS RACHEL CORRIE

**7–30 APRIL**

**Panel 3 — Mortimer's Miscellany / Harold Pinter in Conversation**

JERWOOD THEATRE DOWNSTAIRS

### MORTIMER'S MISCELLANY

JERWOOD THEATRE UPSTAIRS

### HAROLD PINTER IN CONVERSATION

WEDNESDAY 19 JANUARY 7.30pm    THURSDAY 24 FEBRUARY 9.30pm

**Panel 4 — Breathing Corpses**

**24 FEBRUARY – 19 MARCH**

JERWOOD THEATRE UPSTAIRS

## BREATHING CORPSES

**Panel 5 — Wild East**

by April de Angelis, directed by Phyllida Lloyd
JERWOOD THEATRE DOWNSTAIRS    27 JANUARY – 12 MARCH

# WILD EAST

'There is no denying the sheer exuberance of de Angelis's writing.' THE GUARDIAN
'A marvellous, warm, angry play - edgy, pugnacious and bitterly funny.' THE SUNDAY TIMES

design: Mark Thompson. cast: Tom Brooke, Sylvestra Le Touzel, Helen Schlesinger

Frank's got the interview; it's his big break. He just has to convince two
formidable women from the corporation and he'll have his chance to
get back to Russia. But somehow, history is working against them all.

**Panel 6 — Booking Information**

### ON-LINE
www.royalcourttheatre.com

### BUYING A TICKET

PRICES
JERWOOD THEATRE DOWNSTAIRS

JERWOOD THEATRE UPSTAIRS

**Panel 7 — Spring 2005 collage**

ROYAL COURT THEATRE
SPRING **2005**

## WILD EAST
27 JANUARY – 12 MARCH

## STONING MARY

MORTIMER'S MISCELLANY
HAROLD PINTER IN CONVERSATION

## BREATHING CORPSES
24 FEBRUARY – 19 MARCH

SEX ADDICT

MY NAME IS RACHEL CORRIE
7–30 APRIL

# WELCOME TO SPRING 2005 AT THE ROYAL COURT THEATRE

Dennis Creffield
a retrospective
11 march – 3 april 2005

Flowers

**A Retrospective: Dennis Creffield exhibition catalog**

Dennis Creffield has been an artist since the age of 15. This exhibition catalog, designed by Research Studios, was created for his retrospective exhibition, held at the Flowers East art gallery in London. The brief was to create a simple and slick design that functioned as a device to show Creffield's works. The catalog also had to have an air of Research Studios design about it.

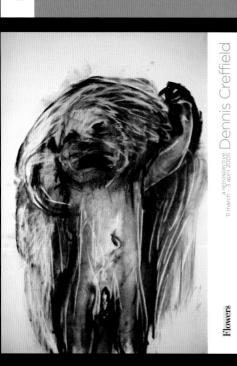

Dennis Creffield
a retrospective
11 march – 3 april 2005

Flowers

a retrospective
11 march – 3 april 2005
Dennis Creffield

Front cover
Little Boy Lost III
Charcoal on paper

Flowers East
82 Kingsland Road
London
E2 8DP

Flowers

Royal Naval College, Greenwich, 1982
Charcoal on paper
(not in exhibition)

he quotes Bomberg's account of being in the crowds acclaiming Einstein at the Savoy in 1939: "Not for being the eminent mathematician but more in the light of the Master of 'Reality', the Adventurer in Infinity." Is it possible to associate Bomberg's use of the "spirit in the mass" with energy, in matter, with the splitting of the atom?

DC There might be something in that thought because he was of the atomic age. But although he coined the phrase I do not know where, or if he ever defined it. Twenty years ago I confidently asserted to Richard Cork: "It is that animating principle found in all nature – its living vibrant being – not simply the sheer brute physicality of the object" but that is just my interpretation.

Certainly, almost always his utterances were more Blakean than Newtonian and you don't have to understand them logically to know what they mean – like Time and Love.

In one thing he was very Newtonian – in his emphasis on the importance of gravity. The physical gravity which we share with all nature – which stops our universe flying apart – the sense of which should be present in the act of drawing and in the image made.

LM Cliff Holden talked about Bomberg's method of teaching as "...dogmatic and contradictory. It was a sort of battle between a trinity of teacher, student and model, a fight

that could not take place away from the materials."

DC Holden should know. He was with him for many years – and he was old enough to understand. But it was not my experience.

Despite many subsequent influences and learnings, Bomberg's teaching remains my most sustaining influence.

LM Bomberg worked with Sickert before he went to the Slade. A line in a Sickert drawing can be traced to a brush-mark in the final painting. Working with colour in tonal layers across the canvas may also have been something Bomberg learnt from Sickert?

DC Sorry, I know nothing of 'tonal layers' or what Bomberg learned from Sickert.

LM In my essay 'From Life' in the collection published for the Pursuit of the Real exhibition, I suggested that Bomberg, Coldstream and Lessons sustained figurative painting in Britain from the 1920s to the 1950s. The Beaux Arts Gallery showed European painters, Martin Bloch, Hans Koppel and Evert Lundquist as well as the painters Kitaj later called 'The School of London'.

DC Figurative painting needed no sustaining in Britain 1920's-1950's – it was taught in all art schools as the essential education for artists – 'learning to walk before you could run'. Unfortunately it was an enfeebled sort

6

17

The Lovers, 1950-51
Oil on canvas

Looking up the East River from Wall Street, 1979
Charcoal on paper

25

## biography

Born South London, 1931

Studied with David Bomberg at the Borough Polytechnic, London, 1948-51

Member of the Borough Group, 1949-51

The Slade School of Fine Art, London, 1951-53
(Member of the Tonks Prize for Life Drawing and the Steer Medal for Landscape Painting)

Prizewinner, John Moore's Liverpool Exhibition, 1957

Member of the London Group, 1962-64

Gregory Fellow in Painting at the University of Leeds, 1964-65

Arts Council Major Award for Painting, 1975

Commissioned by the South Bank Board to draw all the Medieval Cathedrals of England, 1987

House of Commons Fine Art Committee commission, 1989

National Trust's Foundation for Art commissions, 1990-95, 1995-99

Rome Abbey Scholarship, 1991

Dennis Creffield

## solo exhibitions

Leeds City Art Gallery, 1965

Drawings 1960-66, Queen's Square Gallery, Leeds, 1966

Gardner Centre for the Arts, University of Sussex, 1971

Morley Gallery, London, 1972

Brighton Polytechnic Gallery, 1973

University of Essex, Colchester, 1973

Drawings, Serpentine Gallery, London, 1974

Love Paintings and Related Drawings 1970-80, Air Gallery, London, 1980

The Woodall Gallery, London, 1982

A Midsummer Night's Dream - Paintings and Drawings, Goldmark Gallery, Uppingham & RSC Theatre, Stratford-upon-Avon, 1984

English Cathedrals, South Bank Touring Exhibition 1988-90

French Cathedrals, Albemarle Gallery, London, 1991

Selected Paintings and Drawings 1963-83, The Charleston Gallery, Sussex, 1992

Paintings and Drawings of London 1960-90, Redfern Gallery, London, 1992

Paintings of Petworth, Gillian Jason Gallery, London; travelling exhibition Petworth House, Midlands Art Centre, Birmingham; Peterborough Museum & Art Gallery, Durham Art Gallery, Brighton Museum & Art Gallery, 1993-94

Paintings and Drawings of Orford Ness, Connaught Brown, London, 1997

A Year of Saturdays, Paintings and Drawings of London, Clifford Chance, London, 1998

Orford Ness - The Pagodas and Other Buildings, Aldeburgh Cinema Gallery, Suffolk, 1999

Impressions of Castles, drawings of Welsh and English castles, photography, Hay on Wye, 2000

Dennis Creffield: A Retrospective, Hoxton East, London 2005

29

**Exberliner redesign**
Research Studios was heavily
involved in the redesign of
*Exberliner*, the English-
language paper for Berlin.
In addition to creating various
cover designs and images,
Research Studio Berlin also
designed the masthead and
party invites, and contributed
ideas to the inside pages of
several issues.

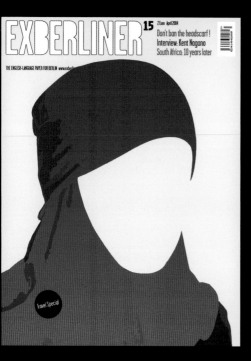

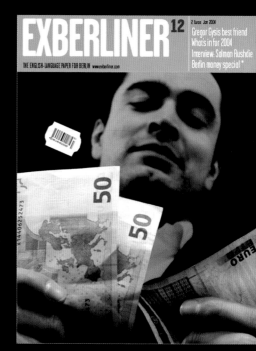

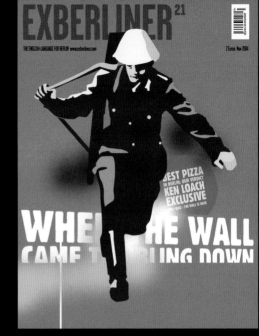

L'AMOUR JEUX

454 PROJETS
POUR PARIS
2012 454
PROJECTS
FOR PARIS
2012

PRÉFACE / FOREWORD

BERTRAND
DELANOË

BERTRAND
DELANOË

PRÉFACE / FOREWORD

LES
ATHLÈTES
AU CŒUR
DES JEUX

ATHLETES
AT THE
HEART
OF THE
GAMES

VILLAGE OLYMPIQUE / OLYMPIC VILLAGE

un village au cœur de la ville
a village at the heart of the city

PARIS

---

VILLAGE OLYMPIQUE / OLYMPIC VILLAGE

UN
VILLAGE,
DEUX
NOYAUX

ONE
VILLAGE,
TWO
CLUSTERS

---

UN VILLAGE
OLYMPIQUE
TOURNÉ VERS
L'AVENIR

AN OLYMPIC
VILLAGE
LOOKING TO
THE FUTURE

Projet urbain à long terme
Long-term urban project

---

**454 Projets pour Paris**
Research Studios was asked
to design a book of the
architecture submissions for
Paris's 2012 Olympic bid
landmark competition. Entitled
*454 Projets pour Paris
2012/454 Projects for Paris
2012*, the book features the
454 submissions for the
competition, with a section on
the winner and highlights of
the 50 commended entries.
Research Studios created the
graphic look and system that
runs throughout the book.
The book was presented to
the Olympic Committee along
with submissions from the
other candidates: London
(ultimately the successful
bidder), Madrid, New York,
and Moscow.

## CONCOURS / CONTEST

### MEMBRES DU JURY

### PANEL OF JUDGES

## PROJETS PRIMÉS
## AWARDED-WINNING PROJECTS

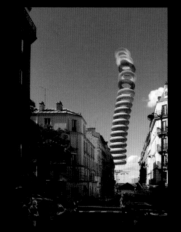

### 1ER PRIX / 1ST PRIZE

## EXPLORATIONS ARCHITECTURE   FRANCE   N°25

1ER PRIX / 1ST PRICE

EXPLORATIONS ARCHITECTURE

PARIS 2012

## PROJETS MENTIONNÉS
## PROJECTS WITH
## DISTINCTIONS

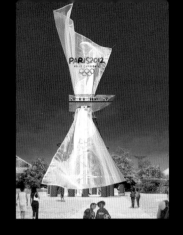

### COSTE-ORBACH FRANCE N°260

DAVID ORBACH, ISABELLE COSTE

*[body text in two columns, illegible]*

Coste-Orbach, septembre 2004

---

## PROJETS REMARQUÉS
## NOTABLE PROJECTS

CHANDÈS-MAILLET

MANUEL BELLIÉ ARCHITECTE

---

## AUTRES PROJETS
## OTHER PROJECTS

BRILLHIMANN CROCHON + ASSOCIÉS

DIGIT-ALL STUDIO

CLAUDE SABATIER ARCHITECTE DPLG

ESPACE

## Beck's Futures catalog

Research Studios began
collaborating with London's
Institute of Contemporary Arts
(ICA) on a variety of projects
in 2002. Beck's Futures, an
annual arts awards scheme
presented by the ICA, aims
to showcase unknown artists.
This Beck's Futures catalog
consists of an A3-format (16½
x 11¾in) piece carrying images
and text, with a shorter, wrap-
around set of pages of text.

17

27

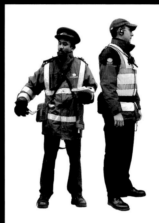

35

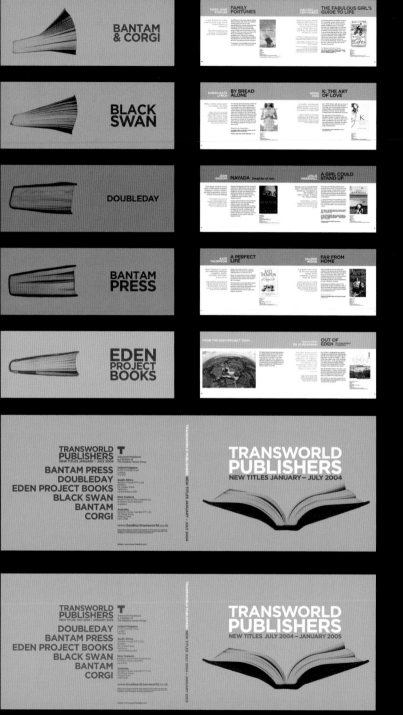

**Transworld catalog**

Transworld Publishers produce a twice-yearly catalog that showcases titles the company will publish over the following six months. Research Studios was commissioned to design one of these catalogs. "We used duotoned images of books, shot from a variety of angles, to create a strong graphic identity for the catalog," comment the designers.

## Issey Miyake catalog

Tribeca Issey Miyake is not only a commercial showcase, but also a constantly evolving art space where artists from a wide variety of disciplines and backgrounds are invited to show or share their visions. Research Studios applied this "art space meets shop" concept to the catalog it was commissioned to design for the store's first anniversary. "We essentially created a 'book within a book.' This allowed Issey Miyake to showcase its key products in the 'outer' book while simultaneously presenting the artists in the 'inner' book."

"the painting itself is part of my life, so that's where I find subject matter"

sebastian blanck

"is a guide rather than a barrier"

"you can learn so much from playing with other musicians"

"I've never understood how an artist who can exist completely as a soloist can..."

"he's looking at all sorts, all the time"

giovanni garcía-fenech

"I am motivated by trying to push my work somewhere new"

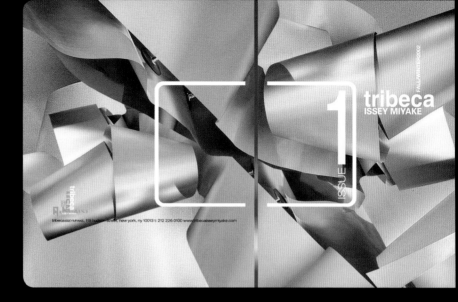

Published by Laurence King
Publishing, copyright Lewis
Blackwell, editor of Creative
Review and Neville Brody.

G1 is a collection of contemporary
graphic design, gathering innovative
work from many of the world's most
influential designers... and then
omitting their names from its pages,
revealing them only at the very end.

It gives the reader the choice of
seeing the graphics as "authored"
works, or as part of the continuum of
communication that is the visual
language of modern design. It is a
book about how design is something
much larger than what "designers"
do.

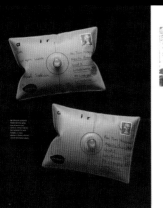

# Segura Inc.

Segura Inc. is a multifaceted design and communications firm specializing in print, collateral, and new media communications. Founder and principal Carlos Segura set up the Chicago-based studio in 1991. Segura's strong advertising background—he spent more than a decade working as an art director for the likes of Young & Rubicam, Ketchum, HCM Marsteller, and BBDO prior to establishing Segura Inc.—has stood him in good stead. "One of our strengths is our ability to give clients the kind of attention they need and deserve. We also believe in building long-term partnerships rather than doing single, quick-turnaround projects. That is how we plan to grow," Segura comments.

Whatever the medium, Segura Inc. prides itself on creating marketing messages that people notice and respond to, with a distinctive sense of style and simplicity that stands the test of time. "Graphic design, print advertising, logos, catalogs, annual reports, brochures, corporate identities, posters, and new media are not the only things we do, but they are among the projects that we do best."

The company is made up of five completely separate, but united ventures, including Segura Inc. (design, advertising, branding, corporate identity, and print collateral); 5inch.com (selling predesigned silk-screened blank CDRs and DVDs online); T-26 Digital Type Foundry (a foundry focused on the creation, distribution, and sale of original typefaces); and the independent record label Thickface.

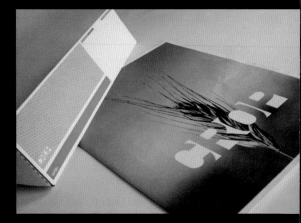

**Corbis Crop-1 catalog**
Segura Inc. designed a number of catalogs for the picture library Corbis' Crop series. The perception of the library in the marketplace, from a creative's perspective,

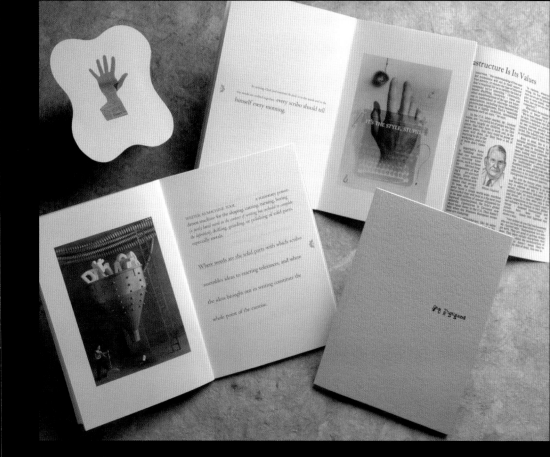

**One Thousand Words
brochure**
Entitled *One Thousand
Words*, this corporate
branding brochure, designed
for technical writer John
Cleveland, was created in

**Crop Perpignan**
This foil-stamped cover
and portfolio case box were
designed for Crop Perpignan,
created specifically for the
Perpignan Photojournalism
conference in France,
to announce the return of
Corbis to the photojournalist

**Crop-3 catalog**
The cover box and sample spreads from the Crop-3 catalog. This catalog focuses on sports and was the first to be subject-specific.

The designers "wanted to create materials that would not only tackle our competition, but also compete with the everyday onslaught of sensory input."

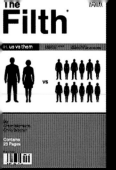

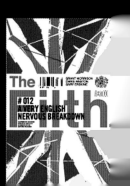

Some of the items for the annual summer concert "Jamboree99", sponsored by Chicago radio station, Q101. They included everything from posters to individual band comic books, passes, t-shirts, stage design and much more.

### Q101 concert series
These comic books were designed to publicize Q101 radio's annual *Jamboree* concert series. As this year's theme was "comics," a comic book was made for each of the bands taking part.

**Right: Itty Bitty font catalog**
One of T-26's projects, this is the Itty Bitty font catalog promoting the T-26 collection of bitmapped fonts.

**Below: 5inch catalog**
This is the 5x5 direct mail product catalog announcing the newest product designs from 5inch.com, a company that sells blank CDRs and DVDs with limited-edition designs silkscreened on them, and joined with color-matched trigger cases. As the company claims, "5inch did to blank media what Swatch did to watches."

5x5 direct mail product catalog. www.5inch.com

**Corbis Crop-4 catalog**
Another in Corbis picture
library's Crop series: Crop-4.
This is Bettman Archive's
"futuristic" insert.

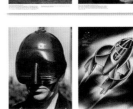

# UNA (Amsterdam) Designers

Founded by Hans Bockting and Will de l'Ecluse in 1987, UNA has an original, playful, and intelligent approach to design that has seen the studio win acclaim both nationally and internationally for its design concepts. UNA distinguishes itself in the Dutch design world through its unique vision. Critical reflection, precision, and attention to detail characterize UNA's designs, while the relationships the studio maintains with its clients are typified by a strong mutual desire to express something of significance.

Based in Amsterdam and supported by a team of six, Bockting and de l'Ecluse work as both designers and consultants to a range of clients, from museums and publishers to government departments and nonprofit organizations. Annual reports, promotional publications, and a wealth of editorial designs are just some of the publications UNA has created. The studio is also renowned for having initiated and produced a series of exceptional desk diaries. Since the first one in 1991, these diaries have been awarded more than 40 important international design prizes.

UNA's design philosophy is based on the semantic relationship between the concepts of "presentation" and "gift."

**present** *the present tense*
**present** *(1) gift*
**present** *(2) being in the place considered; having presence of mind*
**presentable** *suitable for presentation, fit to be seen*
**presentation** *the action of presenting or introducing a person; a bestowal, gift, offering*

According to UNA, "a person or organization who wishes to be 'present' ensures that his 'presentation' is given in the best possible form. This not only implies that it must be appropriate to the person or organization, but also that it must make clear that the relationships cultivated are valued and mean something to the sender. Metaphorically speaking, the manner in which UNA's clients present themselves to their business contacts, therefore, has the character of a 'gift' that has been chosen with love and care and attention. This applies to every design job that presents itself, regardless of who commissions it, the exact nature of the commission, and the medium in which it will be executed."

## UNA desk diaries

Since 1991, UNA designers and their associates have produced exceptional desk diaries as gifts for their respective business relations and friends. Concept, design, photography, illustrations, thematic text, paper, cover, printing, and binding all combine in a unique diary.

### Below: UNA diary cover and bookmarks

The UNA 2006 diary has a transparent colored cover and blank perforated pages. The cover is made from a synthetic material and is produced in six colors, and each diary comes with six different-colored bookmarks.

### Above: UNA diary spreads

At the heart of the desk diary's 53 spreads are images of everyday situations that pass us by. Month, week number, and dates are superimposed. Dutch national holidays are indicated by a white X. The image pages are printed single-sided in full color and silver. The reverse side is in a color that is different for every month and which corresponds to that used for the week number.

## Asko Ensemble identity

Since its establishment in 1966, the Asko Ensemble has been an advocate of the newest developments in contemporary music. In 1974, the Schönberg Ensemble was established for propagating the music of Schönberg, Berg, and Webern. The two ensembles have worked together since 1998, and present themselves both individually and jointly. This can clearly be seen in the corporate identity developed by UNA and implemented in everything from the logo to brochures to programs.

# Asko Ensemble
# Schönberg Ensemble

### F. van Lanschot Bankiers publications

F. van Lanschot Bankiers is the oldest independent bank in the Netherlands, dating back to 1737. UNA's work for the bank includes restyling the family shield, designing the bank's annual reports, annual and biannual reports for the investment funds, and brochures covering a wide range of banking facilities. It also creates brochures for subsidiaries of the bank.

**Below: Nationaal Archief logotype**
UNA designed this logotype for the Nationaal Archief (National Archive). The logotype always appears in conjunction with a varying text message, which provides information about the archive's collection and facilities.

**Right: Nationaal Archief identity**
UNA designed the corporate identity of the Nationaal Archief in line with the archive's objectives: to ensure that the historical treasures contained in the collection are accessible to a society that is either unaware of the existence of the Nationaal Archief or knows very little about it.

**Achter de feiten aan**

Nationaal Archief
**Actueel** Emigratiebeleid en emigrantenlevens in archieven

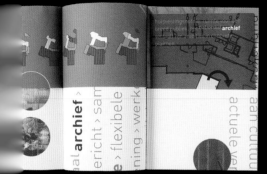

**De oorlog na de oorlog**

Nationaal Archief
**Publicatie** Op zoek naar de betekenis van de affaire 'De drie van Breda'

nationaal **archief** [het] [2003] **1** wil een breed en gevarieerd publiek inzicht verschaffen in de geschiedenis van Nederland; **2** wil de cultuurbeleving stimuleren door op basis van de collectie (inter)actief informatie te verstrekken en activiteiten te organiseren; **3** verwerft en beheert daartoe archieven van landelijke betekenis, afkomstig van de nationale overheid en particuliere personen en instellingen.
Jaarverslag 2003

nationaal **archief** jaarverslag (annual report) 2004

Lessen uit Tsjernobyl

nationaal **archief**

Nationaal Archief
Magazine
2006 / 1

Als de Russen komen

nationaal **archief**

Nationaal Archief
Magazine
2007 / 1

Re-
constructie
van ons
klimaat

nationaal **archief**

Nationaal Archief
Magazine
2007 / 2

Brieven
aan de
premier

nationaal **archief**

Nationaal Archief
Magazine
2007 / 3

Gezocht:
bouw-
materiaal

nationaal **archief**

Nationaal Archief
Magazine
2006 / 1

Rode
kaart
voor
de
KNVB

nationaal **archief**

Nationaal Archief
Magazine
2006 / 2

De
vergeten
Oostzee
connectie

nationaal **archief**

Nationaal Archief
Magazine
2006 / 3

Archief
van een
tv-pionier

nationaal **archief**

Nationaal Archief
Magazine
2006 / 4

Kiezen in
oorlogstijd

nationaal **archief**

Nationaal Archief
Magazine
2005 / 1

Ook
uw
zaak

nationaal **archief**

Nationaal Archief
Magazine
2005 / 2

Een
belaste
relatie

nationaal **archief**

Nationaal Archief
Magazine
2005 / 3

vaarwel
Nederland

hallo
Australië

nationaal **archief**

Nationaal Archief
Magazine
2005 / 4

**Nationaal Archief
publications**

Koninklijke Swets & Zeitlinger Holding NV

Jaarverslag 2003

**Left: Royal Swets & Zeitlinger identity**
Royal Swets & Zeitlinger is a publishing and information services group that operates worldwide, with more than 1,500 employees in 22 countries. Swets Information Services provides numerous options for academic, medical, corporate, and government libraries and information centers worldwide. UNA designed the corporate identity, as well as the annual report and various brochures for the company.

**Below: Swets annual report**
The strong use of typography on the cover of this annual report relays a confident, assured message to the audience.

Royal Swets & Zeitlinger Holding NV

Annual Report 2004

Royal Swets & Zeitlinger

Swets Information Services
An essential partner for publishers worldwide

Swets Information Services
The premier partner for your subscription and information management needs

**Swets annual report detail**
Block colors are used to highlight financial information in a simple, effective manner.

# Carl-Henrik Kruse Zakrisson

Carl-Henrik Kruse Zakrisson grew up in Arboga, Sweden, and worked there for four years in a graphics studio before moving to Copenhagen in 1987, where he worked in-house as a graphic designer. While in Copenhagen Zakrisson contacted Erik Ellegaard-Frederiksen, Jan Tschichold's apprentice at Penguin Books. Ellegaard-Frederiksen suggested he apply to study at Reading University in the UK, which he did and to which he was accepted. It was during his time as a student in Typography and Graphic Communication at Reading that Zakrisson's interest in typography and book design became a full-blooded passion.

In Autumn 1995, armed with his degree, he returned to Copenhagen to set up his own design studio, Polytype. Although Zakrisson occasionally employs freelance designers, Polytype is unique in that it has remained a one-man studio. "I can always pick the best man for the job and still be in complete control. I am something of a lone wolf and prefer not to have to look at the same person day in and day out," he says with a smile.

In Denmark Zakrisson is known as a specialist in "nitty-gritty" typography, and most of his work is highly textual, often requiring simple solutions for complex works. His new editions of the Danish hymnal, in four formats and numerous bindings; the Bible; and a dictionary, in six volumes, are evidence of his skill.

He also works for Museumsbygningen Auctioneers of Fine Art in Copenhagen, the Michael and Anna Ancher's House museum in Skagen, and the Nikolaj Contemporary Art Center in Copenhagen, creating graphic design, book design, identities, promotions, and signage systems. Other domestic and international clients include the Nordic Council of Ministers, Danes Worldwide, and La Maison du Danemark (under The Danish Embassy in Paris), for whom he regularly designs books, exhibition catalogs, identities, promotions, and member magazines. Zakrisson has also recently collaborated on the identity of the Danish-Egyptian Dialogue Institute in Cairo.

He has been recognized locally and internationally for his work. His design of medical journal *Immunological Reviews* was awarded the prestigious Charlesworth Group Main Award for Typographical Excellence in Journal and Serial Publishing, and he was recognized for his Exceptional Contribution to the Field of Typographic Design by the Danish Society for Book Craftsmanship (Forening for Boghaandværk).

***Fodrejse: Fra Holmens Canal til Østpynten af Amager i Aarene 1828 og 1829***
Hans Christian Andersen's debut novel, *Journey on Foot: From Holmens Canal to the eastern point of Amager in the years 1828 to 1829*, was republished in 2005 in celebration of the 200th anniversary of the author's birth. Many talents were brought together to produce a book to live up to Andersen's romantic, frolicking text. The typeface, Andersen, was specially designed for the publication by type designer Per Baasch Jørgensen. As Zakrisson explains, "The body of text has been limited to three sizes, 14, 19, and 42, and the sizes are determined according to the significance of the textual message."

The success of the work lies in its treatment of text and pictures as mutual forms of illustration. "Amager was my playground" is the conclusion of Andersen's protagonist, and in the great, gamboling geography of its pages, the reader is left with a similarly favorable conclusion.

# Credits

I would like to thank all of
the designers who have
contributed to this book
and without whom it would
not have been possible,
especially Vince Frost, Gez
Saint, Nick Bell, Tim Beard,
Mason Wells and Jonathon
Jeffrey, John Morgan,
Roger Fawcett-Tang, Bryan
Edmonson, and Garth Walker.

I'd also like to thank April
Sankey and Lindy Dunlop at
RotoVision, Quentin Newark
(again), and Liz Hancock.

Special thanks to Michael
Hockney, Tiffany Foster, and
all at D&AD.

RotoVision would also like
to thank Jane Waterhouse for
her contribution to this book—
including additional research,
photography, and layouts—
which added tremendously
to its scope.

# Index

**sewn section**
see thread-sewn section

**sewn through**
A method of binding by sewing through the front of a book to the back on an industrial version of the household sewing machine.

**Singer-sewn**
A method of binding by sewing along the centerfold of a document on an industrial version of the household sewing machine. Used as an attractive alternative to saddle-stitching.

**slipcase**
Protective case for a book or set of books. It is open at one end so that the book's spine is left visible.

**spot color**
A color not generated by the four-color process method.

**spread**
Two pages that face each other and are designed as one visual or production unit.

**tabloid**
The smallest newspaper format (23½ x 14¾in/ 60 × 37cm), roughly half the size of a broadsheet. Popular in the UK.

**thread-sewn section**
A method of binding by which the different gathered sections of a book are sewn together with thread. This gives a strong, durable binding, and enables the pages to be opened flat without any danger of damaging the binding.

**tip-in**
An insert attached by gluing along the binding edge.

**uncoated stock**
Paper that has a rougher surface than coated paper, and which is both bulkier and more opaque.

**UV varnish**
A plastic-based varnish applied by screenprinting, available in matte, satin, and gloss finishes. It can be applied over the entire surface or treated as a spot varnish, enabling the designer to print elements purely as a varnish or to highlight selected elements on the page.

**verso**
A left-hand page of a publication. Verso pages always carry an even-numbered folio.

**wire binding**
Binding method by which a thin wire spiral is passed through prepunched holes along the edge of the pages to be bound.

# Glossary

**artwork**
All original copy, including type, photographs, and illustrations, intended for printing.

**bellyband**
The printed band that wraps around a publication, most often seen on magazines.

**Berliner**
The Berliner is a newspaper format of a size between the broadsheet and the tabloid (18½ x 12¼in/47 × 31cm). Also known midi. Popular in Europe.

**binding**
The name given to the process of holding together the pages of a publication.

**bleed**
Printing that extends to the edge of a sheet or page after trimming.

**blind folio**
A page number not printed on the page. In book design, a blank page traditionally is not printed with a page number.

**broadsheet**
The largest newspaper format (17 x 22in/43 x 56mm). Popular in the US.

**casebound**
The term used for a hardback book.

**cast-coated**
Paper that has a very high-quality, high-gloss surface on one side, while the reverse remains matte and uncoated.

**coated stock**
A smooth, hard-surfaced paper good for reproducing halftone images. It is created by coating the surface with china clay.

**comb binding**
Similar in principle to wire binding, a machine is used to punch a row of small holes along the edge of the book, a plastic "comb" is then pushed through the holes to create the binding.

**concertina folded**
Pages folded in a zigzag manner, like the bellows of an accordian.

**creep**
This occurs in saddle-stitched publications when the bulk of the paper causes the inner pages to extend or creep further than the outer pages when folded.

**deboss**
To press an image into paper so it lies below the surface.

**die-cut**
To cut irregular shapes in paper or paperboard using a steel die.

**dust jacket**
A loose paper cover that protects the boards of a casebound book.

**emboss**
To press an image into paper so it lies above the surface.

**endpapers**
The first and last pages of a book, bonded to the inside of the hardback covers.

**face**
see fore-edge

**flush-trimmed cover**
Where a casebound book has its cover boards trimmed flush to the text pages, creating a smooth, crisp finish.

**foldout**
Folded sheet bound into a publication, often used for maps or charts.

**folio**
The printed page number in a publication.

**fore-edge**
The edge of a bound publication opposite the spine.

**French fold**
A sheet, printed one side only, folded with three right-angle folds to form a four-page uncut section.

**gatefold**
A folding sheet in a publication where both sides fold toward the gutter in overlapping layers.

**gutter**
The inside margin, toward the bound edge.

**half Canadian binding**
A method similar to wire binding, although the cover has a spine and the wire is bound through the back cover, which has two additional crease folds.

**ISBN**
An internationally recognized reference number assigned to a published work and usually found either on the title page or the back of the title page.

**Japanese binding**
A binding method whereby the thread is bound from the back to the front of the book and around the outside edge of the spine. It is ideal for binding loose sheets.

**leaf**
One sheet of paper in a publication. Each side of a leaf is one page.

**perfect binding**
Binding in which pages in the gatherings of a book are notched along their uncut edges, to be glued together into the spine. Usually not as strong as a thread-sewn volume, but the method allows for greater flexibility in the number of pages.

**ream**
500 sheets of paper.

**recto**
A right-hand page of a publication. Recto pages always carry an odd-numbered folio.

**reversed type**
Letters left unprinted in a surrounding printed area in order to reveal the base color of the stock.

**roll folding**
A process whereby a long sheet of paper is folded into panels or pages starting from the far right, with each subsequent panel folded back toward the left—effectively it is rolled back around itself.

**saddle-stitching**
The standard method for binding brochures and magazines. The process involves gathering the pages to be bound and stapling them through the folded edges.

**self cover**
A cover printed on the same paper stock as the rest of the publication.

and "Book design in practice," cover a whole range of creative solutions from the master himself. Another good book specializing in this area is *New Book Design* by Roger Fawcett-Tang and Caroline Roberts.

MAGAZINE DESIGN There is a wealth of titles available that deal with magazine design. Two of the best I have come across are *Magazine Designs That Work* by Stacey King, and Jeremy Leslie's *Magculture: New Magazine Design*. The latter begins with five excellent illustrated essays before going on to explore, in more detail, the latest trends and creative design styles in contemporary magazines.

NEWSPAPER DESIGN Newspaper design is a highly skilled job in its own right, especially for a designer working under the pressures and time constraints of a daily. Chris Frost's *Designing for Newspapers and Magazines* covers everything from how to set up a new publication and planning an edition of a newspaper or magazine, to working with text, images, and color. For the novice newspaper designer, *The Newspaper Designer's Handbook* by Chris Harrower is a step-by-step guide to every aspect of newspaper design, from basic page layout to complex infographics, and is loaded with examples, ideas, and advice.

**Individual designers**
I'd like to recommend one of my own books here: *Frost\*: sorry trees* is the monograph of award-winning designer Vince Frost, whose work spans the entire spectrum of publication design, and more. In addition to providing a complete overview of the designer's life and career, the book also explains Frost's philosophy and approach, while individual project descriptions reveal the key characteristics of each project.

Another great title is *8vo: On The Outside*, written and designed by Mark Holt and Hamish Muir. This is an extensive survey of 8vo's work from 1984 to 2001, including *Octavo*, the international journal of typography, and its influence on the emergent, typographically led design movement in the UK during the late 1980s and 1990s. The book emphasizes process; it tries to reveal how designs were made, rather than simply showing finished jobs.

# The best books

There is a myriad of titles available about publication design. Some address specific types of publication, others focus on individual aspects of the process, while some take a more general approach. The type and style of book you choose to refer to will depend not only on your experience, but also on the type of publications that you are interested in designing.

## History
There are not many books about publication design history as such. Rather, there are books relating to specific genres within the realm of publication design, such as magazines or books. David Crowley's *Magazine Covers* is one such title. It is structured thematically, with each chapter covering a specific genre of magazine, and covers the heydays of world-famous magazines such as *Harper's Bazaar* in the 1940s and French *Elle* in the 1960s.

## Theory
AVA's Basic Design Series is a great starting point for any young designer. The series is made up of five books: *Format*, *Layout*, *Typography*, *Image*, and *Color*, which together provide the essential building blocks for this area of design. Providing an invaluable reference tool, each of the books is illustrated with a wealth of current examples supported by clear and concise descriptions, and technical explanations where necessary. *The Designer and the Grid* by Lucienne Roberts and Julia Thrift is another gem, as is Phil Baines and Andrew Haslam's *Type & Typography*, which provides an essential grounding for designers of all levels, from students to professionals.

## Specific publication types
There are numerous books dedicated to specific types of publication.

BROCHURE DESIGN Rockport's *Best of Brochure Design* series highlights the latest and best brochure design from around the world and is a good source of inspiration. *Brochure Design That Works* by Lisa Cyr offers a more practical, hands-on guide to what makes a particular design work.

BOOK DESIGN Derek Birdsall's *Notes on Book Design* is a must for anyone with an interest in this area. The book is entirely illustrated with examples of Birdsall's work. Two chapters, "The process of book design"

It was important to keep each article as a clearly defined unit. Headings for each article are in a beautiful Dante italic and kept in the same type size as the body of text," says Zakrisson of his design. "The character and number relating to each article is the first thing one notices, and it appears at the beginning of each text as an enlarged initial with both functional and aesthetic effects." The decorative figures guide readers to the appropriate article. "Between each article there is just one blank line. All of this gives the publication a sense of gravity and an appealing rhythm."

---

Nordiska rådet bildades 1952 som ett samarbetsorgan mellan parlamenten och regeringarna i Danmark, Island, Norge och Sverige. Finland anslöt sig 1955. Färöarna, Grönlands och Ålands delegationer ingår i Danmarks respektive Finlands delegationer. Rådet består av 87 valda medlemmar (parlamentsledamöter). Nordiska rådet är initiativtagare och rådgivande samt har även kontrollerande och gränslösande uppgifter i det nordiska samarbetet. Nordiska rådets organ är plenarförsamlingen, presidiet och utskotten.

Nordiska rådet
P.B. 3043
DK-1021 Köpenhamn K
Telefon +45 33 96 04 00
Telefax +45 33 11 18 70
www.norden.org

ANP 2002:715
© Nordiska rådet, Köpenhamn 2002
Grafisk form: C.H. K. Zakrisson, www.polytype.dk
Tryck: Phønix Trykkeriet as, Århus 2002
Upplaga: 400
Tryckt på miljövänligt papper som uppfyller kraven i den nordiska miljömärkningen

### Innehåll

---

Nordiska rådets arbetsordning har reviderats genom beslut under Nordiska rådets 53:e session den 30 oktober 2001. Den reviderade arbetsordningen trädde i kraft omedelbart efter beslutet.*

* Nordiska rådets arbetsordning från 1971 ersattes av en ny arbetsordning som fastställdes i enlighet med artikel 59 i Helsingforsavtalet på Nordiska rådets session den 31 november 1996. Den nya arbetsordningen trädde i kraft den 1 februari 1997.

Antagen 2001

Arbetsordning för Nordiska rådet

---

KAPITEL 3

## Gemensamma bestämmelser för presidium, utskott och kontrollkommitté

§ 31 *Rådets organ*
I samband med ordinarie session väljer plenarförsamlingen bland de valda medlemmarna för det kommande kalenderåret ett presidium, en kontrollkommitté, en valkommitté samt utskott.
Plenarförsamlingen utser samtidigt rådets president samt ordförande och vice ordförande i utskotten och kontrollkommittén

§ 32 *Aktivt ordförandeskap*[2]
Presidenten och ordförandena i utskotten och kontrollkommittén ansvarar för att deras respektive organ har en aktuell verksamhetsplan samt för förberedelse av möten och andra sammankomster samt även kontakt till nationella parlamen, närområdena och relevanta internationella organisationer.

§ 33 *Samarbete med nationella utskott*[3]
Utskotten samarbetar med nationella parlaments motsvarande utskott samt med närområdenas och relevanta internationella organisationers motsvarande organ.

§ 34 *Ledamöter i rådets organ*
Vald medlem skall om inte synnerliga skäl föreligger, vara ledamot i minst endera presidium, utskott eller kontrollkommitté. För ledamot i kontrollkommittén gäller särskilda bestämmelser.

§ 35 *Offentlighet*
Möten med presidiet, utskotten eller kontrollkommittén är inte offentliga. Företrädare för delegationssekretariaten och partigruppernas sekretariat har dock rätt att närvara om inte respektive organ beslutar annat.

§ 36 *Aktualiserande av ärende*
Medlem i presidium, utskott och kontrollkommitté får genom skrivelse till respektive organ väcka förslag till beslut i detta.

§ 37 *Tid och plats för möten*
Presidenten, utskotten och kontrollkommittén bestämmer tid och plats för sina möten. Presidiet fattar dock beslut om tid och plats för sådana utskottsmöten som skall hållas gemensamt.
Presidenten, ordföranden i utskott eller kontrollkommittén kan därutöver vid behov kalla till extra möte i respektive organ. Extra möte skall även sammankallas om minst en fjärdedel av presidiets eller ett utskotts ordinarie medlemmar begär det. För extra möte med kontrollkommittén krävs att två medlemmar önskar ett sådant.

§ 38 *Kallelse - möteshandlingar*
Presidenten respektive ordföranden ansvarar för innehållet i dagordningar och övrigt material som krävs för ett mötes genomförande.
Kallelse bör sändas ut av senast före tidpunkten för mötet medan dagordning med tillhörande mötesmaterial skall vara ledamöterna och övriga berörda tillhanda senast en vecka före mötestidpunkten.

§ 39 *Självstyrande områden*
När frågor som berör de självstyrande områdena behandlas vid presidiemöte eller möte i kontrollkommittén kan en vald medlem från berörda självstyrande område om sådan inte finns i presidiet eller kontrollkommittén, närvara, yttra sig och framlägga förslag.

# Arbetsordning för
# Nordiska rådet

## Antagen 2001

SVENSKA

***Katekismus i Kristendom.***
***Børnelærdom for Voksne***
This book uses a classic font combination: Joanna and Gill Sans. The former, with its sublime italic and modern appeal, is used for the main text. The latter is reserved for the lengthy captions: it reflects the blackness of the woodcut illustrations perfectly. The woodcuts are each given their own spread, with captions on the left and illustrations on the right. In this way the volume reads as two books in one.

---

INDLEDNING

er ikke absolut, fordi sproget lader os kigge ind til virkeligheden – og virkeligheden forstås gennem sproget.

Når man spørger om vej, er der to måder at få svar på spørgsmålet på. Nogle mennesker svarer f.eks. således: »Du skal blot gå ned ad gaden, og ved det gule hus drejer du til venstre, og når du er ud for slagteren til højre, kan du se et hvidt stakit lidt fremme. Der skal du ... etc.« Man kan også svare således: »Den pågældende destination befinder sig på Sjællandsgade nr. 12, og den kan tås ad flere veje, hvilket indses, når blot byens grundplan fastholdes i sin helhed ...«. Jeg har valgt den første, som man kunne kalde den barnlige, selvom jeg ikke vil love at jeg altid kan leve op til den. Kendetegnende for børn er at de ikke endnu kan tænke abstrakt og derfor sætter alt i forbindelse med sig selv. Tæt on agtæt, sagde de gamle. Det handler om dig. Det gør det også når vi taler kristendom.

## TROSBEKENDELSEN

Den kristne tro udtrykkes i et lille digt eller bekenderne, som vi kalder *trosbekendelsen*. Den lyder sådan:

*Vi forsager Djævelen og alle hans gerninger og alt hans væsen.*

*Vi tror på Gud Fader, den Almægtige, himlens og jordens skaber.*

*Vi tror på Jesus Kristus, Hans enbårne Søn, vor Herre, som er undfanget ved Helligånden, født af Jomfru Maria, pint under Pontius Pilatus, korsfæstet, død og begravet, nedfaret til dødsriget, på tredje dag opstanden fra de døde, opfaret til himmels, siddende ved Gud Faders, den Almægtiges, højre hånd, hvorfra Han skal komme at dømme levende og døde.*

*Vi tror på Helligånden, den hellige almindelige kirke, de helliges samfund, syndernes forladelse, kødets opstandelse og det evige liv.*

Dette kaldes *Den Apostolske Trosbekendelse*. Man antog at den gik tilbage til apostlenes tid i det 1. århundrede. Man kalder den også for »symbolet«, og trosbekendel-

– 11 –

---

TROSBEKENDELSEN

sen udtrykker således i kort form den kristne tro. Der er tre andre symboler – Den Nikænske Trosbekendelse og Den Athanasianske Trosbekendelse, begge fra det 4. århundrede, samt den Den Augsburgske Bekendelse fra det 16. århundrede, hvor lutheranere markerer sig i forhold til katolikker. Disse fire symboler udgør sammen med Luthers Lille Katkismus Den Danske Folkekirkes bekendelsesgrundlag.

Hvornår bekender man troen ved at sige trosbekendelsen? Ved gudstjeneste og andre lejligheder, men egentlig forudsætter trosbekendelsen at man er kommet væk fra Gud, er skilt fra Ham og ikke længere har et selvfølgeligt forhold til Ham. En af de bibelske beretninger handler om syndefaldet. Adam og Eva spiste af kundskabens træ, og derfor blev de bortvist fra Paradisets Have. Siden da har vort forhold til Gud været kompliceret. Vi lever bortvendt fra Hans ansigt. Vi moder Ham: egentlig mest, når Han ikke er der. Gud taler gennem sin fraværd – det er et tema i megen moderne litteratur. Hans fraværd kan være påtrængende. Vi råber på Ham, fordi Han ikke er os nær. Og vi søger at gøre Ham nær ved at bekende og bede.

Gud er ikke nær, men ligegyldigt hvor meget man prøver at flygte fra Ham, så er Han der alligevel.

At sige »Gud« kan af og til være en tom og intetsigende kliché. At sige »kærlighed«, »håb« eller »fred« kan i virkeligheden være at tale om Gud. Og som sprogforskeren Paul Diderichsen bemærkede: Uden »Gud« bliver disse og mange andre vigtige ord slatne og intetsigende.

At være Gud er derfor også at være nærmere ved mig end noget andet i verden.

Hvor skulle jeg søge hen fra din ånd?
Hvor skulle jeg flygte hen fra dit ansigt?
Stiger jeg op til himlen, er du dér,
lægger jeg mig i dødsriget, er du dér.
Låner jeg morgenrødens vinger
og slår mig ned, hvor havet ender,
så leder din hånd mig også dér.

Det er en gud man ikke kan flygte fra, fordi

for rødder bliver til på min tunge,
kender du det fuldt ud, Herre;
bagfra og forfra indeslutter du mig,
og du lægger din hånd på mig.

(Sl 139)

Adam og Eva spiser af kundskabens træ, lokket dertil af slangen. Træets frugt giver »kundskab på godt og ondt« (1 Mos 3). Det er ikke helt sikkert hvad der menes, men det mest sandsynlige er at det ikke blot er etisk kundskab, men i virkeligheden viden om alt mellem himmel og jord. Den bibelske verden – og også den antikke og middelalderlige – er mere skeptisk over for viden som ikke har et veldefineret fornuftigt formål. I middelalderen er nysgerrighed en af de syv dødssynder; i trangen efter viden ligger også at man kan sætte sig op mod Gud, at man gerne vil gøre sig til hans medskaber eller konkurrent. Fornærmelig ligger der også en afstandtagen fra den skam som opstår når man bliver sig det seksuelle bevidst. I kortens historie har man den diskuteret om Adam og Eva havde et seksualliv i paradis. Luther mente afgjort ja – hvorfor skulle mennesker ellers være indrettet med de dertil hørende organer? Sex er derfor ikke syndigt – det ligger jo før syndefaldet. Noget andet er at det som alt andet kan få former som er syndige. (*Træet of Hans Sebald Beham, ca. 1520*)

– 12 –

– 13 –

**Den Danske Ordbog**
Danish tradition within dictionary design is based on relatively narrow columns with ragged right edges. *Den Danske Ordbog* vol. 1-6 follows this tradition and uses the space on the left of each column to display hierarchical lists. This is a complex and multilayered design, in other words, "nitty-gritty typography." For example, different meanings are displayed under the headword. The number of each definition is pulled to the left to facilitate the quick location of a desired definition. Under these numbered definitions, further categories are displayed by utilizing bullets. The design of this dictionary has been recognized for its highly functional effects and user-friendly composition.

As one publisher wrote, "A good-quality paper with a reader-friendly color, and an exceptional composition characterized by a designer's vast knowledge of the means and effects of typography, make this six-volume dictionary far more accessible than its predecessor. Let us hope Carl Zakrisson's fine work will set the basis for a new paradigm!"

# Z

**Z, z** sb. itk.
-'et, -'er, -'erne; [ˈsɛd]
1 det 26. bogstav i den danske version af det latinske alfabet □ *Goddag, jeg hedder Zabak med Z* DetBAnd89
2 bruges for at betegne en variabel, fx i en ligning el. en formel; *jf* x, y; [sæt i formen z]
**fra A til Z** se -A^

**zairer** sb. fk.
-en, -e, -ne; [ˈsaiˀɐ]
person fra Zaire (siden 1997: Den Demokratiske Republik Congo); **SYN** *zaireisk* sb. □ *Zapperne kaldes disse urgerlige type i forstadem Herlev, fordi de ikke er til at få hold på med umiddelbar fritidstilbud* Pol95

**zambier** sb. fk. – *usofficiel, men alm. form*: zambianer
-en, -e, -ne; [ˈsamˀbiɐ]
person fra Zambia.

**zambisk** adj. – *usofficiel, men alm. form*: zambiansk
-, -e; [ˈsamˀbisk]
fra el. vedr. Zambia.

**zambo** sb. fk.
-en, -er, -erne; [ˈsambo]
person hvis ene foralder er indianer, og hvis anden foralder er mulat el. sort □ *Til de tropiske lystegnes plantager [...] Sydamerikaj indfortes talrige negerslaver. Her findes derfor store grupper af negre, mulatter og zamboer* Fakta88
**HIST** fra sp. *zambo*.

**zappe** vb.
-r, -de, -t; [ˈsabə]
skifte tv-program vha. fjernbetjeningen, ofte gentagne gange og lidt tilfaeldigt for at se hvad der sendes på de forskellige kanaler; [NGN *zapper* (+ADV.)] □ *kan lide at danskere se absurdens kanaler og zappe fra program til program. Det er, hvad man med rette kan kalde passiv tv-kigning* BerTT91
• *tofoj til stadighed skifte mellem forskellige aktiviteter, især som udtryk for rod- el. rastloshed; *jf* flakke; [NGN *zapper* (+ADV.)]* □ *vi mangler tyngden og alvoren i vores liv. Vi zapper gennem livet og forsoker ikke på, at vi hver dag igen vagt, som ikke står til at andre* Akt96

**zapning** sb., zappen ib...
*zapper* sb., *zappen* ib **SIDAFL** *zap* sb.
**HIST** 1987: fra eng. *'zap* 'beskyde, angribe', opr. lydefterlignende ord.

**zapper** sb.
[ˈsabˀɐ]
1 person der zapper fra tv-kanal til tv-kanal *Bendt fra 1988* □ *Jeg er en rigtig zapper, så ser jeg en god film, er det ofte tilfældigt* EksBI2000
• *tofoj person der ofte skifter job el. aktivitet, afhængigt af hvad der umiddelbart virker mest tillokkende* □ *Zapperne kaldes disse urgerlige type i forstadem Herlev, fordi de ikke er til at få hold på med umiddelbar fritidstilbud* Pol95
2 • *fjernbetjening Bendt fra 1992, uformelt)* □ *på torsdag frd jeg laggr min ellers handt provede zapper vark og bare flade ud til TV2-underholdning og -reklamer hele aftenen* Pol95
**SMS** til bet. 1 *zappergeneration.*
-kultur. -mentalitet.

**zar** el. **tsar** sb. fk. – *usofficiel, men alm. stavemåde: czar*
-en, -er, -erne; [ˈsɑ̤]
(titel for) den mandlige monarkiske regent i Rusland fra 1547 til 1917 □ *Zaren var enevældig og udøvede al magt selv. Det hlev der større og større utilfredshed med i befolkningen* skoleb-hist.89c
**SMS** *zarfamilie, -rige*
**HIST** fra russ. *tsar*, lånt via got. *kainar* fra lat. *caesar*, se *kejser*.

**zarathustrisme** sb. fk.
-n; [saɑtuˈ'sdrismə]
religion grundlagt i oldtidens Iran efter profeten Zarathustras lære, med Avesta som hellig skrift og kendetegnet ved dyrkelse af en enesridende gud der kræver godhed og renhed af sine tilhangere i oppiret med tilvoerelsens onde magt; **SYN** *zoroastrisme*; **EMC** *finds i dag isor i Indien*.

**zardomme** el. **tsardomme** sb. itk.
-t, -r, -rne; [ˈsɑ̤domə]
styreform i en stat hvor en zar er overhoved (med uindskrænket

magt) - om Rusland fra 1547 til 1917;
**SYN** *zarisme* □ *I 1913 kulminerede det russiske zardommes despoti og diskrimination mod den ... jødiske minoritet* PaHamn88.

**zarina** d. **tsarina** sb. fk.
-en, -er, -erne; [sɑ'riˀna]
en zars hustru □ *Danmarks prinsesse Dagmar ... blev Ruslands zarina Maria Feodorovna* BerTT91.

**zarisme** el. **tsarisme** sb. fk.
-n; [sɑˈrismə]
styreform hvor en zar har uindskranket regeringsmagt; **SYN** *zardomme* □ *det traditionelle jødiske levned [blev] trykket ned af zartismen* fagb-hist.91b.

**zaristisk** el. **tsaristisk** adj.
-, -e; [sɑˈristisk]
vedr. el. karakteristisk for en zar el. zartidens Rusland □ *det gamle, zaristiske undertrykkelsesmaskineri ... herskede så uhæmmet som nogensinde* BT88.

**zebra** sb. fk.
-en, -er, -erne; [ˈseˀbra]
afrikansk hestelignende hovdyr med sorte og hvide striber; **EMC** *omfatter flere arter inden for hestefamilien*, bl.a. Equus burchelli (almindelig zebra) □ *Jeg gleder mig til at se elefanter, zebraer og giraffer.' Sådan siger frimderen af en tre ugers rejse til Kenya* BT91
**SMS** *zebrakind*
**HIST** af uvis oprindelse, muligvis oindannet af sp. *enzebra* 'vildæsel'.

**zebrafink** sb. fk.
-n, -e, -ene
lille gråbrun spurvefugl hvis han har rødbrune kinder og sorte tvarstriber på struben - er en alm. burfugl; **SYN** *Poephila guttata*; **EMC** *stammer opr. fra Australien; tilhorer familien af pragtfinker*.

**zebrafisk** sb. fk.
-en, -, -ene
op til 4,5 cm lang, indisk fersk-vandsfisk med blå og gyldne striber på langs af kroppen - bruges som akvariefisk; **SYN** *Brachydanio rerio*; **EMC** *tilhorer karpefamilien*.

# Preface

# The Orto Botanico in Padua

# The Hortus Palatinus

# Herrenhausen

# GREAT
## AN ATLAS
# EUROPEAN
## OF HISTORIC
# GARDENS
## PLANS

**Great European Gardens: An Atlas of Historic Plans**

"Everything about this book is great. The gardens, the format, the size of illustrations and even the typography!" says Zakrisson. "Walbaum is used in 14 and 18pt for the body of text and 70pt in headings. Type becomes shapes instead of letters."

The volume's overall consistency is also "great." Each garden is presented over a single spread. The plan, with a short caption, is presented on the right-hand page, while the main text, with auxiliary illustrations and a short chronological list of the garden's development, is found on the left. Thus, the reader is guided through each garden. The pale, uncoated, cream-colored paper reflects that of the original plans, and by ensuring that each plan is contained on a single right-hand page, no information becomes lost in the binding.

Sven-Ingvar Andersson · Margrethe Floryan
Editor Annemarie Lund

# GREAT
## AN ATLAS
# EUROPEAN
## OF HISTORIC
# GARDENS
## PLANS

THE DANISH ARCHITECTURAL PRESS

### Min Sundheds Forliis: Frederik Christian von Havens Rejsejournal fra Den Arabiske Rejse 1760-1763

In this annotated edition of an eighteenth-century manuscript detailing a Danish philologist's journey to Arabia, Zakrisson makes his own point of departure from the original proportions and layout of *Frederik Christian von Haven's* travel notes. Comments concerning the original manuscript are arranged in two columns at the foot of the page, while von Haven's own comments retain their original placement within the side margins, along both inner and outer pages. The typeface, Niebuhr Antikva, designed by Allan Daastrup, takes its name from one of the journey's delegation. A significant element in the book is the extensive use of Arabic as well as Greek and Hebrew characters. "What is important is to ensure that all characters are in accord. Regardless of individual languages and writing systems, they must correspond naturally in terms of weight, blackness, and intonation," says the designer.

Even the binding respects the period. The corners and spine are reinforced with gray cloth, while the boards are bound in special paper produced from hops. Yellow is a recurring color. The type is embossed in black and the calligraphy in yellow, with the endpapers and top edge also in yellow.

**Jihad i klassisk og moderne islam**

The Danish translation of Rudolph Peters' *Jihad in Classical and Modern Times* presents selected Muslim texts, along with notes from the author's own studies, on the reemergence of jihad. With so many quotations in this text, there was a danger of the book having an overly cluttered appearance and "italic overkill." Zakrisson set all Koranic quotations in red, Peters' commentary as a traditional footnote, and the text's original footnotes along the outer margins of the book. Thus, all tools remain at hand.

FORLAGET VANDKUNSTEN

H.C. Andersen
Cai-Ulrich von Platen

## Fra Holmens Canal til Østpynten af Amager i Aarene 1828 og 1829

---

Amagerport er dog den
meest poetiske af alle
Byens Porte. – I Flyve-
posten er den bleven
caracteriseret, som den
idylliske, men jeg vil
hellere kalde den Livets
og Dødens Port.

Det er den første store
Port igjennem hvilken
den uskyldige Amager-

---

hvorfra Tanken, som en
vinget Cherub, svinger sig
op i det Uendelige.«

»O snik snak!« sagde Manden, »her vil jeg nu ikke ræson-
nere Dem, men med det første vil De paa Tryk høre fra mig,
naar De seer en uforskammet Recension, saa kan De vide
den er fra mig.«

»O Gud hjælpe mig! det er bestemt min fæmte Amager-
kone der har forklaret sig,« snikkede jeg. »Men Kjære!« vis-
dog Skaansel med en mig begyndende Forfatter! Siig mig
Fr6lcen! Giv mig Grunde …«

»Grunde!«snerrde han, »naar har De lært at Folk af min
Race give Grunde? Gaae i Lund, snart skal De hore fra mig,
i samme Øieblik slog han mig med sin Stok lige over
Næsen saa St. Peders Briller fløi over Bord og forsvandt
i Bølgerne og med dem var ogsaa Vandmanden borte; men